Boris Groys David A. Ross Iwona Blazwick

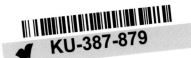
Ilya
Kabakov

Φ

To Gerard
Happy Birthday
June 1999
much love from

ზიძია ჯიმი
(bidzia timi)

Publisher's Acknowledgements
Special thanks to **Emilia Kabakov**,
New York. We would also like to
thank the following authors and
publishers for their kind
permission to reprint texts: **Oxford
University Press**, Oxford; **Robert
Storr**, New York; and the following
for lending reproductions:
Archivio Merz, Turin; **Chinati
Foundation**, Marfa, Texas;
Collection Herbert, Ghent; **Boris
Groys**, Cologne; **Allan Kaprow**,
Encinitas, California; **Claes
Oldenburg**, New York; **Carolee
Schneeman**, New Paltz, New
Jersey; **Victoria and Albert
Museum**, London; **Westfälisches
Landesmuseum für Kunst und
Kulturgeschichte**, Münster.
Photographers: **Robert Archer**;
Boris Becker; **D. James Dee**;
Thomas Demand; **Todd Eberle**;
Jan Engsmar; **Peter Fleissig**;
Jacques L'Hoir; **Emilia Kabakov**;
Jennifer Kotter; **Bob Lebek**; **Igor
Makarievich**; **Boris Michaelov**;
Philippe Migeat; **Elio Montanari**;
William Murrey; **Alicia
Nabamina**; **Dirk Powels**; **Joachim
Rohfleisch**; **Noel Rowe**; **Adam
Rzepka**; **Nic Tenwiggenhorn**;
Morten Thorkildsen; **Elke
Walford**; **Stephen White**

Artist's Acknowledgements
We would like to give special
thanks to Iwona Blazwick and
Gilda Williams for initiating and
commissioning this project. Our
thanks also to the editorial team,
Ian Farr and John Stack, designer
Stuart Smith, and Veronica Price at
Phaidon Press.

All works are in private collections
unless otherwise stated.

Phaidon Press Limited
Regent's Wharf
All Saints Street
London N1 9PA

First published 1998
© Phaidon Press Limited 1998
All works of Ilya Kabakov are
© Ilya Kabakov, Emilia Kabakov

ISBN 0 7148 3797 0

A CIP catalogue record of this book
is available from the British
Library.

Printed in Hong Kong

front cover, **The Man Who Flew
into Space from His Apartment**,
from **Ten Characters**
1985–88
Wood, board construction, room,
furniture, found printed
ephemera, household objects
Dimensions variable
Installation, RFFA, New York, 1988

back cover, **The Toilet**
1992
Stone, cement, wood
construction, men's room,
women's room, household
objects, furniture
Overall h. approx. 5.5 m, w. 4.17
m, l. 11 m
Installation, Documenta IX,
Kassel, Germany
Collection, Museum van
Hedendaagse Kunst, Ghent

page 4, **School No. 6**
1993
Constructed and found school
objects
Dimensions variable
Installed, disused barracks
building, Chinati Foundation,
Marfa, Texas

page 6, **Ilya Kabakov**
c. 1981
The artist's studio, 6/1 Sretensky
Boulevard, Moscow

page 30, **The Man Who Never
Threw Anything Away** (detail)
1985–88
Album, books, household objects,
string, labels
Dimensions variable
The artist's studio, 6/1 Sretensky
Boulevard, Moscow

page 80, **Looking up. Reading the
Words** (detail)
1997
Steel
h. 1500 cm, inscribed area 1445 ×
1130 cm
Installed, Skulptur Projekte in
Münster, Germany

page 90, **On the Roof**
1996
Wood, board, paint construction,
rooftops, chimneys, 10 rooms,
furniture, household objects,
slide projections of photographs
in each room in chronological
sequence, relating to biographical
memories of the artist and Emilia
Kabakov
Dimensions variable
Installation, Palais des Beaux-
Arts, Brussels

Texts appended to captions are
English translations of the artist's
own texts for his works.

Contents

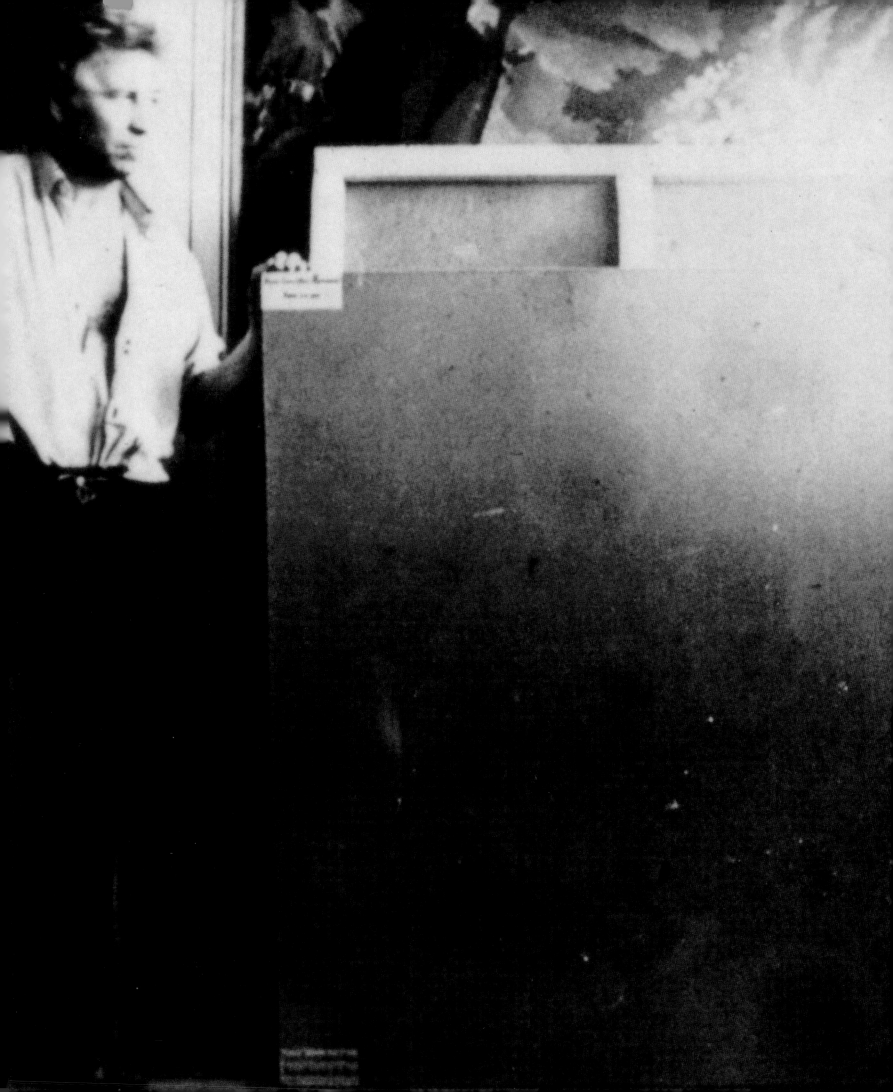

Contents

David A. Ross in conversation with **Ilya Kabakov**

David A. Ross I was thinking of bringing a guitar – you could sing some Russian songs and maybe I'd sing Bob Dylan. The first time I was in Moscow in 1979, I was taken to a dinner party the likes of which I'd never seen before: one chicken for around fifteen people, and of course a great deal of vodka. I remember passing a guitar around the table, and everyone singing Russian and Jewish folk songs. It's slightly embarrassing to recall, but when my turn came I sang Dylan's *Blowin' in the Wind*. I remember thinking: was this really an adequate rejoinder? Was there a way that an American Jew, from a generation that took for granted so many aspects of identity, independence and freedom, had anything to say to these young Soviet Jewish artists?

Ilya, when you were growing up in the Soviet Union, did you have a particular sense of your own Jewish identity?

Ilya Kabakov **Because this question has been asked so often, it is now easy for me to answer. I never had, and still don't have, a clearly defined sense of racial belonging. I see myself a little like a stray dog. My mentality is Soviet; my birth place is the Ukraine; my parents are Jewish; my school education and my language are Russian. My dream was to belong to European culture, a dream that was practically unattainable during most of my life.**

Looking back on my childhood, my school and the Surikov Art Institute in Moscow, I cannot say that we were differentiated by racial or religious identity. In our circle there were people from Azerbaijan, there were Tartars, Russians, Ukrainians, Jews, but who belonged to which religion was relatively unimportant. We all belonged to the Soviet religion. We all shared a similar unhappiness, because we were all Soviet. One of the qualities I saw in the Soviet people was the feeling of their own inadequacy, the feeling that somewhere beyond the border, there existed a real, more authentic, life. It's like a child who doesn't love his parents: the neighbour's soup always tastes better.

Ross The grass always seemed greener ... But isn't this feeling what was always decried as 'cosmopolitanism'? Didn't the paranoiac nature of the Stalinist Soviet state discourage the desire to engage the notion of the modern multicultural city, sensing that it was inherently anti-national, the carrier of the hybridizing influences of modern European urban society?

Kabakov **Yes, in official life, cosmopolitanism was strictly forbidden. But, as you know, thirty years of my life were spent in the circle of Moscow's unofficial culture, which was isolated to a certain extent from Soviet society. It was possible to remain safely cosmopolitan inside this circle. But this is a general theoretical position; personally, I did feel that I was Soviet.**

Ross Can you describe your family life, what your parents did, how they encouraged or discouraged your interest in art?

Kabakov **Neither of my parents had any connection with the arts. I discovered my 'real family' at my school in Samarkand and later at the Art Institute, which represented the standard model of Soviet society in all of its aspects. I was eight years old when the Second World War started. My father was drafted and my mother and I were evacuated in 1943 to Samarkand, in Uzbekistan. It so happened that the Leningrad Art School, the dormitory**

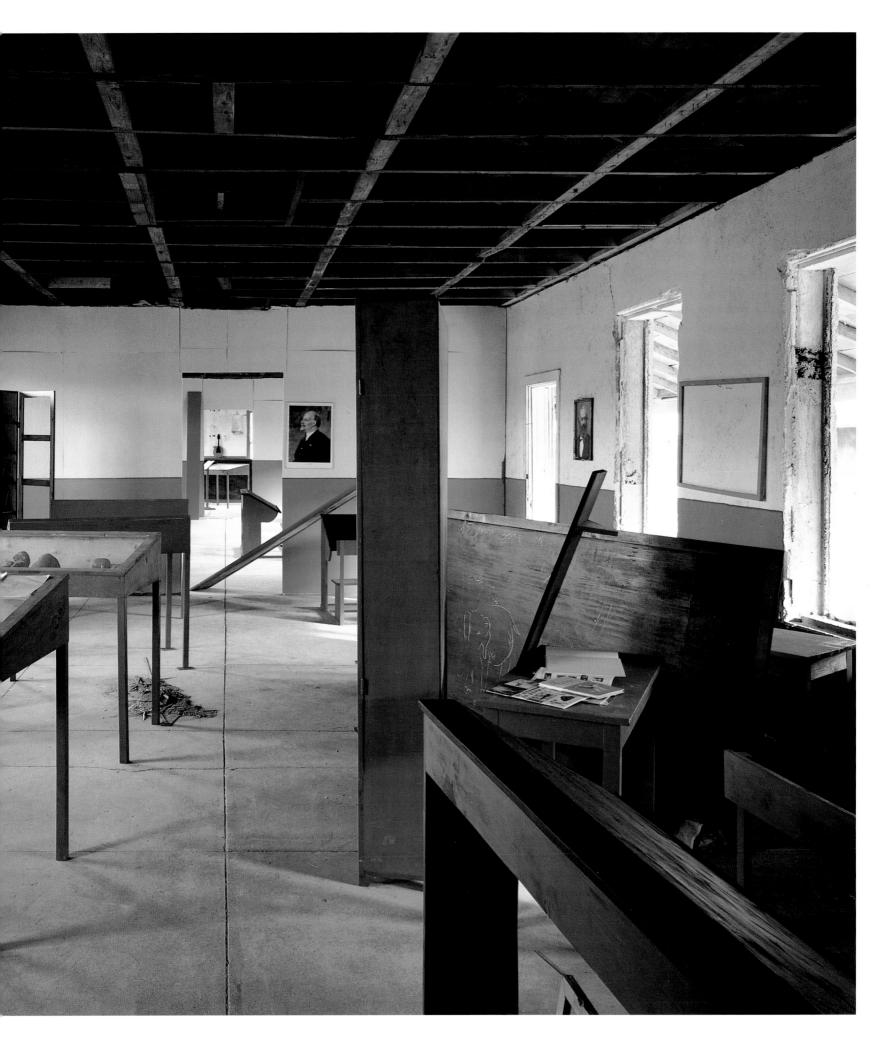

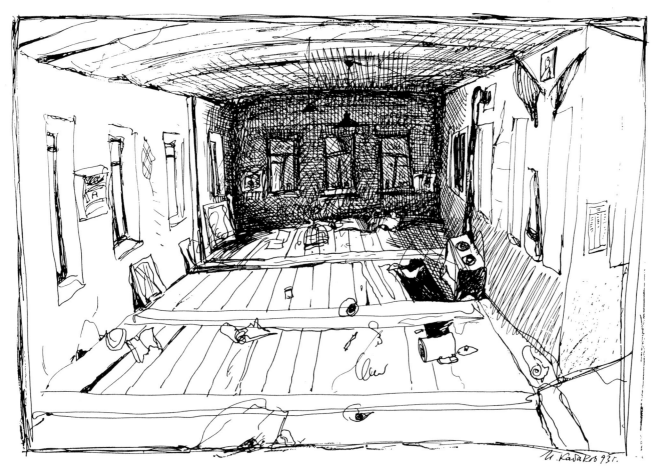

previous page, **School No. 6**
1993
Constructed and found school
objects
Dimensions variable
Installed, disused barracks
building, Chinati Foundation,
Marfa, Texas

left, Drawing for installation
Ink on paper
29.5 × 42 cm

school for 'artistic' children, had also been evacuated there. They saw some
of my drawings and I was accepted into the school.

Ross So, very early on, people recognized your ability to draw.

Kabakov **Maybe they recognized my talent for drawing but at the same time
they thought I was quite talentless at painting.**

Ross Would you say your talent was nourished by the State?

Kabakov **Looking back, after having lived by now for ten years in the West, I
can say that the State gave me a lot, in a material sense. My education both at
school and at the Art Institute was free, and at the Institute I even received a
small stipend.**

Ross By the end of your formal education you must have been deeply imbued
with the idea – which presumably was so pervasive that it was like the proverbial
forest where you can no longer see the trees – that art was in the service of the
people. What did you feel was your role as an artist? To follow some inner desire
to express yourself, or to follow orders, stay on course and make art that served
the State?

Kabakov **Like everything in the Soviet Union, outside appearances did not
represent what was inside. From the outside, the school looked highly
professional. We lived in the school; they fed us, and gave us clothes and**

materials to work with. From the inside it looked completely different. It was just the shadow of the art system that had existed before the Revolution.

Maybe it was inevitable that the academic system, like everything else during the Soviet years, had deteriorated so much. But there was also a personal psychological phenomenon that I would like to describe: from early childhood I demonstrated a complete distrust of everything they were trying to teach me, no matter who my teacher was. Nevertheless, during my early years as a student and later as an illustrator at a children's publishing house, I did everything that was expected of me. In the same way, I accepted the Soviet reality – like the weather, it was a given entity. If you live in a country where it always rains you can't expect to fight the rain by organizing a demonstration.

Ross The problem within the meritocracy of the Soviet art system must have been, how do you reward something better or of more value while remaining true to a notion of complete equality and non-hierarchy?

This kind of idealism is particularly ironic when you think of the eventual influence of Zen and John Cage's thought on the development of Soviet Conceptualism in the 1970s, wherein a levelling or emptying of Western hierarchies of experience, the notion that no experience is better than another kind, was imposed on this system in its last moments of decline. This was in some ways a wonderful mockery of the impossible idealism of Soviet Socialist art. The absorption by the Collective Action group of this Westernized-Eastern approach subtly criticized the Soviet system's inability to impose pure Communist egalitarianism into the aesthetic system.

To return to your early experience of Soviet society, I'm interested in how you became aware of these social and psychological contradictions, of the lie that you were living.

Collective Action Group
Action: Painting
1980
2 black and white photographs
16 × 27.5 cm
Documentation of performance

Kabakov **This is a central question. This awareness began in my early childhood: a feeling that the outside is not co-ordinated with, or is not adequate to, what's taking place inside.**

I didn't want to see this social reality as a given. My problem was how to learn to have a double mind, a double life, in order to survive, so that the reality wouldn't destroy me. At school I was amicable but inside was a small scared person watching the other person behaving in a socially acceptable way. This little person was incredibly scared, all tied together inside.

Ross What you're describing sounds like a kind of schizophrenia.

Kabakov **Yes, that makes it easier to understand how I was working as an artist. I very quickly learned everything that my teacher instructed me in order to go by the rules, but the person inside never understood what was going on. I was like a trained monkey or dog. The person inside me didn't have any contact with my hands, with what was produced by these hands. So what was natural for others, in order to become a Soviet artist, for me was a learned ability.**

Ross What did it mean to become a Soviet artist, to employ your talents in the service of the people, of the State? What was expected of you?

Kabakov **The Soviet art system was strictly and formidably divided into themes, subjects and formal styles. The programme was already set – there had to be happy, festive paintings, works celebrating the structure of social life. Each artist would receive a list of the same themes, which he or she had to follow in order to exhibit or sell to the State.**

Ross So if Matisse said that art was like an armchair for the weary businessman – the bourgeois owner, or viewer, of a painting could just relax in its presence and take pleasure from it – in the Soviet Union this Matissian formula became a prop for the State. Art became a function of communal happiness, with conditions that everyone understood. Your job was to help people feel better about the reality of their lives.

Kabakov **As I recall, the structure of Soviet art production, by the end of the 1950s, was strictly hierarchical. Paintings depicting the history of the Soviet State were considered the most important and prestigious. Then, in descending order, were portraits of Party leaders, metal workers, *kolchosniks* (collective farms); then landscape, still life and, at the lower end, genre painting. Incidentally, this was reminiscent of the hierarchy used by the Bologna School in the sixteenth century.**

opposite, **Wassily Kandinsky**
The Last Judgement
1910
Oil on canvas
67.5 × 40.5 cm

Ross So what had happened to the revolutionary idea of pure, non-objective painting and sculpture, via Malevich, Kandinsky, Tatlin and their contemporaries? How did this early modernist legacy disappear?

Kabakov **These ideas were channelled into the propaganda structure.**

Ross So, during the period of Productivism, these ideas were only acceptable when mediated through industrial and graphic design? In a sense, the avant-

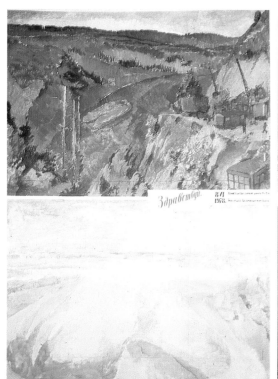

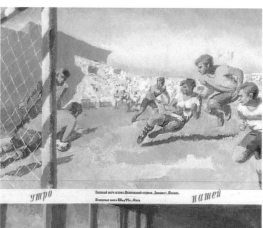

opposite, **Hello, Morning of Our Homeland!**
1981
Enamel on masonite
Triptych, 260 × 190 cm each panel
The artist's studio, 6/1 Sretensky
Boulevard, Moscow, 1982

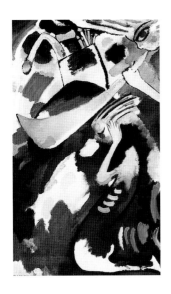

opposite, **Hello, Morning of Our Homeland!**
1981
Enamel on masonite
Triptych, 260 × 190 cm each panel

garde was being taken at its own word, because its impetus was 'art into life' and the slogan of Productivism was, 'Not the new, not the old, but the necessary!' The State absorbed the avant-garde and then dismantled it by embedding it into everyday life; artists no longer made art but made everyday objects. Rather than being dismissed as anti- or counter-revolutionary, or cosmopolitan, was this artistic tradition just invisible, forgotten?

Kabakov **What I describe is the situation in the 1950s, the artistic climate in which I and my friends were formed as artists. I didn't see the works of Malevich, Tatlin and others, because their works weren't exhibited and publications didn't exist. But no, I'm wrong – in the Pushkin Museum during the 1960s Kandinsky's paintings appeared in the section of Western art with the label: 'Wassily Kandinsky. French Painter'.**

Ross But surely you saw their influence in your environment? There were posters, there still is the great architecture, there were examples in your day-to-day life, at least in Moscow, of revolutionary artistic thinking.

Kabakov **The things you are talking about were visible to all the civilized world, but my friends and I saw Maria Ivanovna in the communal kitchen frying *pozarski kotletas* – meat patties.**

Ross So none of your art teachers said privately, or whispered to you, 'I'm going to tell you about something … '?

Kabakov **Private conversations and whispering would have been politically incorrect.**

Ross So how old were you when you first encountered these avant-garde traditions in your own culture that had been hidden from you?

Kabakov **I found out about them when I was almost forty, and by that time they were dead for me. The majority of us didn't know about any traditions at all. We all started from scratch.**

Ross Almost forty years old – that's 1973!

Kabakov **In the Soviet Union time passed at a different pace from the rest of the world.**
Many of the older artists were working at home, in the tradition known as 'Cézannism'.

Ross Because that was the last radical movement before the 1917 Revolution?

Kabakov **In the 1950s and 1960s the 'Cézannists' didn't exhibit, that is true, but they did live in Moscow and the tradition of this kind of art was still alive. They were called formalists and they were 'underground', a term synonymous with modernist. When we visited Robert Falk's studio, for us his abstract style of painting, which was known as 'Cézannism-Cubism' represented a grand art form in opposition to Soviet art.**

Ross Yet when you walked past buildings in Moscow designed by architects such as Konstantin Melnikov, surely you couldn't look at them without realizing that there was an entire aesthetic world attached to this architecture that was different from anything you knew. These buildings were as radical as any painting – did they not lead you to the same notions of non-objective space and abstraction that you would glean from a Malevich painting?

Konstantin Melnikov
Rusakov Workers' Club
1927–28
Moscow

Kabakov **I didn't see them. The problem was that I didn't have any contact with this vanished civilization. My perception of these buildings was like that of a dog running about the ruins of the Parthenon. I was on another level. For me it was the past; maybe it was beautiful, but it had nothing to do with me.**

Ross Why did you become an illustrator of children's books rather than an artist who represented and glorified the State? Where are the illustrators in that hierarchy you were just describing? Were they below the landscape painters?

Kabakov **My view as an outsider to this person, to myself, was that this artist, educated in Soviet institutions, was always aware that he couldn't escape the system. He had to do exactly as the Soviet institutions asked him. Yet the person inside, who didn't understand why he was supposed to do all this, who was always trying to express what he was really feeling, didn't understand that everything of artistic importance was in the art of the outside, the art of others. This small person could only see the boring or scary or banal aspects of everyday life. He saw dirty bottles, a lot of garbage, tickets to the subway, advertising. This little person felt a unity with everyday life. There wasn't a desire to disappear, to run away from the everyday, to do something romantically high; there was rather a desire to express this unity with banal everyday life. That's how he created two ways to live in order to survive in this society. To survive, he started making illustrations and, in order to be paid, he completely followed the rules.**

I was always aware that I was making children's book illustrations for only one reason: to make a living. It left me with free time in which I could do what I really wanted. I learned how to produce children's books so fast that for twenty-eight years of my life I could spend only two and a half months a year doing this job.

Ross So it was your decision not to seek entry into the official Soviet art academy and become an official artist? Would that have been denied you?

Kabakov **If I had continued only making children's illustrations I would have made a great deal of money and risen up the official hierarchy.**

Ross So, in your role as an artist, as opposed to your official job as an illustrator, you had to be invisible?

Kabakov **I was making enough money to build my own studio and I was a legalized artist, which was incredibly important. An artist who wasn't a member of the artists' union had problems working at home, because it was against Soviet laws.**

Ross But couldn't art be your 'hobby'?

The Poetry Train, from **Overseas Poetry for Children**
1974
Sample pages, illustrated children's book
28 × 17 cm
Children's Literature Press, Moscow

Kabakov **Yes, but you would have to work and then have it as a hobby in your free time off work, even if that meant sweeping the streets.**

Ross So if you wanted to be a painter, you could take a job as a street-sweeper and work eight hours a day and then paint at night, no problem.

Kabakov **I had the right to make drawings for myself because I was officially an illustrator.**

Ross In one sense there isn't a totalitarian overtone to the kind of decisions you had to make. You made the same kind of decision as any young artist whose work is not in favour with the prevailing system. For example, Edward Hopper had to survive by working as a magazine illustrator until eventually people became interested in his paintings, when he was in his forties.

Kabakov **Except for one difference. In the Soviet Union you wouldn't have a background activity that was the same as your official activity. That's why official people couldn't understand what it meant to be an unofficial artist, to have an unofficial art world. Especially if you were an artist with official education and recognition. That's why there were such wild explanations: they were spies, they wanted to sell their paintings in order to discredit the Soviet Union.**

Ross Who created that notion?

Kabakov **The Soviet government officials. They couldn't understand. If you were an accepted artist why would you produce this garbage? To discredit the Soviet Union?**

Ross How did you answer those questions? Can you describe the first formal incident where you were confronted by an authority about your unofficial work?

Kabakov **It was when my drawings were first shown outside the Soviet Union, in a group exhibition, 'Contemporary Alternatives II' at Castello Spagnolo, L'Aquila, Italy, in 1965. Antonelli Trombadori, a member of the Italian Communist party, attended Communist meetings in the Soviet Union and wanted to demonstrate that we had another art apart from official art.**

Ross Why would an Italian Communist want to do that?

Kabakov **The Italian Communist Party had a broader understanding of Communism at that time. Trombadori was also a well-known poet; he would visit the studios of unofficial artists, who gave him a generous amount of drawings, so eventually he exhibited them. He showed a series of my drawings entitled *Shower* (1965/78). They depicted a man standing under a shower but with no water. This series, which I continued over a number of years, developed a number of metaphors, one of which related to the person who is always waiting for something but never receives anything. In Italy however, the drawing was interpreted as a metaphor for Soviet society: people are always waiting for a material reward that never arrives.**

Эй.
Спасайтесь поскорей
Убежал из кухни Клей!
Никого он не жалеет:
Всех.
Кого ни встретит.
Клеит!
Склеил банки и бутылки.
Ложки.
Плошки.
Чашки.
Вилки.
Склеил вешалку и мылся.
Склеил лампу и пальто.
К стулу он
Прикинул шляпу –
Не отклеить ни за что!
Склеил книжки и игрушки.
Одеяло и подушки.
Склеил пол и потолок –
И пустился
Наутёк.

Он бежит – и клеит. клеит...
Их.
А клеить он умеет!

Не успел закончить драки.
Кот
Прильнился к собаке.
А к трамваю
В тот же миг
Прильнился грузовик!
Побежал что было духу
К ним на помощь постовой –
Постового, словно муху
Клей приклеил
К постовой!

Что же делать?
Всё пропало!
Люди. вещи. звери. птицы –
Все склеились как попало
И не могут
Разлепиться!

Гаснут в городе огни –
Тоже склеились они...
И глаза
Слипаться стали.
Чтобы все
Скорее
Спали!

The Glue
1980
Enamel on masonite
260 × 190 cm
Painting used in the installation
The Untalented Artist, from **Ten Characters**, 1985–88

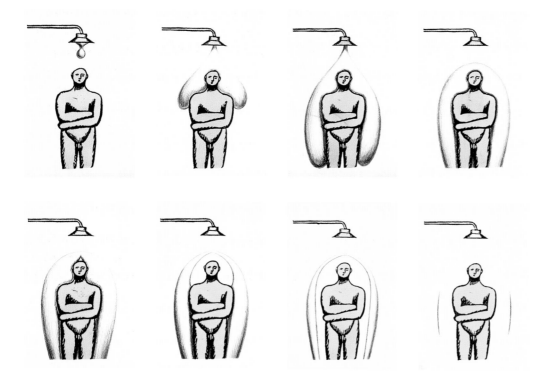

left, **Shower**
1978
Ink, coloured pencil on paper
From the series of 10 drawings
22 × 15.5 cm each

opposite, **The Release**
1983
Linoleum-cut, watercolour,
coloured pencil on paper, screens
24.5 × 18 cm each

Ross What exactly happened – was an export licence requested, or were you visited by a member of the union, or by a local commissar?

Kabakov **No, it's a long story. For almost twenty-eight years there was a feeling of danger. One sensed that at any moment somebody could come and take your work away or destroy it. Because of this exhibition, for four years I couldn't get a job in any Soviet publishing house and was forced to make my illustrations under someone else's name.**

Ross Was there ever any actual confrontation where someone came to you, or was it more like blacklisting in America in the 1950s?

Kabakov **There were articles in the newspapers stating that these artists were making fun of the Soviet Union. During the Stalin era, after appearing in this kind of article you would be completely destroyed. Contact with foreigners was forbidden. The 1960s were different times; the KGB knew everything but didn't grab you. If they thought that there would be no reaction in the West, they would make an arrest and throw you either out of Moscow or into a mental institution. But they were reluctant to touch people who had received more attention in the West.**

Ross So what happened to a literary figure like Alexander Solzhenitsyn was different from what could happen to a visual artist?

Kabakov **The foreigners who visited us were rather like a protective shield.**

Ross Yet, the officials could still act upon you by denying you a living? Were you ever formally confronted by a colleague or by a former employer, by someone who said, 'Ilya, you're making a mistake. Don't do this, you're going to hurt yourself'?

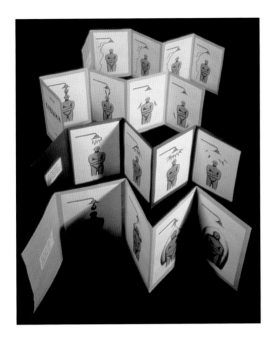

Kabakov **Yes, many times. All artists were controlled by someone on the side of the government, who would patronize them and give them 'advice'. I had a few conversations with the chief artist of Detgize where I was working. He said, 'You participate in exhibitions with anti-Soviet artists like Rabin and others. You are not supposed to participate in these exhibitions. I would recommend that you write a letter to the newspaper stating that you have nothing to do with all this. In your place I would do that.' I refused to follow his advice and immediately lost my job.**

Ross Did any of the people in your circle of artists turn out to be working for the KGB?

Kabakov **I don't know. For me it was an ideal circle, very intimate, friendly, with very decent people, and strongly tied together. But the KGB knew very well what was going on in the studios. I imagined that whenever a foreigner arrived, there was always an agent in a car outside listening to what was going on upstairs in the studio. All the telephones were bugged and the KGB knew exactly who came to the studios and what they talked about.**

Ross In 1979 I was making a video performance work with Roschal, Donskoi and Skersis in Moscow, which referred to Chris Burden's work. They buried themselves in a mass grave while painting and talking about their experiences as Soviet artists. When I got back to Berkeley I discovered that I had been followed the whole time in Russia. Even when I thought I'd freed myself and went out in a taxicab into the countryside, they knew exactly what I was doing. So that's a life that I wasn't used to as an American, even as a paranoid anti-war activist. We were all paranoid about being followed, but none of us actually were. In Russia everyone was.

Kabakov **In Russia it was everyday reality. It was the normal climate.**

Ross At a certain point, even though you could continue working in Moscow and your reputation was growing, you still decided that you had to leave.

Kabakov **I applied to leave three times, because I knew that the climate was not going to change. But something inexplicable prevented me from leaving.**

Ross Were you officially prevented from leaving?

Kabakov **Maybe something in my character stopped me from leaving. I couldn't make a serious decision and radically change my life. I could live a double life but I couldn't change my reality. Probably I would have stayed there forever if Perestroika hadn't come. I was offered a grant by the Kunstverein in Salzburg in 1986 and received permission to leave. It was the first time that someone was granted such permission, an artist by himself, alone, for three months. So I left not because I was a heroic person, not because I decided to change, but because the situation had changed. I have to say that today I have a comfortable psychological feeling that I didn't emigrate, I didn't leave my country. I simply work. I receive many invitations and I am constantly working around the world. This has a long tradition, for example Chagall worked outside of Russia, and Kandinsky left and worked in**

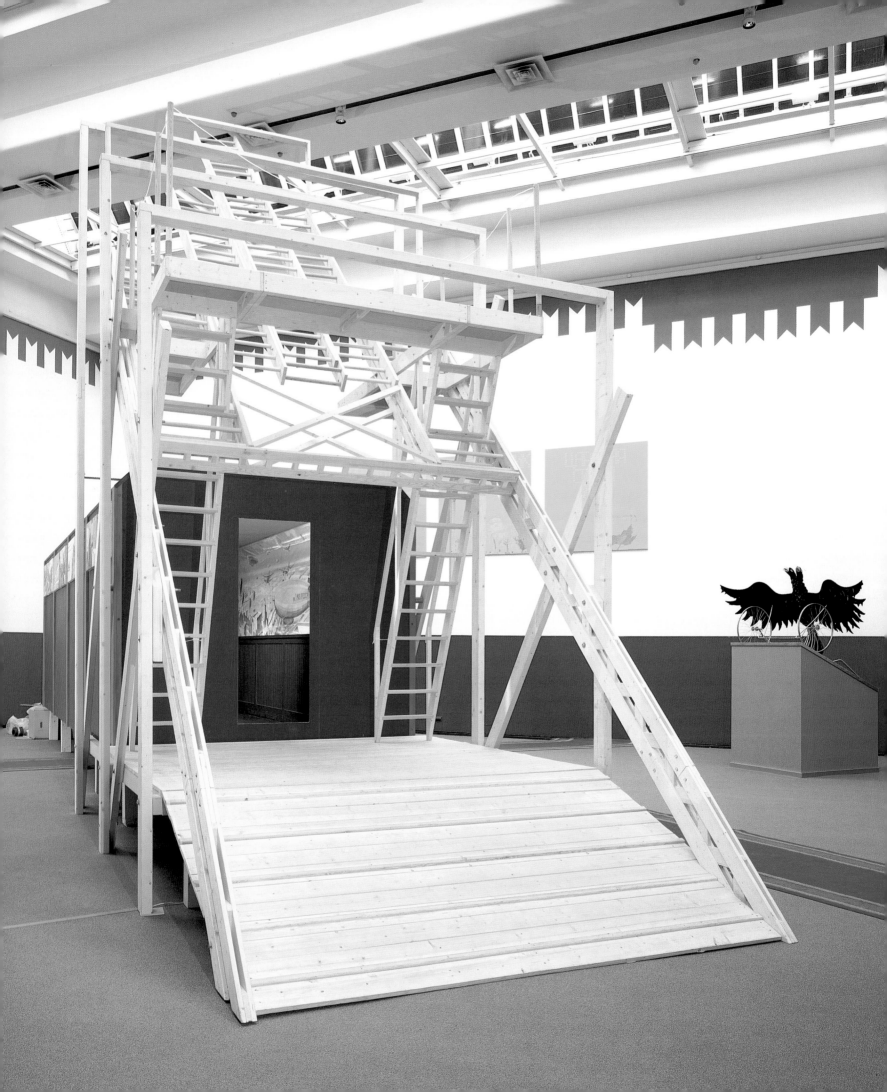

Paris. In any case, I know for sure that I will never return.

Ross Earlier you talked about a kind of a Europeanism that was your ideal in terms of your identity.

Kabakov **I wanted to be accepted and to participate in a family that I know, which for me is a 'family' of European contemporary artists.**

Ross One of the things that I noticed, in my brief exposure to a Russia in a period of rapid change, is that in my early visits there was this enormous sense of community, particularly among the unofficial artists. There was an unbelievable sense of compassionate criticism and mutual empathy. Everyone was equally respected internally. People would stay up all night talking about art, not complaining that their work didn't sell or that they didn't get the right show, or any of the realities of the Western art world.

I remember seeing a show of Conceptual Art in Moscow that wouldn't draw fifteen people in New York. People were lined up around the block to see it because it was unofficial. It represented freedom and independence. I wonder if everyone sensed the loss of that sense of community as rapidly as an outside observer, like myself, observed it?

Kabakov **The unofficial world has many levels. A new kind of artist came after Perestroika, but the general core of artists that existed before Perestroika kept working in the same way as before. The changes were on a different**

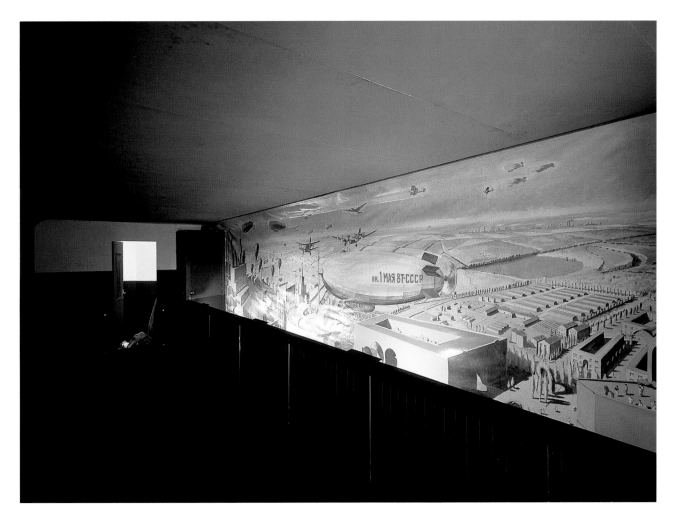

The Red Wagon, with musical arrangement by Vladimir Tarasov
1991
Wood, steel, board, paint construction, 'train wagon', carpet, Socialist Realist style paintings and mural by the artist, garbage
Overall h. 700 cm, w. 350 cm, l. 1700 cm
Installation, Kunsthalle, Dusseldorf

right, Installation detail

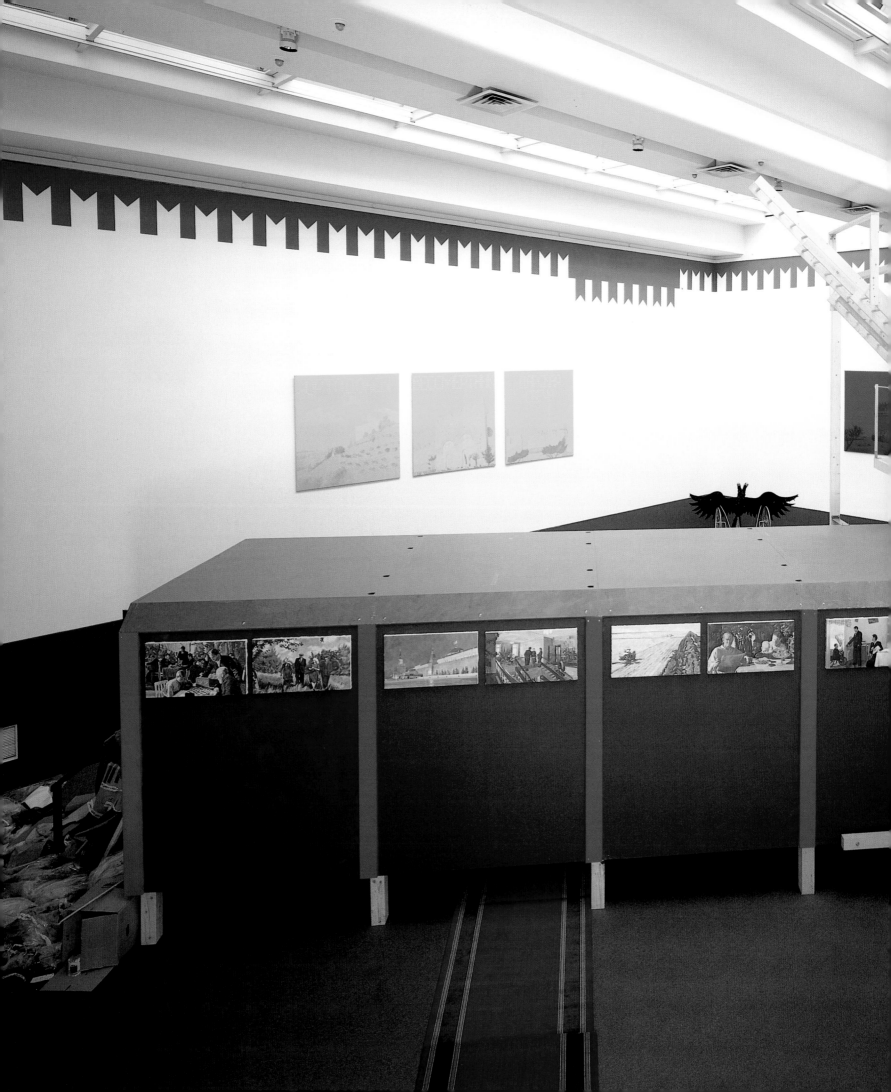

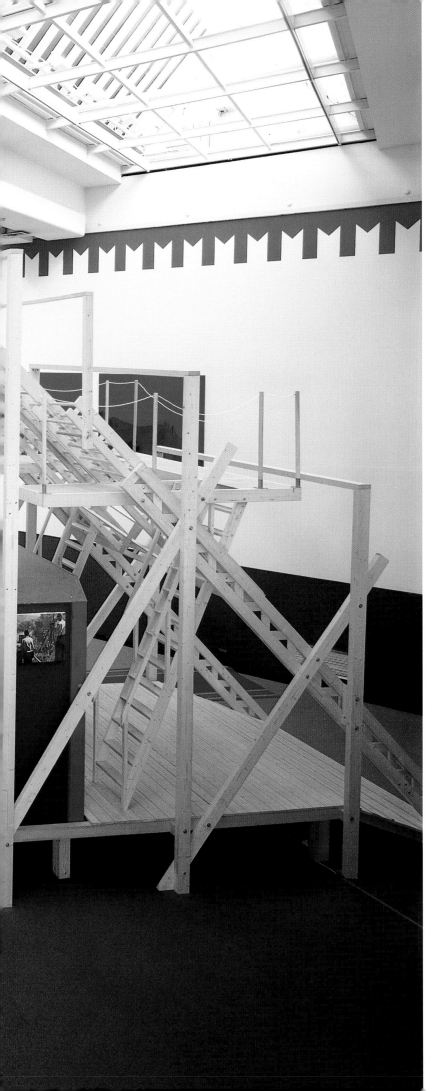

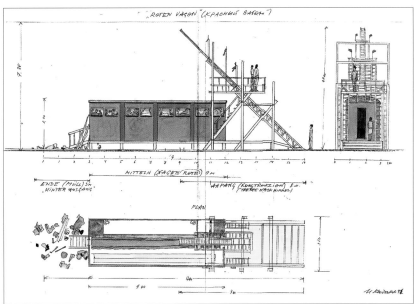

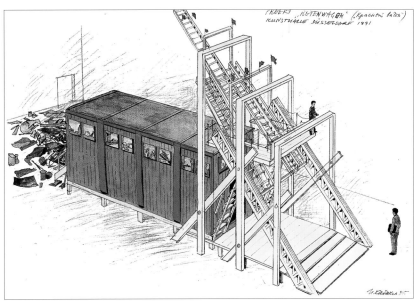

opposite, **The Red Wagon**, with musical arrangement by Vladimir Tarasov
1991
Wood, steel, board, paint construction, 'train wagon', carpet, Socialist Realist style paintings and mural by the artist, garbage
Overall h. 700 cm, w. 350 cm, l. 1700 cm
Installation, Kunsthalle, Dusseldorf

above, Drawings for installation
Ink, watercolour, coloured pencil on paper
29.5 × 42 cm each

level. During the Soviet period it was as if everybody was living in a bomb shelter – there was a war going on outside, but they were all together. Like a friendly circle, they were very close to each other, they exchanged news. Everybody respected each other even if they weren't close, artistically speaking. Perestroika was the moment when the war ended, the sirens stopped sounding, the doors opened and you could come out. At that point the connection that held everybody together for thirty years stopped working. That was the price of peace, and from an ethical point of view this was the real tragedy for many. Today the feeling within this circle is one of great bitterness.

Ross For artists whose content was based on an analysis or critique of that oppression, the content was pulled away, there was no longer the frisson needed to construct their work. Your work, which is about a certain kind of internalized duality and the irony of modern life, could in fact be anywhere. It is not ideologically specific – although it was generated within a specific ideological and social context – because it addresses a broader philosophical and spiritual set of concerns. It must have been important for you to recognize that your work could be independent of the Soviet system, as an artist living in the late twentieth century, experiencing the reality of modernity.

Kabakov **For me it's important to exist in the perception of others. In fact, the opinions of others are more significant to me than my own. The mind of the other, for me, is not relative but completely idealized.**

Ross An idealized and imagined space.

Kabakov **It was only in my imagination, but the image I used to have in my mind was so clear that I could see worlds that I never saw in reality. I saw images of curators, the art world, who could understand my work. When they came from the West to my studio, I recognized them as if they were long-lost relatives. I projected my internal state of mind onto them, so their language was my language and I felt that I was finally understood. This is how it was, and it's interesting psychoanalytically, even if it sounds sentimental.**

For me the art world is like a huge river, which began somewhere in the past and keeps flowing towards the future. Speaking metaphorically, I was always dreaming about coming to this river and being able to swim in it. For me the two scary possibilities were either of being too far away to dive in or of sitting on its banks, only watching the others swim.

Ross Ironically, the years you spent as an illustrator, developing the ability to tell simple stories to children, became an operating condition for your art, a language you could bring to the production of very sophisticated art. Your art still tells very simple stories and speaks in a very direct way to people. It's very accessible to audiences who aren't very knowledgable about art. I remember spending some time observing people walking around one of your installations, people who'd mostly never seen your work before and who would have had no understanding of Soviet Conceptual Art made in that era. They walked into the space and seemed to understand it completely, viscerally, without being able to read the conventions of Modernity or Postmodernity or Conceptualism.

ILYA KABAKOV *MUSICAL IMPROVISATION* VLADIMIR TARASOV

RED PAVILION

VENICE BIENNALE 1993 JUNE 14 - SEPTEMBER 14

The Red Pavilion, with musical arrangement by Vladimir Tarasov
1993
Wood, board, paint construction, pavilion, wood fences, flags, builders' materials, loudspeakers, sound installation
Dimensions variable
Installation, Russian Pavilion, 45th Venice Biennale
Collection, Museum Ludwig, Cologne

opposite and top, Installation details

above, Poster for the installation, 45th Venice Biennale

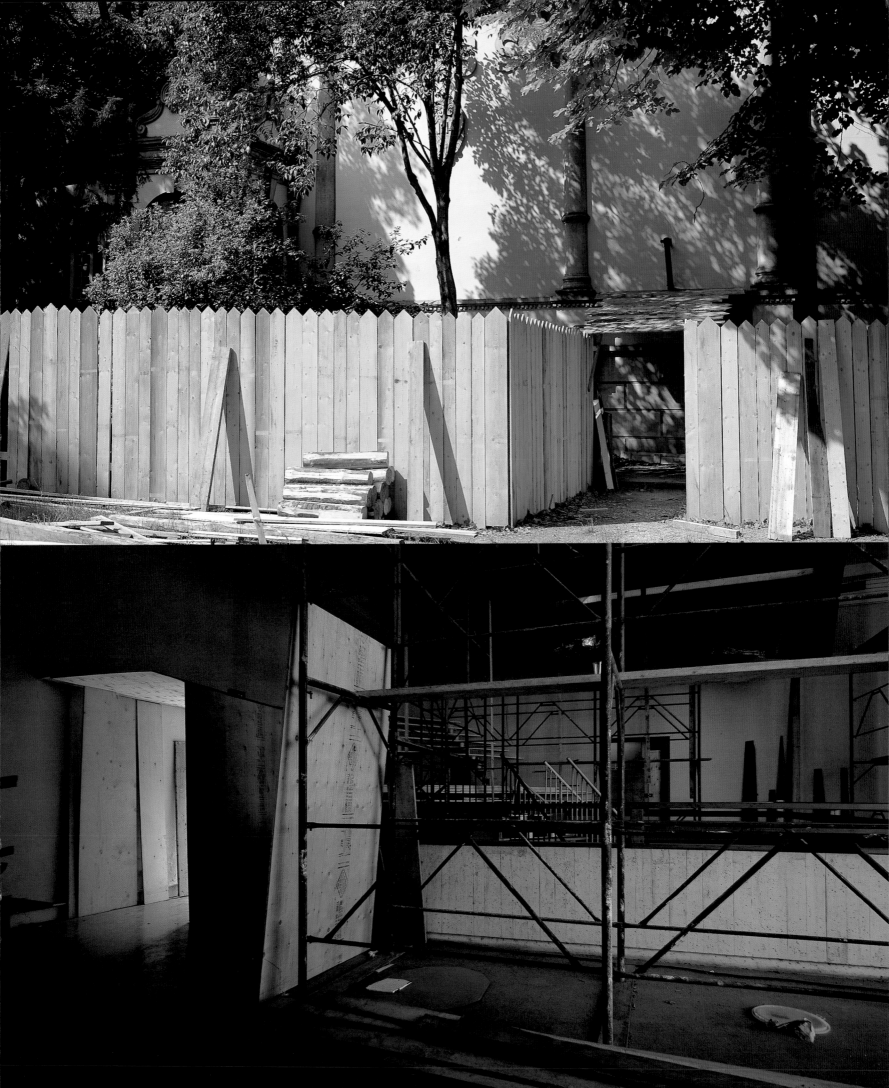

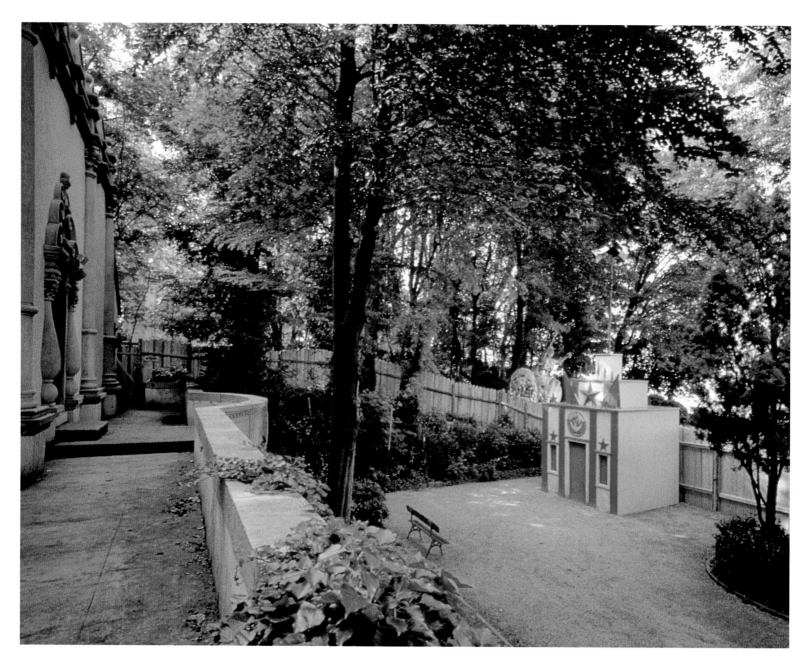

How do you see yourself now in relationship to artists of your generation, Russian or otherwise? What traditions do you sense that you're part of?

Kabakov For almost eight years I felt like an airplane that was fuelled up with gasoline. It took time to burn this gasoline, these endless stories about Soviet civilization. Now I feel that the gasoline tanks are empty, as though the Soviet theme is almost over for me.

I think that in every culture, in every country, there is a person who is very unhappy inside himself, very closed inside, out of contact with real life. Someone who creates projects that nobody needs. On the other hand, of enormous importance for me is the paradox that I've noticed since I came to live in the West. I became far more aware that in Eastern consciousness, the culture of the nineteenth century still plays a major role. I noticed that all these issues connected with sentimental life, with the life of the soul, which are enormously important for the Eastern world, are taboo in the West.

The Red Pavilion, with musical arrangement by Vladimir Tarasov
1993
Wood, board, paint construction, pavilion, wood fences, flags, builders' materials, loudspeakers, sound installation
Dimensions variable
Installation, Russian Pavilion, 45th Venice Biennale
Collection, Museum Ludwig, Cologne

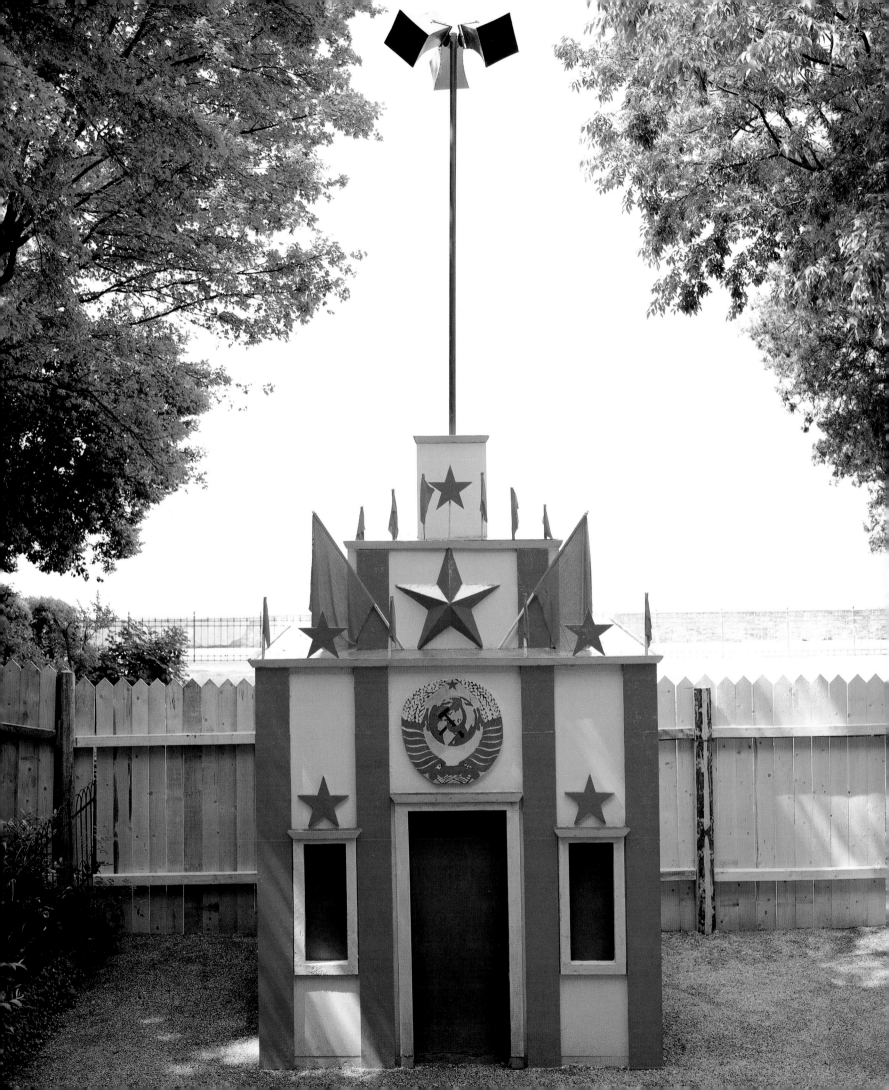

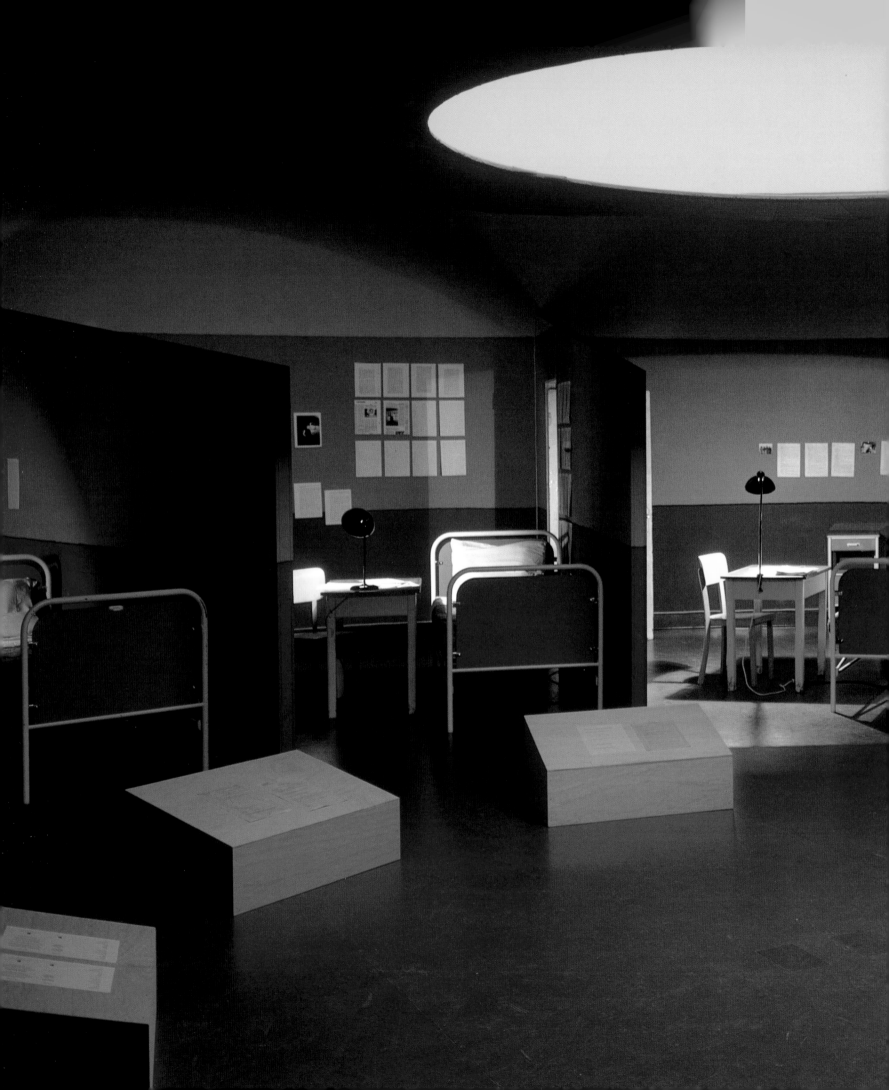

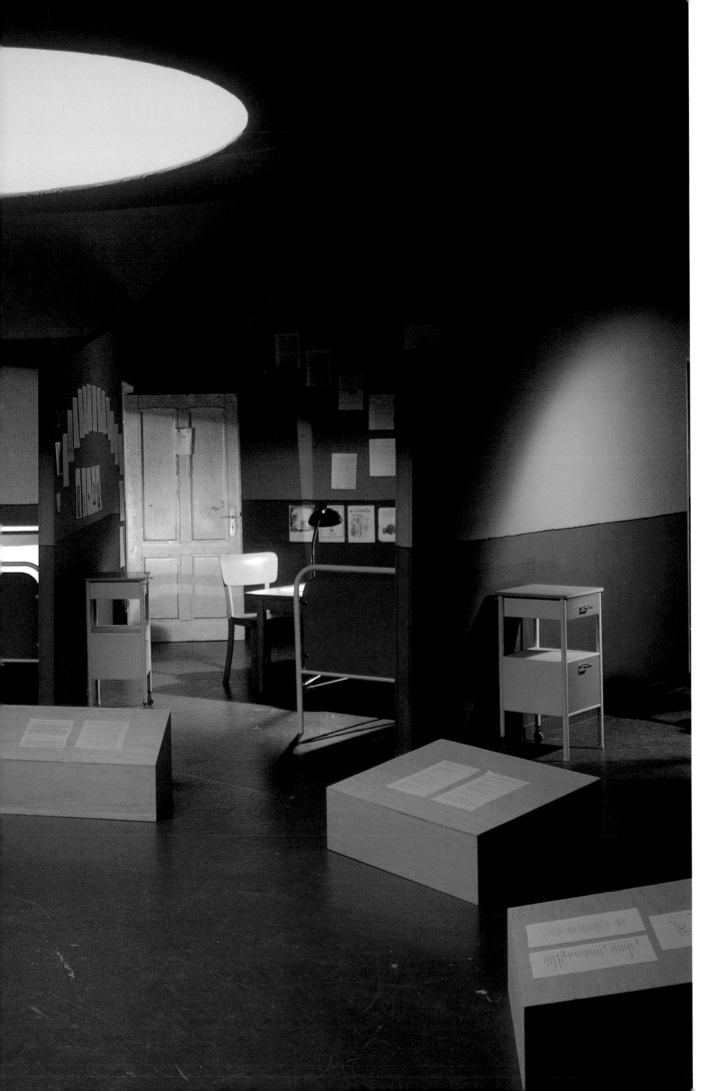

For me it was extraordinary to discover this huge attention in the West to the body. So many issues are explored in terms of sexuality and the body, yet there is the impression that in the contemporary art world there exists some kind of taboo on everything soulful, metaphysical or transcendent.

Ross I think that's true. I noticed, in the response to the Bill Viola show that I curated in 1997, that many younger artists were very uncomfortable to see an artist like Viola become so involved in issues like spirit and transcendence. There's no language to talk about it, it seems taboo. It seems like, how could you fall for that? Those issues are not real issues, the real issues are social ones. The complete rejection, by so many, of art's ability to address transcendence is a remarkable backlash from a period when so much social struggle was about creating a space where that was possible.

Kabakov **It may sound reactionary, but I think that in the future it will be important to look back to the nineteenth century.**

Ross How would you define, at this moment in your life, the purpose of art?

Kabakov **I don't see any special goals, but I think there will be a sharp and fast turn to the viewer. Today, the level of contact between the viewer and the work that exists, for example, in theatre and other forms of performance, does not exist in visual art. Perhaps this difference will disappear.**

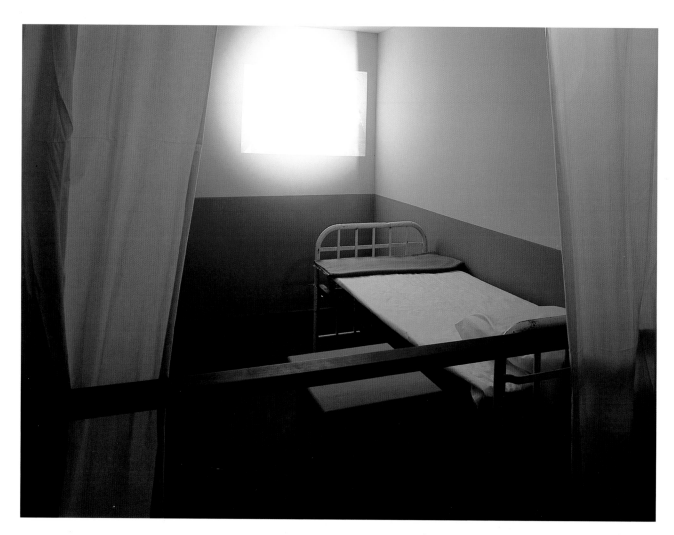

left and opposite, **Treatment with Memories**
1997
Wood, board, metal construction, corridor, room, hospital bed and furniture, curtains, screen, slide projection
Dimensions variable
Installation, Whitney Biennial, Whitney Museum of American Art, New York

above, Two of the series of autobiographical slides used in the installation

Contents

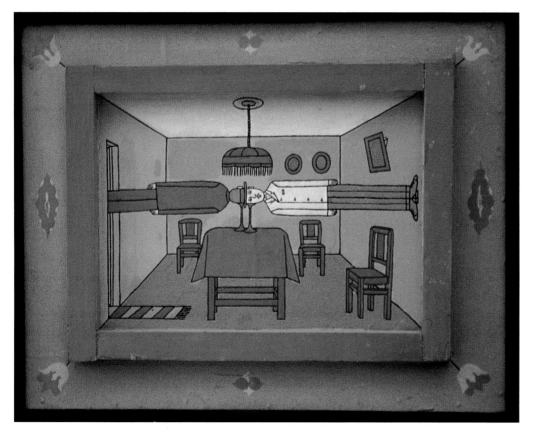

In the Room
1965–68
Enamel on plywood
56 × 70 cm

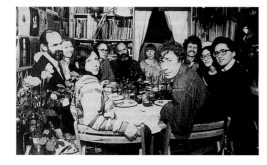

**Studio of Francisco Infante,
Moscow**
1980
l. to r., Erik Bulatov, Natalia
Bulatov, Galina Tshuikov, Irina
Schwarzmann, Mikhail
Schwarzmann, Natalia Gorjunowa-
Infante, Ivan Tshuikov, Francisco
Infante, Natalia Nikitin, Boris
Groys

Engagement with his own memories is a recurrent theme in Ilya Kabakov's work: recollections of his childhood and early youth play an important role but above all there is the repeated theme, albeit often indirectly and cryptically expressed, of his situation as an unofficial artist during the more than thirty years of the Soviet Union's decline. Kabakov was one of the co-founders of the unofficial art scene that had come into being in Moscow in the late 1950s, and of which he remained a member until the late 1980s, when he left Russia and began to work as an artist in the West. The history of the origin and development of Russian unofficial art from Stalin's death to Gorbachev's Perestroika has been broadly described elsewhere, but there is as yet no detailed art-historical account of the period.[1] With the relative liberalization of cultural life in the Soviet Union that followed the death of Stalin, many Russian artists turned away from the official art of Socialist Realism, attempting to link up with the traditions of Western and Russian Modernism. No longer as ruthlessly repressed as they had been under Stalin, these artists were assured both of physical survival and the possibility of continual artistic work, yet they were almost completely cut off from museums, galleries and publications, the conduits by which they could have brought their works, officially, to a wider public, earning their livelihood through their art.

As a result, in major cities such as Moscow or Leningrad, unofficial art scenes emerged, existing in semi-legality at the margins of Soviet normality. Without the authorization and social recognition available only through membership of the official artists' association – which obliged artists to make work in line with the tenets of Socialist Realism – unofficial artists were unable to practise their profession publicly. They could, however, earn a livelihood by turning to applied art, by taking up another profession, or by selling their works to a handful of private collectors. Due to the precariousness of their social status they felt insecure and threatened, but alongside this anxiety their isolation also generated a degree of euphoria: they could adopt a relatively independent lifestyle in a country where such

a thing was beyond the dreams of most of the population. Despite lack of public approbation, their lifestyle was secretly envied, and many Moscow and Leningrad non-artists during this period thought it a great adventure to have an unofficial artist as a friend. Unofficial artistic circles also included independent authors, poets and musicians, who had even less opportunity than visual artists to establish themselves in Soviet official culture. Small exhibitions, poetry readings and concerts were held on a regular basis in artists' studios, in an informal, closely-knit social environment. The constant fear of possible repression made the work all the more compelling: the ambivalent state between being excluded and being chosen defined the unofficial artists' sense of themselves. This tension is always apparent in Kabakov's work.

During this period his Moscow studio was an important centre of unofficial cultural life, host to an artistic scene in which Kabakov had many close peers, and in which he was a constant and active presence. His own work therefore assumed a special, isolated position within this scene. Most unofficial Moscow artists at this time saw their art in terms of a higher mission, a way of bringing important truths and deep insights into the profane Soviet world around them. Their work was inspired by what they perceived as the dramatic revelation of unconditional artistic truth in, for example, the painting of the post-war American neo-avant-garde, from Jackson Pollock and Mark Rothko to Barnett Newman. They were also concerned to exhume the radical claims of early modernist art in a country where it had been

Boy
1965
Enamel relief on masonite
160 × 120 cm

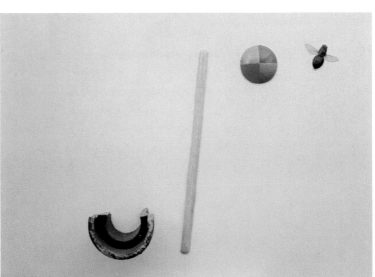

Pipe, Stick, Ball and a Fly
1966
Plywood, box, enamel
130 × 160 cm
Collection, Museum Ludwig, Cologne

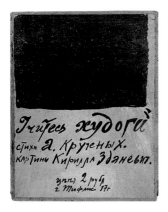

A. Kruchenykh
Learn Art
1917
Lithograph wheat-pasted on
brown paper board cover
23.5 × 19 cm

unable to lay claim to an assured social position. However, they were in a much worse position to attempt this than their American counterparts. Their almost complete isolation from the international art world meant that they could not create a similarly innovative art that would give an 'objective' art-historical credibility to their subjective claims to genuine individuality. They were to learn that if an artwork did not appear innovative or original in the international context, there was no 'guarantee' that it had arisen out of an authentic inner impulse. This discovery – that all art in our time is judged in internationally comparative terms, according to accepted art-historical criteria and against the background of a collective experience of art – was a painful realization for many of the unofficial artists, who had tended to appropriate, and rather naively invest in, the radically individualist rhetoric of earlier forms of Modernism.

Kabakov, however, from the outset, was not interested in laying claim to this kind of unconditional, individualist, ahistorical, asocial expression of authenticity. Even his earliest works play with the banality of everyday Soviet life: the drawings often appear to be random distracted scribblings, or ironically employ the clichés of official Soviet drawing style. If Kabakov uses texts in these earlier works, he also studiously avoids portentous theoretical messages. Even if a picture is explained and interpreted as a sign system, the interpretation is just as casual and unpretentious as the picture itself.[2] For years Kabakov worked officially as a highly successful illustrator of children's books. In the Soviet Union, the

children's book was traditionally one of the very few official niches where the remnants of the Russian avant-garde could survive; to a certain degree the form allowed artists and poets a playful, absurdist, disrespectful treatment of text and image. In particular, the poets of OBERIU, the last significant Russian avant-garde group of the 1920s and 1930s, which included such outstanding authors as Daniil Kharms and Alexander Vvedensky, established a relatively independent status for the children's book, despite the fact that neither of these authors survived the Stalinist terror. Kabakov and a number of other post-war authors and artists in many respects followed on from the absurdist, Dadaist poetry of OBERIU, which acted as an antidote to the poisonous, over-ideological mood of the time.

The Albums

While Kabakov's early work of the 1960s was already clearly distinguished from that of most of his Soviet contemporaries by its ironic, playful character, it seems in retrospect no more than a preliminary sketch for his later output. The real breakthrough, the discovery of his own set of artistic issues, only came at the beginning of the 1970s, when he made a series of *Albums* (1972–75),[3] each themed around one character. These loose-leafed books recount through texts and drawings the fictitious story of a series of artists who live on the margins of society and whose work is neither understood, acknowledged nor properly received. The drawings are each to be understood as the visions or works of each central artist-protagonist. Many have captions with

comments on their content from the perspective of the various acquaintances and relatives of the artist in question. The final image in each album is a white sheet of paper announcing the artist's death, and each closes with some general comments on his complete work, spoken by other fictional commentators, whom we are supposed to see as representing the opinions of the educated class that finally documents and administers the artist's legacy.

The private visions that obsess the central characters of these albums in many ways refer to the histories of this century's avant-garde movements. The artistic execution of the albums, on the other hand, refers to the conventional aesthetic of typical Soviet children's book illustration, which had continued using nineteenth-century illustrative traditions, more or less unchanged. The internal 'avant-garde' vision of each artist character is largely discredited by the trivial visual language in which it manifests itself. In addition, the comments of the outsiders, appended to each artist's vision, demonstrate the various levels of misunderstanding to which all art is necessarily exposed. These albums are, at the same time, wonderfully poetic, filled with pathos, and impressive in their painstaking and precise execution. They thus aestheticize the incapacity and anonymous failure of their unfortunate protagonists and, through this compelling portrayal of their fate, produce an ironic representation of the very modernist myths whose revival had inspired the Moscow unofficial art scene of the time.

In the accompanying commentaries, Kabakov also created an imaginary audience for his artist characters. For Kabakov, this compensated for the lack of a real audience for unofficial art, yet the imaginary viewer sketched out in his albums has no particularly deep understanding of art. The viewers' opinions diverge greatly; their interpretations have the potential to multiply infinitely and the meaning of the work is lost in this endless process of interpretation. Far from making the artist feel pessimistic, however, this has the effect of increasing his optimism. The artist wants attention from the viewer, but not interpretative control. In integrating within itself the very commentaries that it can provoke, the work can draw the audience's attention, without being at its mercy.

In the albums, Kabakov was experimenting for the first time with an approach that could be said to define his artistic practice – the construction of 'characterhood' (*personazhnost*). He was beginning to invent fictitious characters: artists and authors who were given equally fictitious biographies, and to whose authorship certain artworks were attributed. This process gave him the chance to assume the most divergent attitudes, positions and personal histories, and to examine their effects without completely identifying with them. Attention thus shifted from the production of individual artworks to the context in which they were produced. Central to this concern was the psychological context of artistic production. In the albums, Kabakov sought to demonstrate that the individual artworks were the product of the hopes, self-deceptions and disappointments of his protagonists; the result of

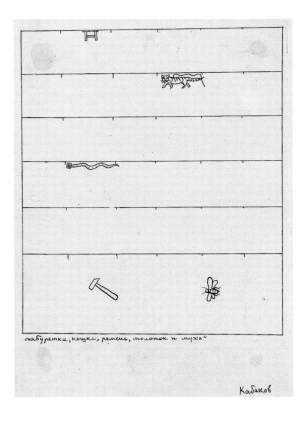

Stool, Cat ...
1964
Coloured pencil on paper
28 × 18 cm

How Much?
1970
Ink on paper
20 × 29 cm

What, how much?
Give soon!
What, how much?
Give soon! [...]

Calf?
1971
Ink, coloured pencil on paper
25 × 30 cm

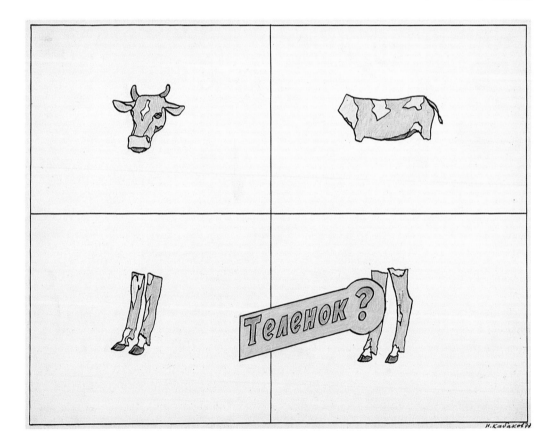

particular, psychologically motivated, artistic strategies they had pursued. These strategies are shown against the background of a broader social and art-historical context, which in many ways calls these strategies into question whilst not discrediting them entirely.

Rather than waiting for the art-historically knowledgeable interpreter who discerns hidden intentions and strategies behind the images by trying to contextualize them, Kabakov himself creates the context of his art by telling the stories of the fictitious artists behind it. To a certain extent, we can trust these stories, since their heroes can also be considered pseudonyms or alter egos of Kabakov himself. Nonetheless, the ironic detachment by which these fictitious artists are described is not merely simulated. Kabakov only partly identifies with his characters, who often ironically assume certain artistic postures. He constantly dramatizes the play between identification and non-identification with his characters, and often displays his own strategies while describing them as their strategies, concealing them by that very identification. This could be understood as a play between the appropriation of other people's artistic practices and self-expropriation in favour of a fictitious other.

In the early 1970s Kabakov was by no means alone in his attempt to shift attention from art production itself to its context. The same shift was occurring both in the West and amongst Moscow's unofficial artists. Viewers were gradually losing hope of grasping the meaning of artworks through the traditional process of discerning the artist's

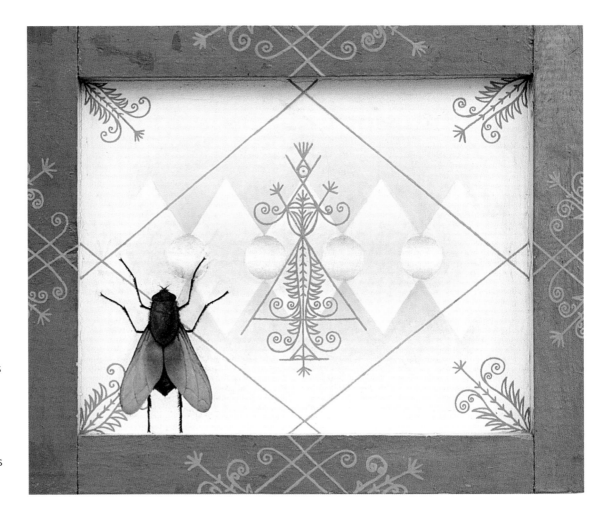

inner, autonomous intention. This was the first sign of the crisis that was to culminate in the famous phrase 'the death of the author'. The artists of classical Modernism continued to believe in the possibility of transcending, vanquishing the identity bestowed on them by social context and achieving their true, hidden identity by means of an inner vision. At this time, only artists capable of overcoming their conventional social role were considered worthy of serious discussion. The situation changed drastically, however, when the role of the artist as a breaker of social conventions was seen to be merely one among many others, a particular social convention – as demonstrated, amongst other things, in the *Albums*.

Queen Fly
1965
Enamel on plywood
56 × 70 cm

From the album **Agonizing**
Surikov
1972–75
Ink and coloured pencil on paper
50 pages, album 4 of series of 10
51.5 × 35 cm each page

He says:
Whenever I tried to examine
everything that surrounded me in
life, the result was a small scrap,
like a keyhole, and everything else
was hidden from me by an
impenetrable shroud which never
disappeared, no matter how
carefully I tried to look through
this hole. A few times, because of
this agonizing effort, I had visual
hallucinations which scared me a
lot. I went to the best eye
specialist, Dr Godlevsky …

In the Soviet Union of the 1970s, the shift of interest from art to its context was encouraged above all by two additional circumstances. Firstly, the cultural imagination of the Soviet intelligentsia was dominated by the Moscow-Tartu School of structuralism,[4] which combined the tradition of Russian formalism with contemporary theoretical developments in the West, above all in France. The insight that the meaning of the individual sign is determined by its position in the semiotic system, which governed structuralist literary and cultural studies, was easily transferred to the language of art.

Secondly, there were particular cultural and political reasons for this shift towards the context of art: in the 1970s a kind of allergic reaction developed in relation to the dissident pose that suggested access to a reality hidden to everyone else. Such an unreflective, oppositional stance was, incidentally, easily integrated within the world-view of official Soviet ideology, which reserved a special place for its enemies. Totalitarianism means not so much the homogeneity of society as its extreme division into friend and foe,[5] excluding any neutral, analytical gaze aimed upon it from outside. One could be for this ideology and survive, or be against it and be destroyed, but a neutral attitude was simply unthinkable, unimaginable, structurally impossible. Thus, some intellectuals and artists who wanted to escape the power of Soviet ideology felt an increasing displeasure at confirming, once again, the radical gulf that this ideology had dug through society, by their own oppositional attitude. They wanted, rather, to call the gulf itself into question,

and to look at the whole Soviet cultural context with the neutral, descriptive, analytical eye of an outsider. This meant artistically thematizing the Soviet cultural codes and the visual world produced by the Soviet ideology, which was completely ignored by most of the Russian unofficial artists in search of a reality hidden behind it. Paradoxically, official Soviet culture was for most people the great unknown until its discovery in the early 1970s, both because that culture was itself incapable of analyzing its own mechanisms and because the opposition deemed Soviet culture false, base and unworthy of interpretation.

The attempt to stop looking behind the facade of official Soviet culture, and to open people's eyes to the culture itself, was not undertaken until the early 1970s; this was done by the circle that became known as the Moscow Conceptualists,[6] of which Kabakov was at the time a member. This circle, which included artists Erik Bulatov, Vitali Komar and Alexander Melamid, Dmitri Prigov and Ivan Chuikov, to mention only a few, as well as some authors and theorists, did not attempt any direct political engagement. Instead, these artists tried to describe the specific Soviet visual and ideological context as neutrally and objectively as possible. The effects of these descriptions were, however, extremely ironic and deconstructive – particularly in their 'Sots-Art' variant, as practised by Komar and Melamid[7] – and were for that reason seen as particularly anti-Soviet by representatives of Soviet ideology, although in the milieu of unofficial art they were generally scorned as overly politicized. Consequently, Moscow Conceptualism

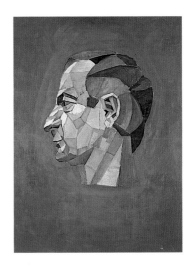

Erik Bulatov
Red Horizon
1971–72
Oil on canvas
150 × 180 cm

Komar and Melamid
Portrait of Melamid's Father
1972
Tempera on cardboard
100 × 80 cm

From the album **Anna Petrovna Has a Dream**
1972–75
Ink and coloured pencil on paper
32 pages, album 5 of series of 10
51.5 × 35 cm each page

Olga Markovna HAD lots of acquaintances at the seashore

Legend:
1. Olga Markovna Koss
2. Inga Borisovna Zayats
3. Boat 'Dawn'
4. Masha Zadonskaya
5. Shevronskaya – (special)
6. Georgy Aslamazian
7. Katya Bezrukova
8. Lena Korovina
9. Kiosk 'Blue Wave'

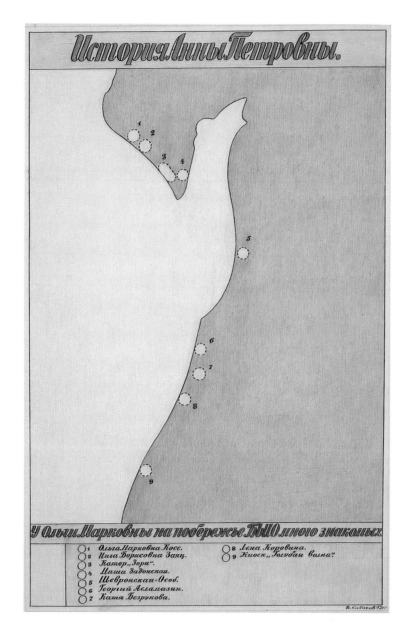

The uniqueness of the Soviet cultural context was that individual artworks were defined almost exclusively by their purely ideological relevance to the dominant ideological-political discourse.

Kabakov, however, also occupies a particular position within the circle of Moscow Conceptualists, with whom he remained closely connected until the late 1980s. Unlike many others, he doesn't believe in the objective describability of the artistic context, including the Soviet art context, or in the possibility that an artist might make a picture of this context, because such a picture must remain only one among many others. If doubt is cast on the possibility of an objective description, it is only because the contexts are revealed as infinitely large and impossible to grasp as a whole, so that the author cannot be positioned precisely within such an infinite context. Thus the universal context of the production of art reveals itself as an infinite play of signs, a movement of difference, a process of never-ending simulation. Consequently, in Kabakov's work all authorial intention is subverted; the authorial figure is fictionalized once and for all.

In so far as Kabakov sees art as an endless play of signs that can be neither described nor controlled, his art in many ways parallels post-structuralist theory. But Kabakov's chief interest does not lie primarily in the proof that a complete overview of the context is impossible – although in the mid 1970s he brought out a four-volume album entitled *A Universal System for Depicting Everything*, in which this proof is delivered in a wonderfully ironic way. If authorship, as such, is

remained to a large extent culturally isolated on all sides.

Certainly, the artistic practice of Moscow Conceptualism was strongly influenced by the various trends in Western art at the time, from Pop Art to Conceptualism, which dealt in various ways with the visual world and cultural codes of Western commercialized mass culture. Nonetheless, the practice was not a simple transfer of Western artistic practices to the specifics of Soviet culture.

fictitious, Kabakov seeks to make it his explicit theme by introducing fictitious authors into his albums, particularly since the fiction of authorship also has its real aspect.

It would be naive to claim that the artist works exclusively in a real 'here and now' context. Positivist sociological description, for example, of the context of art,[8] ignores the fact that art is not only made with today's viewer and social context in mind. Art lives on the promise of a durability that transcends the boundaries of the context in which it is produced. The artwork is made in the expectation that it will live beyond the context of its production, that it will be perceived in the other times and the other places that we cannot predict, let alone describe. Even commercial art is made in the hope that it will be received worldwide and over time – and in the expectation of resultant profit. For that reason, the context of art is not describable in positivistic terms, being utopian, fantastic. We can only react to this hypothetical, future context – which is not yet apparent but can only be anticipated – with hope or fear, not with understanding.

From the *Albums* onwards, Kabakov has dealt with this mixture of hope and fear with which an artist and, generally speaking, an author must wait for an unknown viewer, the future context, the reception by a stranger. This waiting makes for hope: the other, future viewer may understand the work better than his or her uncomprehending contemporaries, and bring the artist the attention, love and admiration that he lacks in his immediate surroundings. At the same time, the artist is filled with the fear that the new, unknown future viewer

may not, in turn, even perceive his work, and declare it to be worthless, with only sentimental meaning for the artist's immediate circle.

Again and again, vividly and brilliantly, Kabakov demonstrates this mixture of hope and fear in his fictitious characters. They are forever wishing to escape their immediate surroundings through art – and at the same time they are afraid of being judged, and possibly condemned, by criteria unknown, unfamiliar and

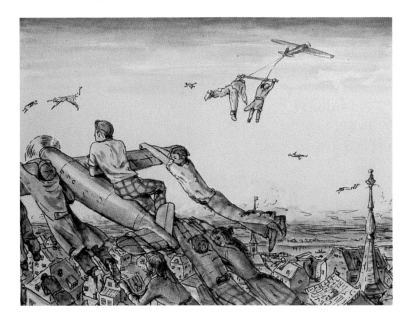

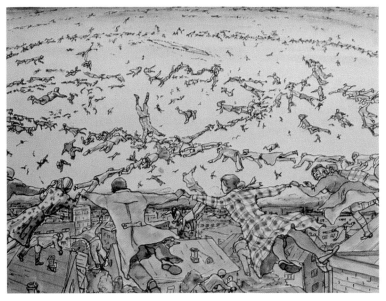

From the album **The Flying Komarov**
1972–75
Ink and coloured pencil on paper
32 pages, album 6 of series of 10
35 × 51.5 cm each page

This character, after long and excruciating discussions with his wife, after almost entirely mutual recriminations and accusations, in total despair, and having opened the balcony door, steps out near dawn to get some fresh air. Suddenly, he sees that in the sky, which is beginning to lighten, there are people hovering in the air. Either they descend down near the ground or they rise up high, so high they almost become invisible; they either fly alone or in pairs or in groups, or, clasping hands, they form rings, which slowly revolve. Hovering between them in the air are things of their everyday existence – mugs, tables, couches, coat racks ... Some of them grab the wings of airplanes flying by, or harness the wings of birds, and go on far-off outings ... Our character, having climbed up on the railing of the balcony, waves his arm and also tries to take off after them.

From the album **Sitting-in-the Closet Primakov**
1972–75
Ink and coloured pencil on paper
47 pages, album 1 of series of 10
51.5 × 35 cm each page

from top, l. to r., **In the Closet; Olya is Doing Homework; A Strong Wind is Blowing; The Open Closet; Mother's Room; The Back Yard of Our House; Rosa Luxemburg Street; Ust-Kamensky Region; Bagdasarsky Region; A Fresh Carrot; Clear Sky; [untitled]**

incomprehensible to them. In waiting for the judgement of the unknown other, set against the background of an unfamiliar context, every sign can be interpreted in either direction: future salvation, or threat and ruin. The hope that drives modern art onwards emerges from the artists' Van Gogh complex: today's success could result in tomorrow's failure, and today's defeat could promise future victory. But perhaps our defeats will not be great enough to be interpreted as victories later on. And perhaps our victories are not real victories: they may distort us later on. Everything that an artist feels to be successful in a work, including a successful failure, could cause others to reject the work. And inversely: that which the artist ignores, or feels to be a failing, can be precisely why others value the work.

Modern art has positioned itself in this neurotic cycle because it has developed the fear of becoming outmoded, and therefore, rather than living up to the criteria of the present, has attempted to predict the criteria of the future, to 'save itself' for that future. This is, incidentally, familiar to every Christian waiting for Judgement Day; as a believer, one has no guarantee of interpreting the signs correctly and predicting the future judgement. In the Soviet Union at that time, this impossibility of predicting the judgement was, of course, very apparent. Throughout the Brezhnev period, the failure of the Communist promise, with which so many historical hopes were bound up, to which so many people had been sacrificed, and whose future victory seemed so certain to so many people, had become apparent once and for all.

With this failure before one's eyes, it was

impossible to continue to believe in a historical promise. Nevertheless, all that remained to an unofficial Russian artist, cut off from effect and recognition in his own cultural context, was the hope of a benevolent reception in the future – or beyond the boundaries of the Soviet Empire, in the West.

But the West – from the Soviet perspective – appeared no less apocalyptic than the most remote future. The Moscow artists were entirely cut off from the international art scene. The criteria that the work needed to meet in order to survive in the international context, as well as the mechanisms of the art business in the West, were largely a mystery to them. All they had was the unfounded hope that they might nonetheless be accepted by the West. Kabakov describes the situation very vividly in one of his later essays:

'The life of the unofficial artist and author lasted almost thirty years in a world that was sealed and bolted away. All through those years unofficial artists and authors were unable, because of political, ideological and aesthetic censorship, either to exhibit or to publish […] In this almost "cosmic" isolation, the artists of this circle were completely thrown back on their own devices, and became, for each other, what other people should have been for them: viewers, critics, connoisseurs, historians and even collectors.

This situation inevitably meant that all criteria for the quality of a work were distorted. What were these pictures or concepts for the disinterested outside world? What were they not only for us, their creators, but also for other people? This tormenting question hung like a sword of Damocles over

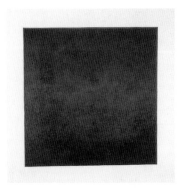

Kazimir Malevich
Black Square
c. 1922
Oil on canvas
106 × 106 cm

В шкафу.

Оля делает уроки.

Дует сильный ветер.

Открытый шкаф.

Малина комната.

Задний двор дома.

Улица им. Розы Люксембург.

Черниговская обл.

Балдасарский край.

СВЕЖАЯ МОРКОВЬ

ЧИСТОЕ НЕБО

everyone who had to work for many years without objective criticism or – and this was perhaps even worse – only ever met with the well-meaning approval of family and friends.'[9]

More than any other, the first of the *Albums – Sitting-in-the-Closet Primakov* – deals with this invisibility abroad, and has remained in many respects paradigmatic for Kabakov's subsequent work. The first pages of the album show a monochrome square reminiscent of Malevich's *Black Square*.[10] But from the text we learn that this black field is the view of a little boy who sits in the dark closet and – at first – refuses to come out. When he gradually begins to open the closet, first he sees his family in the apartment, then his city, then the district, then the region, then the earth as a whole, then various levels of the sky, in which objects and words begin to disintegrate, as in modernist abstract paintings. The final image is of an expanse of white. The text informs us that the boy disappeared from the closet and was never seen again. Birth into the world is here equated with death.

The boy had flown further and further – in search of a greater overview, a greater horizon. The further he flew, however, the more everything disintegrated, until finally, nothing more could be seen. At the end of the album his consciousness has become a void, a white sheet of paper, a neutral surface. We might say that his final defeat has been written down. But the utterly banal commentaries following Primakov's death are written on the white paper, which we know to be the boy's empty consciousness. However unreasonable, stupid and alien to the work these texts might be,

they still belong to the work. The wider artistic context is here demonstrated as being purely imaginary. The only thing that corresponds to it is the reality of death. The presence of death renders ironic everything that is present, positive and describable, making it disintegrate, yet at the same time it signifies that our hopes may extend beyond the narrow horizon of the living. Although the insight that everything present must decline may be unpleasant, at the same time it is reassuring – particularly for someone suffering in the present, who can only hope for change outside of the immediate context. This same mood is, incidentally, very pronounced in the Russian literary classics of the nineteenth century, in which Kabakov's work is more deeply grounded than in the history of visual art.

The heroes of Kabakov's albums are highly reminiscent of Dostoyevsky's heroes, lonely 'little' people living in very tight circumstances but obsessed by universal, absolute ideas, thinking in the widest global terms and carrying on a constant inner dialogue with the great minds of world history. Kabakov's texts also refer stylistically to Gogol's writings, above all to his 'Dead Souls'. Like Gogol, Kabakov comes from southern Russia (now the Ukraine), and looks with a certain ironic detach-ment at the inhabitants of the North Russian metropolises, like Moscow and St Petersburg, driven by pretension and ambition. And like Gogol, Kabakov calls to mind the endless expanse of the Russian territory – the infinite space of the Russian provinces – in which any attempt to stabilize a cultural context is doomed to failure, and which swallows whole all civilizing projects,

plans and enterprises. But the infinite sadness and hopelessness of the Russian provinces is not only lamented by both Gogol and Kabakov, but also used with quiet delight as an illustration of the arrogance of all attempts, particularly Western ones, at civilization. The idea, repeatedly suggested by Russian literature, that in Greater Russia all attempts at civilization are doomed to failure and dissolution, has been the reason for a deep inner complacency on the part of the Russian reader, at least since Gogol and Tolstoy. For a long time now, Russia, for the Russians, has been a dependable test for the vanity of all human effort – and Russian literature is always delighted if it can show that one more thing, such as Communism, has failed that test. This delight is also clear in Kabakov's work.

In this interpretation of classic Russian literature, incidentally, Kabakov has a forerunner: Mikhail Bakhtin. His critical texts, mostly written from the 1920s to the 1940s, were only made available to a wider public in the 1960s, and made a strong impression on Russian readers of that time. For Bakhtin, everyday normality simply has no context. The normal state of communication is repressive because it separates individual discourses, isolates them and rules out the possibility of any overall context containing them all. For Bakhtin the general context of cultural attitudes, which he calls 'ideologies', must only be produced by art and, above all, by literature. Thus Bakhtin does not address how a work of art or a text functions in the context of the social, political, communicative or psychological reality: for him, such a contextual description would be

just as 'monologic' and isolated as the ideologies that it seeks to contextualize. Rather, he poses the reverse question: how would it be possible for art to create a general 'dialogic' context in which political, social, psychological and other attitudes, positions, theories and ideologies can confront one another? The answer, said Bakhtin, lay in the novels of Dostoyevsky.

In his noted book on Dostoyevsky,[11] Bakhtin seeks to demonstrate that the novelist does not introduce his own language of literary description, but rather tries to bring separate, existing, socially established languages into a single context in which they communicate. Dostoyevsky then renounces his own living language and becomes, one might say, a sheet of paper upon which others can write their own texts. Bakhtin speaks of an apocalyptic dialogue beyond the grave. For him, the transfer of concrete speech from its isolation within everyday reality in the context of 'polyphonic dialogicity', dramatized in the novels of Dostoyevsky, means primarily a leap over death. Bakhtin defines this context in its broader theoretical development as the carnival.[12] In the carnivalesque all things that are separated in normal life are brought together, with the obliteration of all hierarchical differences, so that all discourses can mingle freely. But the carnivalesque is also determined by certain conventions and rules – even if they contradict the rules of normality. Accordingly, for Bakhtin, the carnivalesque does not mean the festival of pure destruction and waste as it was described by Georges Bataille and Roger Caillois at around the same time. The carnivalesque humiliation of

За чистоту!

Расписание

выноса помойного ведра по дому № 24 подъезд № 6
улица им. В. Бардина ЖЭК № 8 Бауманского р-на.

	Январь Февраль	Март Апрель	Май Июнь	Июль Август	Сентябрь Октябрь	Ноябрь Декабрь
1979 г.	15 Прохоров Н.А. кв.16	15 Солод Е.С. кв.20	15 Лапин Г.С. кв.24	15 Левчук С.Е. кв.28	15 Гитман О.К. кв.18	15 Зусман И.С. кв.22
	31 Буркова А.С. кв.17	31 Акинченко Е.Л. кв.21	31 Сизова И.В. кв.25	30 Сумной А.П. кв.29	30 Зяоба И.Б. кв.19	30 Сорокин И.П. кв.23
	15 Гитман О.К. кв.18	15 Зусман И.С. кв.22	15 Панченко И.С. кв.26	15 Прохоров Н.А. кв.16	15 Солод Е.С. кв.20	15 Лапин Г.С. кв.24
	28 Зяоба И.Б. кв.19	30 Сорокин И.П. кв.23	30 Кошь С.Л. кв.27	31 Буркова А.С. кв.17	31 Акинченко Е.Л. кв.21	31 Сизова И.В. кв.25
1980 г.	15 Панченко И.С. кв.26	15 Прохоров Н.А. кв.16	15 Солод Е.С. кв.20	15 Лапин Г.С. кв.24	15 Левчук С.Е. кв.28	15 Гитман О.К. кв.18
	31 Кошь С.Л. кв.27	31 Буркова А.С. кв.17	31 Акинченко Е.Л. кв.21	31 Сизова И.В. кв.25	30 Сумной А.П. кв.29	30 Зяоба И.Б. кв.19
	15 Левчук С.Е. кв.28	15 Гитман О.К. кв.18	15 Зусман И.С. кв.22	15 Панченко И.С. кв.26	15 Прохоров Н.А. кв.16	15 Солод Е.С. кв.20
	28 Сумной А.П. кв.29	30 Зяоба И.Б. кв.19	30 Сорокин И.П. кв.23	31 Кошь С.Л. кв.27	31 Буркова А.С. кв.17	31 Акинченко Е.Л. кв.21
1981 г.	15 Зусман И.С. кв.22	15 Панченко И.С. кв.26	15 Прохоров Н.А. кв.16	15 Солод Е.С. кв.20	15 Лапин Г.С. кв.24	15 Левчук С.Е. кв.28
	31 Сорокин И.П. кв.23	31 Кошь С.Л. кв.27	31 Буркова А.С. кв.17	31 Акинченко Е.Л. кв.21	30 Сизова И.В. кв.25	30 Сумной А.П. кв.29
	15 Лапин Г.С. кв.24	15 Левчук С.Е. кв.28	15 Гитман О.К. кв.18	15 Зусман И.С. кв.22	15 Панченко И.С. кв.26	15 Прохоров Н.А. кв.16
	28 Сизова И.В. кв.25	30 Сумной А.П. кв.29	30 Зяоба И.Б. кв.19	31 Сорокин И.П. кв.23	31 Кошь С.Л. кв.27	31 Буркова А.С. кв.17
1982 г.	15 Гитман О.К. кв.18	15 Зусман И.С. кв.22	15 Панченко И.С. кв.26	15 Прохоров Н.А. кв.16	15 Солод Е.С. кв.20	15 Лапин Г.С. кв.24
	31 Зяоба И.П. кв.19	31 Сорокин И.П. кв.23	31 Кошь С.Л. кв.27	31 Буркова А.С. кв.17	31 Акинченко Е.Л. кв.21	31 Сизова И.В. кв.25
	15 Солод Е.С. кв.20	15 Лапин Г.С. кв.24	15 Левчук С.Е. кв.28	15 Гитман О.К. кв.18	15 Зусман И.С. кв.22	15 Панченко И.С. кв.26
	28 Акинченко Е.Л. кв.21	30 Сизова И.В. кв.25	30 Сумной А.П. кв.29	31 Зяоба И.Б. кв.19	31 Сорокин И.П. кв.23	31 Кошь С.Л. кв.27
1983 г.	15 Левчук С.Е. кв.28	15 Гитман О.К. кв.18	15 Зусман И.С. кв.22	15 Панченко И.С. кв.26	15 Прохоров Н.А. кв.16	15 Солод Е.С. кв.20
	31 Сумной А.П. кв.29	31 Зяоба И.П. кв.19	31 Сорокин И.П. кв.23	31 Кошь С.Л. кв.27	30 Буркова А.С. кв.17	30 Акинченко Е.Л. кв.21
	15 Прохоров Н.А. кв.16	15 Солод Е.С. кв.20	15 Лапин Г.С. кв.24	15 Левчук С.Е. кв.28	15 Гитман О.К. кв.18	15 Зусман И.С. кв.22
	28 Буркова А.С. кв.17	30 Акинченко Е.Л. кв.21	30 Сизова И.В. кв.25	31 Сумной А.П. кв.29	31 Зяоба И.П. кв.19	31 Сорокин И.П. кв.23
1984 г.	15 Лапин Г.С. кв.24	15 Левчук С.Е. кв.28	15 Гитман О.К. кв.18	15 Зусман И.С. кв.22	15 Панченко И.С. кв.26	15 Прохоров Н.А. кв.16
	31 Сизова И.В. кв.25	31 Сумной А.П. кв.29	31 Зяоба И.Б. кв.19	31 Сорокин И.П. кв.23	31 Кошь С.Л. кв.27	30 Буркова А.С. кв.17
	15 Панченко И.С. кв.26	15 Прохоров Н.А. кв.16	15 Солод Е.С. кв.20	15 Лапин Г.С. кв.24	15 Левчук С.Е. кв.28	15 Гитман О.С. кв.18
	28 Кошь С.Л. кв.27	30 Буркова А.С. кв.17	30 Акинченко Е.Л. кв.21	31 Сизова И.В. кв.25	31 Сумной А.П. кв.29	31 Зяоба И.Б. кв.19

Carrying out the Slop Pail
1980
Enamel on masonite
150 × 210 cm
Collection, Kunstmuseum Basel

3A
Cleanliness!

Schedule for Carrying out the Slop
Pail in House No. 24., Entrance
No. 6, V Bardin Street, Zhek No. 8
of the Bauman Region

1979
January–February
15 Prokhorov N.A. apt. 16
31 Burkova A.S. apt. 17
15 Gitman O.K. apt. 18
28 Zyabova I.B. apt. 19 […]

superiority, the mocking of cultural pretensions, finally rescues them once they have lost their arrogance.

The parallels with the principal strategies in Kabakov's art are apparent. Kabakov too does not trust the various 'monologic' philosophical, semiotic, aesthetic or political discourses. For him, these theories are only random voices among many others that comment upon and judge art. These may be uneducated, profane, purely banal; they may not 'understand' art, or they may judge it from an utterly alien perspective. For Kabakov,

however, all these judgements and opinions – whether they have deep philosophical foundations or whether they are vulgar and primitive – are completely equivalent, for in his eyes, all ideologies are equally private. Kabakov accepts no hierarchies that privilege certain attitudes or opinions over others. Thus, in his albums, comments from fictional, 'educated' viewers are set on the same visual level as idiotic observations like 'seen enough of this crap, let's hurry or we'll be late for the cinema!' The complete failure to understand the picture, or even a refusal to look at

the picture, are, for Kabakov, completely legitimate variants of interpretation: there is no privileged perspective for looking. But if all claims to a universally applicable, privileged perspective are abandoned, only individual positions are left, and these are dictated by specific life circumstances. This takes us away from the sphere of impersonal theoretical discourse and into the territory of literature. By renouncing authorship, Kabakov becomes a total author: creating a space for the infinity of outside commentaries, without discriminating among them, he transforms them all into heroes of the novel he is writing with visual and literary means.

If Kabakov is close to Bakhtin in his scepticism towards monologic theories, he clearly does not share his optimism that there is a context in which separate dialogues might all communicate. In Kabakov's pictures the texts containing individual voices are enclosed in specially designed rectangles that divide the picture surface. The texts do not communicate with each other, they no longer form a carnivalesque linguistic body. Rather, they assume the appearance of tombstone inscriptions. They are the voices of the dead, which have long since lost their original meaning or their original, living context. Kabakov is constantly attempting to represent the opinions and comments of his characters as purely individual – and in the process he stresses their finitude and mortality. The script that is meant to capture these voices seems to break down into a meaningless arabesque on the white surface of the picture, which returns voice back to oblivion – beyond all hope of carnivalesque revitalization.

The white background also plays an important part in the later, large-format paintings,[13] made primarily in the second half of the 1970s whilst working on the albums, of which they are like oversized pages. They also recall the boards used in public offices to display announcements, information, lists of names, charts and instructions. The use of such copious amounts of text within the picture was certainly inspired to a large extent by Western Conceptualism, but Kabakov does not use the text to ask the question 'what is art?' Rather, Kabakov's pictures each evoke memories of a story, a theme, a life situation captured in a programmatically dead, bureaucratic form. The irony of such a representation is reinforced by the fact that his works play with the visual and textual clichés of the Soviet bureaucratic apparatus, whose out-of-touch absurdity – at least to all Soviet viewers of these pictures – was extremely familiar. At the same time, however, these works heralded the inevitability of death – the greatest bureaucrat and at the same time the greatest artist of all time – taking everything living and filing it away, archiving it and making it a museum-piece for ever. Now that modern art has won itself the right to absorb everything that exists, it has come to resemble death. The 'anything goes' in contemporary art basically means 'everything dies'. Thus, in Kabakov's white paintings, the irony of the dead formulas of bureaucracy is mingled both with melancholy, in the face of the inevitability of death, but above all, with this insight into the complicity between art and death.

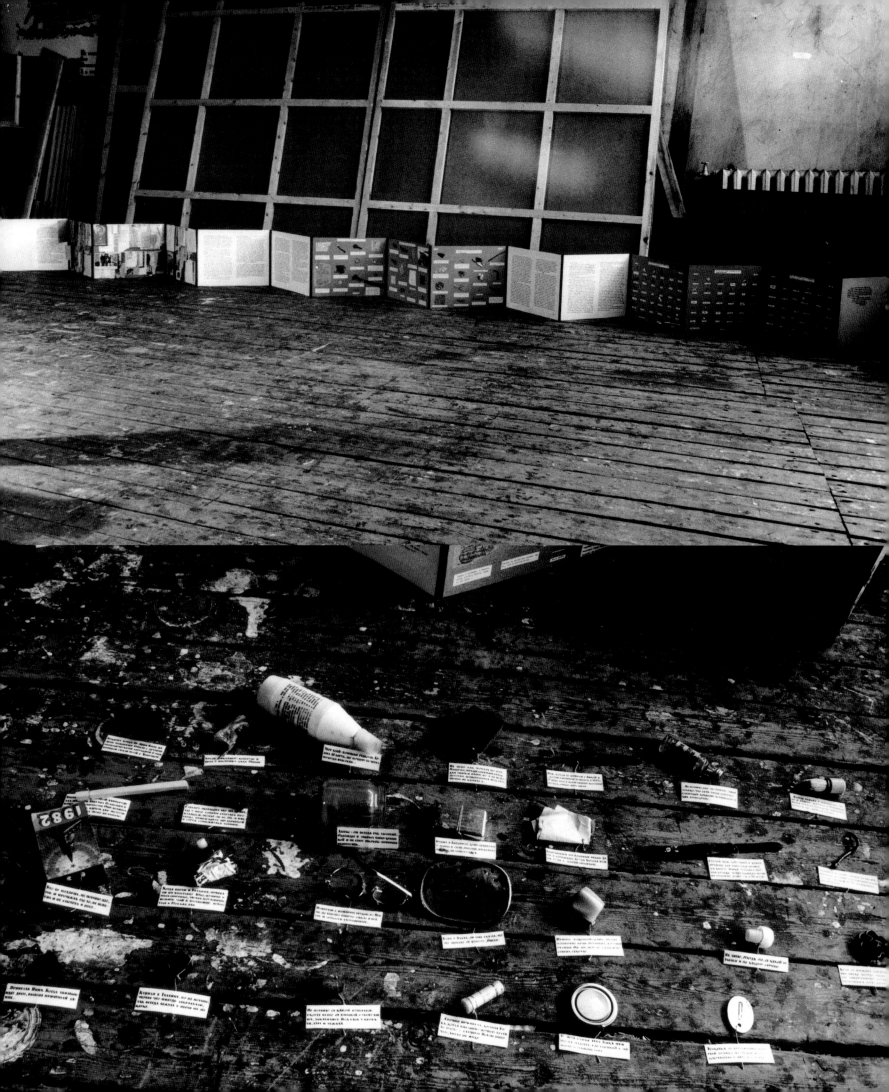

Garbage

Kabakov's most famous painting from this series, *Carrying out the Slop Pail* (1980), represents the rota for Soviet communal apartment dwellers to put out the dustbin. It schedules the next six years of rubbish collection: an ironic comment on Soviet planned economy and its attempts at extreme bureaucratic control. On the other hand, it is also an image of death. In the top right-hand corner of the picture is a dustbin full of garbage – the only patch of colour in the painting. Putting out the dustbin thus signifies the removal of life, with all its colours, and the arrival of death, which, as in Malevich's paintings, is suggested by the all-encompassing white, with the fragments of life swimming helplessly on its surface. One might even see this endless white as inspired by the snow-covered plains of Russia.[14] Here Kabakov's artistic strategy is, as ever, a dichotomous one. He is laughing at dead bureaucratic planning and at the same time expressing his solidarity with death. In this phase of his work the white background still embodies a kind of hope in the relationship between art and death, one expected to diminish the fear of death – the very same hope that inspired the art of Russian Suprematism. In some of his texts from this period, Kabakov deals at length with the ambivalence of the white background in his paintings: on the one hand it is a colour like any other, and accordingly the paintings that use colour might be seen as a part of life's garbage, but at the same time, white marks the source of light in which everything in the world can be seen. Kabakov sees his own paintings as places in which these two

interpretations compete – although it remains impossible to choose between the two.[15]

Our tense gaze into the white background is rendered potentially infinite by the impossibility of this decision. But the tension gradually relaxes, even if it never quite goes away. For Kabakov in the 1980s, the sheet of paper, along with the writing on it, seem increasingly to belong in the dustbin. At this time he deals more and more frequently with the subject of garbage – the refuse he thought he had carried out once and for all. That garbage represents an important philosophical problem was observed long ago in Plato's *Parmenides*: 'Parmenides: I mean such things as hair, mud, dirt, or anything else which is vile and paltry; would you suppose that each of these has an idea distinct from the actual objects with which we come into contact, or not? Certainly not, said Socrates; visible things like these are such as they appear to us, and I am afraid that there would be an absurdity in assuming any idea of them, although I sometimes get disturbed, and begin to think that there is nothing without an idea; but then again, when I have taken up this position, I run away, because I am afraid that I may fall into a bottomless pit of nonsense, and perish […] Yes, Socrates, said Parmenides; that is because you are still young; the time will come, if I am not mistaken, when philosophy will have a firmer grasp of you, and then you will not despise even the meanest things.'[16]

For Kabakov, garbage represents the eternal return of the same. However, it cannot be reduced to a concept, nor can death overcome it, and every idea is rendered stupid beside it: it is like a swamp

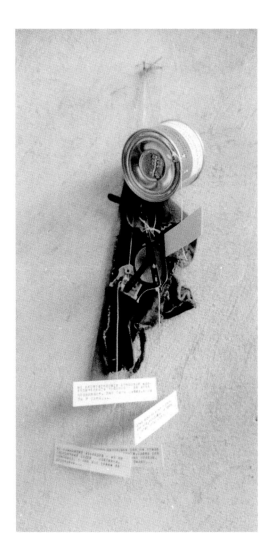

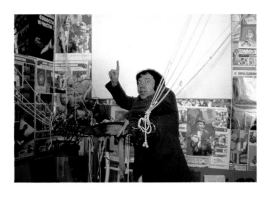

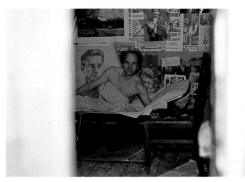

**The Man Who Flew into Space
from His Apartment**
1986
Wood, board construction, room,
furniture, found printed
ephemera, household objects
Dimensions variable

opposite, Installation, the artist's
studio, 6/1 Stretensky Boulevard,
Moscow

top, Installation, the artist's
studio, with artist Viktor Pivovarov
at catapult

above, Installation, the artist's
studio, with composer Vladimir
Tarasov

in which both philosophy and art are submerged.[17] Garbage creates an infinite play of differences, but boring rather than fascinating ones. Garbage is too diverse to be theoretically grasped – but at the same time it is too monotonous for us to desire a sensual experience of it. Garbage subverts and deconstructs the usual distinction between memory and forgetting, between death and survival. Thus, garbage threatens art but simultaneously provides it with an opportunity. For Kabakov, as for many other artists, art is above all the means of overcoming death. He is constantly prey to the anxiety that his art might be physically destroyed – that it might simply be thrown into the dustbin and forgotten. During his time in Moscow this anxiety was intensified by the fact that his work was given no institutional stature or protection. Kabakov began increasingly to take an interest in garbage, where his own works might have ended up, presenting itself as their final context. Yet, as often occurs in Kabakov's work, anxiety mingles with hope, because Kabakov immediately discovers an analogy between the dustbin and the museum.

There is an internal kinship between art and garbage: the work of art and the piece of garbage are equally useless, non-functional, superfluous things, peripheral to the universal traffic in commodities. While the artwork stays in the museum, where it is stored, catalogued and annotated, the piece of garbage is thrown away and disappears somewhere 'outside', away from our cultural living space. Garbage forms the great Other of our culture: it is dangerous, poisonous, hostile to humanity, and must be destroyed. Our

civilization has been repeatedly fascinated by its garbage. From the Romantic era to the present, sewage and garbage dumps have been a popular metaphor for the dangerous, the demonic and the extraterrestrial, both in literature and, later, in film. At the same time, all cultural forms and products face a final choice after their inevitable historical death: either they are turned into museum pieces or they end up on the 'garbage-heap of history', where they may continue to have an uncontrollable, ghostly and threatening life. The boundary between museum and garbage dump is extremely fluid – and historical judgement perpetually subject to revision. Thus archaeological museums are filled with items dug up from the garbage pits of earlier times. And modern artists make copious use of the everyday detritus of our own times, practising a kind of archaeology of modern life. But the relationship between art and garbage cannot be seen solely as salvation from garbage through art. On occasion, garbage can rescue art as well.

In his texts, Kabakov repeatedly points out that art – at least the Russian unofficial art of his times – might, in the end, be interesting only as garbage.[16] If the aesthetic value of art becomes uncertain, if artistic production is no longer oriented towards particular criteria, then only art's sentimental value remains. An artwork has worth for us – both as authors and as viewers – only because of our associated memories. If the universal validity of art is lost, then the artwork is actually reduced to a piece of garbage; but garbage can have a sentimental value in that it reminds us of particular events in our lives that are personally

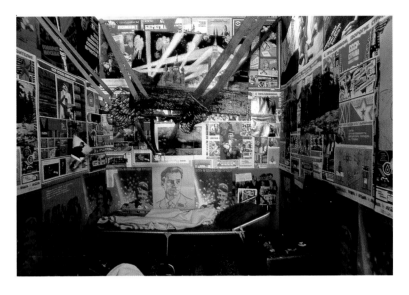

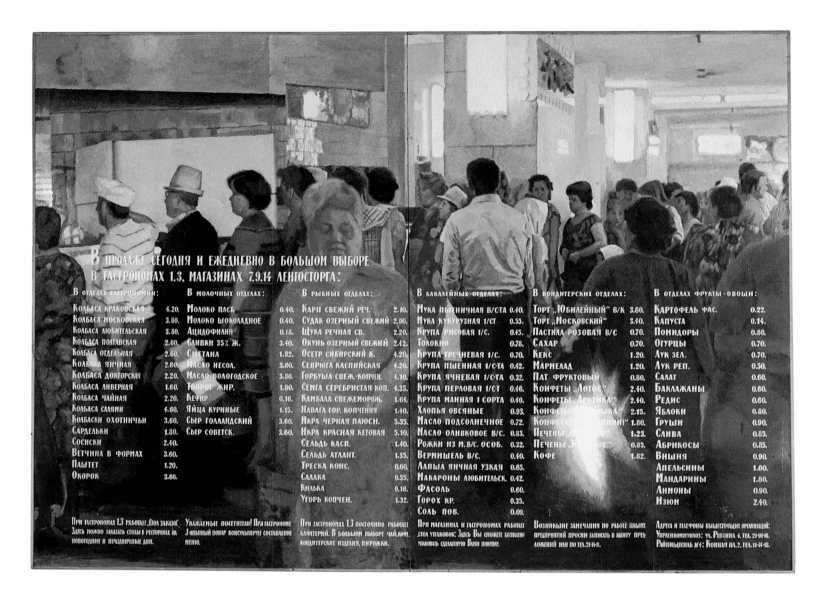

Gastronom
1981
Enamel on masonite
260 × 380 cm
Collection, Kunstmuseum Basel

important to us. Certain artworks, even if they have no objective aesthetic value, are also dear to us for sentimental reasons, even as pieces of trash – assuming, of course, that they remain materially identifiable.

In one of his earlier texts, Kabakov distinguishes between wet and dry garbage.[18] In wet garbage all the boundaries disappear for good, becoming a mass which, as Kabakov says, is popular among artists who wish to draw attention to the impersonal, instinctive, expressive and living forces in their art. Kabakov, on the other hand, sees himself as an artist dealing with dry garbage, forming, so to speak, an intermediate stage between wet garbage and the museum. In a dustbin full of dry garbage, the individual piece of rubbish disappears in the mass, but it can, under certain circumstances, be dug up, identified, annotated and thus transformed into a museum piece. Thus, dry garbage oscillates between total oblivion (vanishing in the wet garbage of impersonal passions) and respectful conservation in the museum. Dry garbage becomes an allegory for the total insecurity of modern man in regard to

all values apart from the personal and sentimental. In turn, if Kabakov ironizes all cultural claims and throws them into the garbage, then the garbage becomes of sentimental value. Garbage as the final, fantastic, universal context of all art, like the white sheet of paper, fills Kabakov with both anxiety and hope.

In the late 1970s and early 1980s Kabakov turned more and more to the subject of garbage. The perfectionism of his earlier albums was replaced by loose collections of garbage. In the files that Kabakov produced during this period (called 'garbage novels'), well-ordered literary stories are replaced by chaotic collections of random scraps of paper. At the same time he began collecting everyday garbage in boxes that he presented to the patiently astonished visitors to his studio. In the 1980s the subject of garbage developed in Kabakov's work alongside the large-scale paintings, which become increasingly devoted to depicting everyday social reality, like his painting *Gastronom* (1981), in which a list of foodstuffs is belied by empty shelves. Here the characteristic theme of the disappearance of life and its replacement by text assumes a character that is less 'metaphysical' than it is social.

Around the early to mid 1980s Kabakov's work encountered Gorbachev's Perestroika. In 1985 his first solo exhibition was held at the Kunsthalle, Bern. He was not allowed, however, to travel out of the Soviet Union to attend the opening. Not until 1987 was he given his first opportunity to journey abroad, and soon afterwards he moved to the West to continue exhibiting without official hindrance. For Kabakov, this was a completely new

psychological context. Until this time, only a few of his works had reached the broad Western public, and this had been mostly through the publications of Western journalists writing about Moscow's artistic life. For the first time for more than thirty years, since he began to work as an artist in the mid 1950s, with the advent of Perestroika Kabakov could show his art not only to a small circle of friends in his private studio or his apartment, but to the wider public in 'normal' exhibition conditions. This forced him to re-examine and rethink the mass of his work, to consider it in light of the foreign, Western eye.

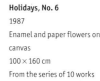

Holidays, No. 6
1987
Enamel and paper flowers on canvas
100 × 160 cm
From the series of 10 works

Holidays, No. 2
1987
Enamel and paper flowers on canvas
100 × 160 cm
From the series of 10 works

Ten Characters
1985–88
Wood, board, paint construction,
series of rooms, furniture, found
printed ephemera, paintings,
household objects, garbage,
labels, texts
Dimensions variable

opposite, Installation, Hirshhorn
Museum and Sculpture Garden,
Smithsonian Institution,
Washington DC, 1988

right, Drawing for installation
Ink on paper
40 × 29.5 cm

The Installations

The first large installation that Kabakov made in the West was *Ten Characters* (1988, Ronald Feldman Gallery, New York). Characteristically, when he asked himself how to show his work in the West, he immediately fell back on the idea of a character, of fictional authorship, which he had developed in the early 1970s in his albums. In New York, works that Kabakov had largely made in Russia were distributed between ten different fictional authors; each was given an imaginary biography and presented as a lonely, solitary soul practising art in the isolation of a little room. Kabakov's installations originate neither in performance nor in post-Minimalist site-specific art, like those by many of his Western colleagues, but in narrative literature, or more precisely, in the novelistic tradition. Each of Kabakov's installations tells a story, and in almost every case it is the tale of an isolated figure in an uncomfortable, menacing environment. The relationship with their surroundings is shown as an agonistic one: the character makes ironic his environment, and the environment reciprocates. The two levels of irony are generally witty, but their interplay is melancholic.

Though there are many similarities between these Western installations and the earlier works, the differences between them are just as telling. A purely formal difference is obvious: a clear spatial design has been introduced. However, the space is not bright, like the white pages of the early albums, but dark, obscure. This darkness, like the uncomfortable placement of the individual pictures and objects within the space, deliberately

Nothing was more alien to Kabakov at that time than the desire to present his work in the 'white cube' of the Western exhibition space. He did not want to be transposed to an alien context, because even if he dreamed, as an unofficial Russian artist, of an international art public, he made his work for that dream, not for its reality.

In the art institutions of the West, Kabakov decided to build his own spaces, his own imaginary context, which is neither Russian nor Western, but a dream-like setting, reminiscent both of utopian projects and of garbage. In order to do this he turned to an art form that he had only toyed with in Moscow – installation. After his move to the West, the construction of installations became his main occupation, as it remains to this day.

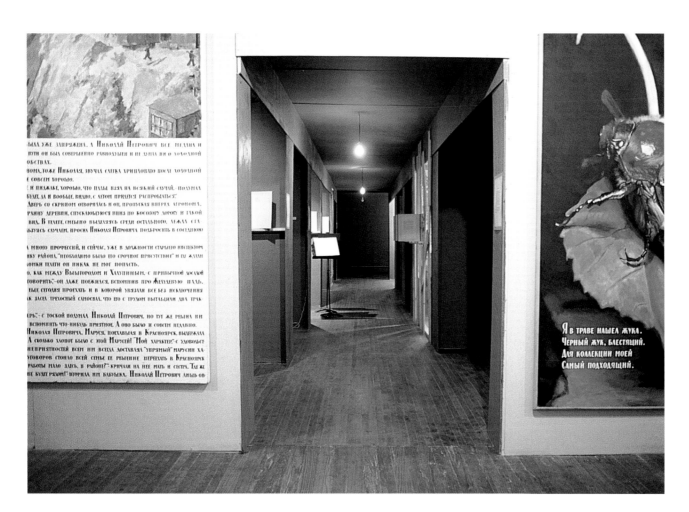

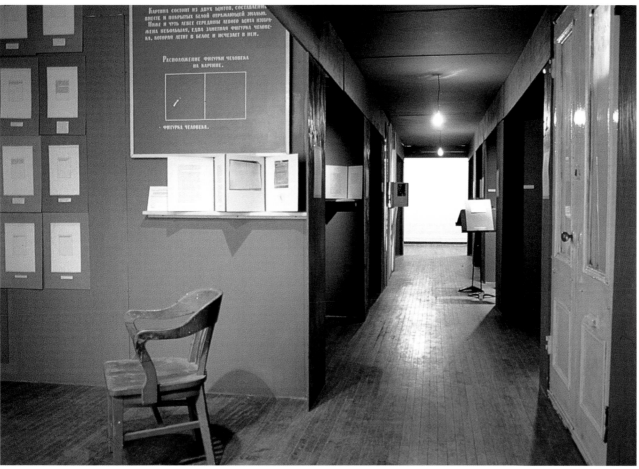

From **Ten Characters**
1985–88

opposite, **The Collector; The
Composer**
Installation, Hirshhorn Museum
and Sculpture Garden,
Smithsonian Institution,
Washington DC, 1989

below, left, **The Man Who Flew
into His Painting; The
Untalented Artist**
Installation, RFFA, New York, 1988

below, right, Drawings for
installation
Ink on paper
42 × 29.5 cm

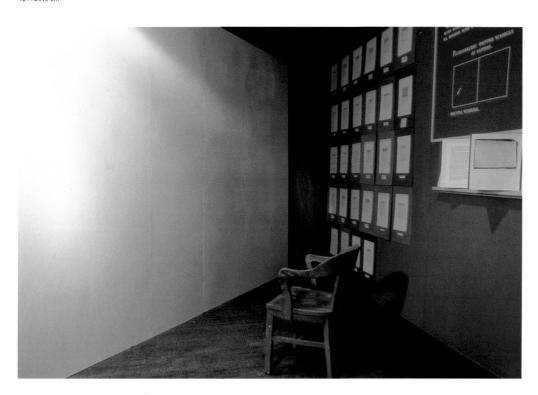

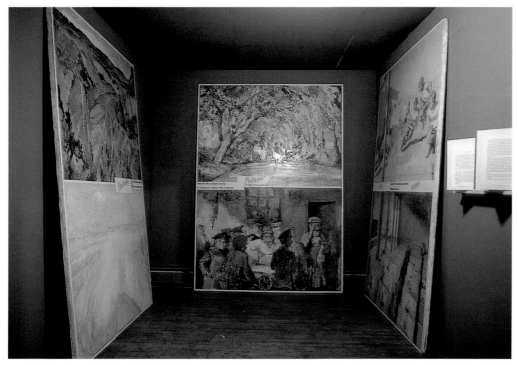

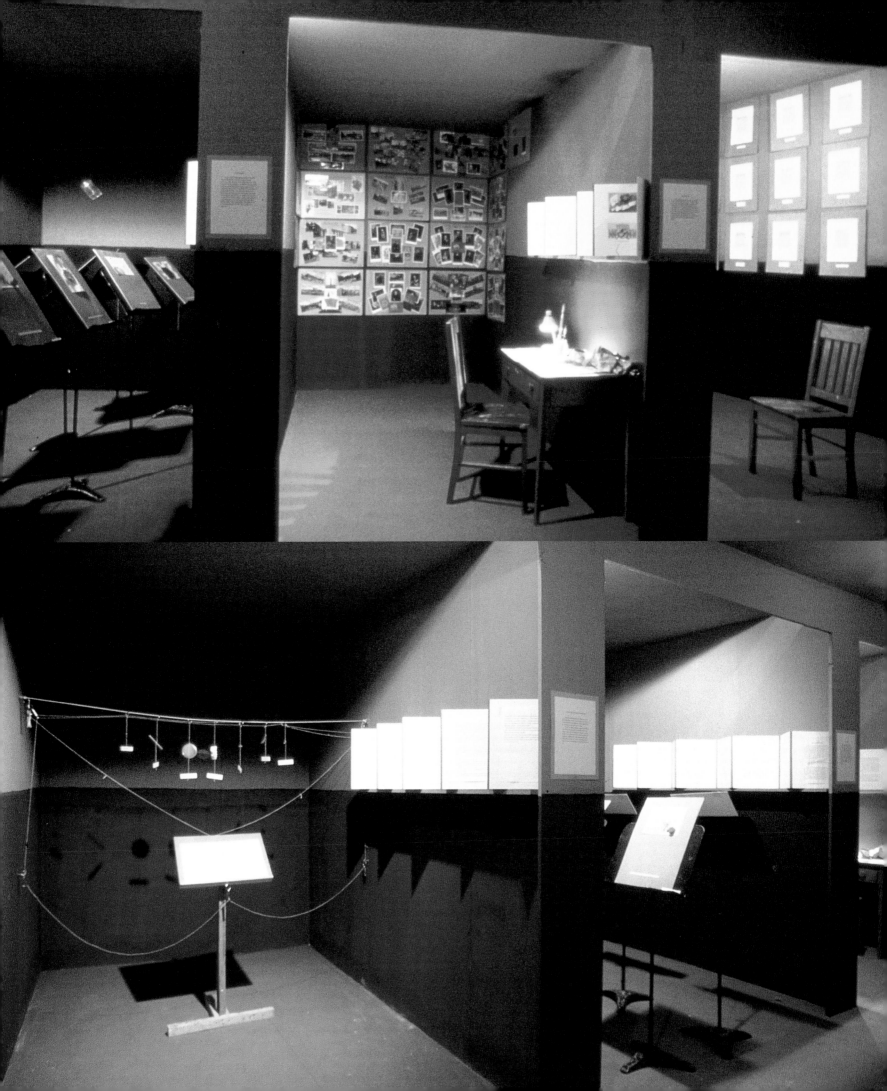

Ten Characters
1985–88
Drawings for installation
Ink on paper
42 × 29.5 cm

l. to r., **The Man Who Collected
the Opinions of Others; The Man
Who Flew into Space from His
Apartment; The Short Man; The
Composer**

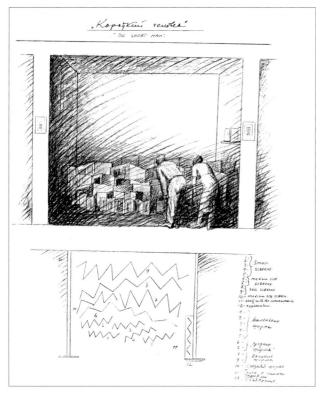

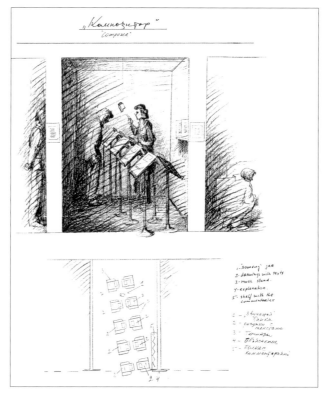

Ten Characters

1985–88

Drawings for installation

Ink on paper

42 × 29.5 cm

l. to r., **The Collector; The Man
Who Described His Life through
Other People; The Man Who Never
Threw Anything Away; The Man
Who Saved Nikolai Viktorovich**

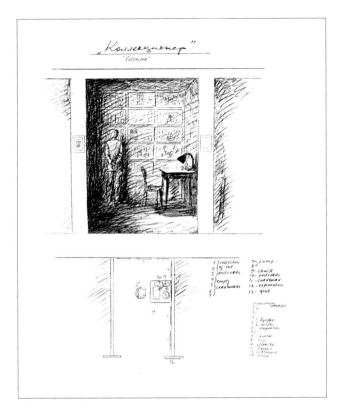

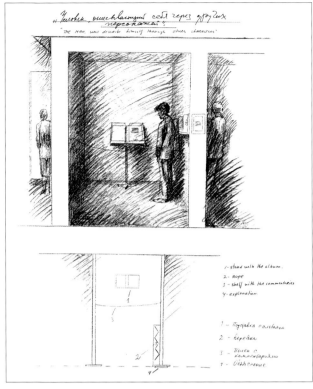

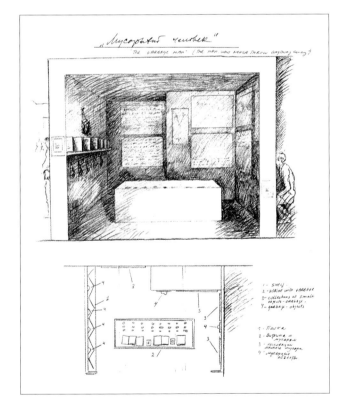

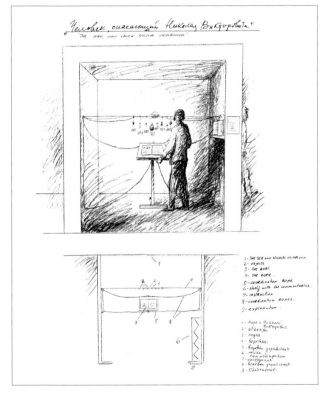

obstructs the viewer's gaze, and makes it difficult for us to see. These are baroque installations, programmatically distinct from the 'white cube' of Minimalist-Conceptualist installations, staging the play of light and shadow and thus emphasizing the difficulties involved in looking into a private world, in surveying the intimate garbage of an unknown life – and asking why, looking voyeuristically into their dark, hidden, intimate spaces is so intriguing. Here, art is seen as the surrender of private garbage, which should really be protected against the harsh light of publicity, but at the same time, this surrender of intimacy is what interests us. It is no coincidence that the installation *Ten Characters* was staged as an ordinary Soviet communal apartment, whose former inhabitants had left behind some rubbish

that ought to have been cleared away.

The communal apartment had also been the theme of some of Kabakov's earlier albums, but in *Ten Characters* all of the rooms of the apartment are inhabited solely by artists. Each is immersed in a personal dream – and yet they all live in the same apartment. The work is about communication without communication, a close, everyday cohabitation dominated by internal isolation. The communal apartment symbolizes the quality of life under Soviet Communism, a life informed by the fear of betraying oneself while living in extreme physical and spatial proximity to others. This mixture of isolation and intimacy was extremely burdensome, but Kabakov set out to discover a *condition humaine universelle* in this unbearable mixture – even a utopia. His installations in the West generally evoke the collapsed Soviet society, repeatedly representing its ugly, unbearable, tedious, depressing traits. This is not, however, a critique or a lament, but a bid to understand the experience of Russian Communism as the discovery of a level of human existence that would otherwise have been left concealed – one that promises not only negativity but also a certain hope.

In his famous book *La communauté désoeuvrée*, Jean-Luc Nancy[19] attempts to define collective life, as differentiated from notions of society and community – and in doing so he comes surprisingly close to Kabakov's interpretation of the communal apartment. In brief, for Nancy society is usually seen as communication between autonomous individuals enjoying certain human rights – above all the right to anonymity, a certain

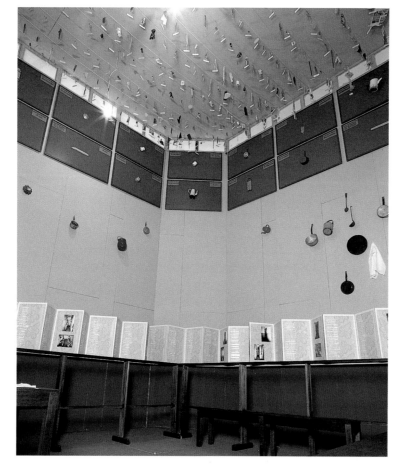

The Communal Kitchen
1991
Wood, board, paint construction, room, household objects, enamel on masonite paintings with household objects, photographs, texts, folding paper screens
Overall h. 6 m, w. 6 m
Installation, Sezon Museum, Nagano, Japan, 1993
Collection, Musée Maillol, Paris

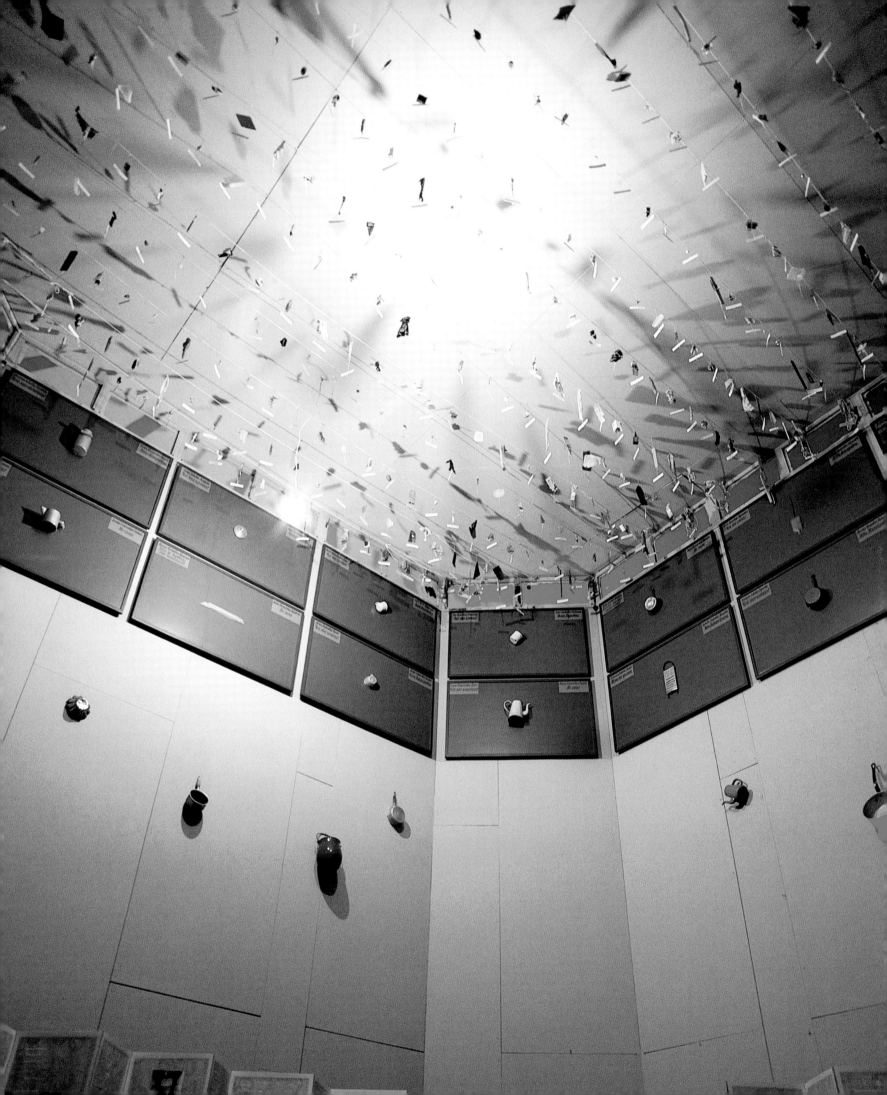

The Metaphysical Man
1989/98
3 paintings, 3 partition walls, 2
tables, 4 benches
Dimensions variable
Collection, Kunsthalle, Bremen

right and opposite, Installation,
De Appel, Amsterdam,

below, Drawing for installation
Ink on paper
29.5 × 40 cm

Paintings used in the installation:
Berdjanskaya Spit
1970
Enamel on masonite
185 × 216 cm

The Man and the House
1969
Enamel on masonite
135 × 160 cm

The Great Game
1983
Enamel on masonite
Painting, 150 × 210 cm, text
panel, 150 × 108 cm

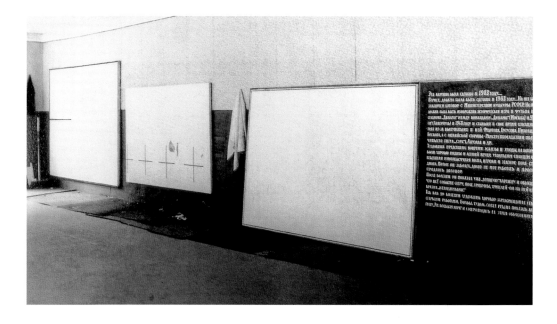

protection against the public sphere – and community is seen as a family, a religion, ethnicity, or class, but always as a community of love, of fusion, of inner unity. Such a communal subject, like an autonomous individual in society, controls his own images and aesthetic represent- ation. But in communal life, in actuality, we supply an image of ourselves that we no longer control: others have a surplus of visual knowledge of us. For Nancy, the communal is above all this other, uncontrollable side of communication, which he defines as *être exposé*. Within this model, we could interpret all human efforts to make images as an attempt to correct those that others already have of one – or at least to play with them.

For Kabakov, the Soviet communal apartment is also such a site, where the person is inordinately exposed to the gaze of others. In the Soviet Union,

communal apartments came into being after the revolution, when many families with nothing in common and of different ethnic and social origin were crammed together under one roof. The private was no longer opposed to, or at least separated from, society, as a sphere of emotions against the coldness of the social. Rather, the communal apartment was where the social appeared in its most terrible, intrusive and radical form, where the individual was entirely exposed to the gaze of others – a generally hostile gaze from cohabitants who consistently exploited this visibility to win advantages for themselves in the power battle raging in the communal apartment. For the extreme intimacy of the communal apartment reveals the whole field of the visual as a battlefield, where the ability to observe others is as important as protecting oneself from the gaze

of the other. And while Soviet Communism has been swept away, nothing has changed in communal life. Others continue to have too much power over one, yet while wanting to protect oneself from this gaze, it can also be enjoyed: now that the notion of God as an intimate and all-seeing observer has gone, the communal remains the sole observer interested in our intimate life. Many people, after the defeat of Communism, miss the excitement of being observed, of being the object of permanent interest on the part of another – even if that other is hostile.

The communal turns everyone into an artist, or into an artwork; thus, the inhabitants of the communal apartment in *Ten Characters* are all artists and the space they inhabit serves as a metaphor for the 'art community'. What is a museum or a large exhibition but a communal apartment in which various artists, each pursuing very different goals and interests, are crammed together by the will of someone whom society has appointed as a curator? Thus, artists repeatedly find each other in the imposed intimacy of a shared context – with neighbours who are often unknown to them, even hostile. And the issue is not whether and how this context may be described, controlled and reflected socially, politically or institutionally, but that a remnant of uncontrollable communal exposure transcends every such description. This remnant does not turn the museum into a place of peaceful contemplation, but into an arena of battle for the gaze, in which every possible strategy of self-exposure and self-concealment is involved. Many of Kabakov's installations conceptualize and stage this conflict,

in which the artist's pseudo-intimacy is the means of displaying and concealing himself at the same time. Another means is the issue of frustrated perception which Kabakov repeatedly explores – and above all, the inevitable fatigue to which the viewer succumbs in the face of an overabundance of drawings and, above all, texts, most of them in Russian. Kabakov disrupts the homogeneous, evenly lit, 'viewer-friendly' museum, where everything presents itself equally calmly and 'ideally' to the viewer, if not to destroy it, at least to call it into question.

At the same time, Kabakov's installations evoking the atmosphere of the communal apartment deal with the search for an ideal communality, a utopian balance between isolation and communication – because the communal apartment not only arouses in Kabakov memories of terror, hatred and denunciation by one's neighbours, but also memories of the cohesive group that was Moscow's unofficial art scene. In that world every artist went his own artistic way, but on the everyday level each showed solidarity with the other. If Kabakov finds in the modern Western museum the place of peace, order and security that was constantly under threat in the Soviet communal apartment, he also misses the intimacy of Moscow's unofficial circle, to which he devoted his installation *NOMA, or the Moscow Conceptual Circle* (1993),[20] which also resembles a kind of communal apartment. In Kabakov's work, the stagings of the communal apartment oscillate between two kinds of violence: the violence of communal intimacy and the violence of control. He is clearly seeking an impossible equivalence

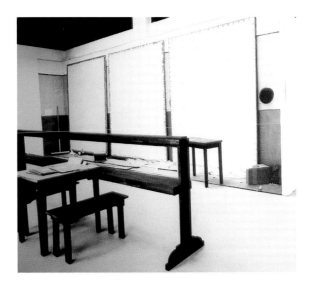

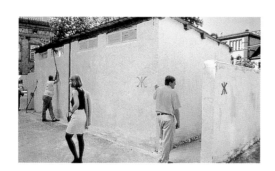

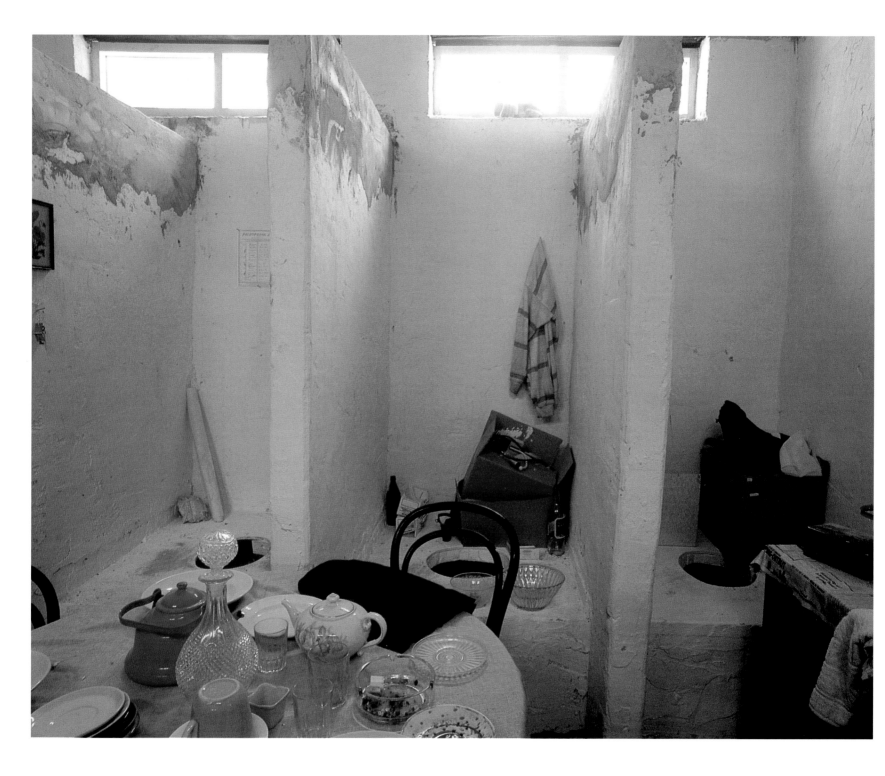

The Toilet
1992
Stone, cement, wood, paint
construction, men's room,
women's room, household objects,
furniture
Overall h. approx. 450 cm, w. 417
cm, l. 1100 cm
Installation, Documenta IX,
Kassel, Germany
opposite, entrance, men's room
below, women's room

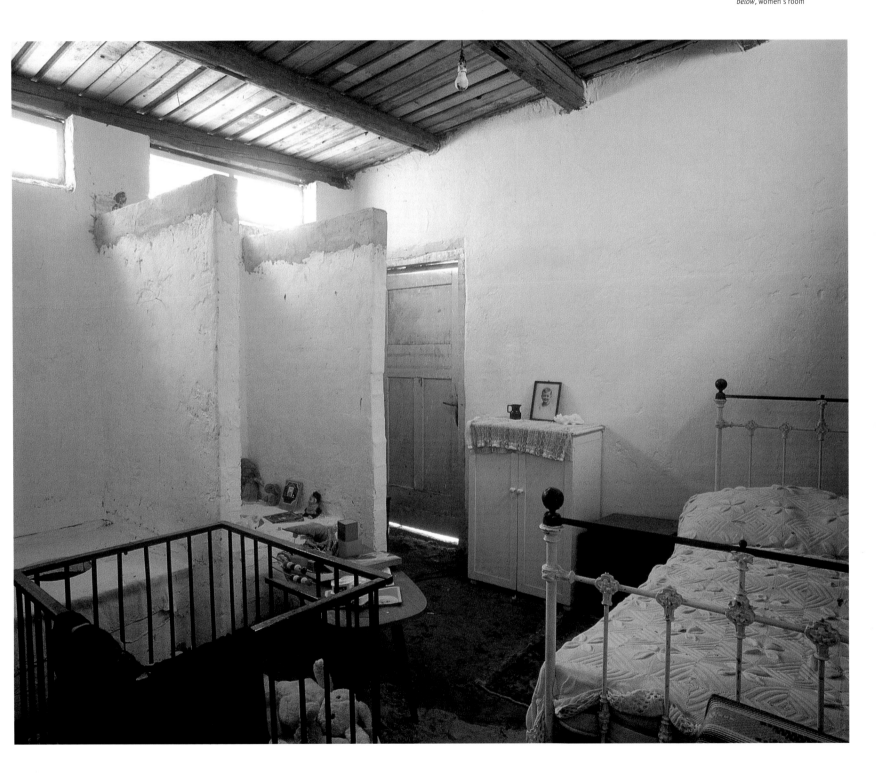

right and opposite, **The Ship**
1986/92
18 wooden frames, shelves, 1
wooden showcase with stand, 22
easels, 22 tables, 1 wooden
display shelf, 32 rolls of paper,
manuscript documents of
grievances concerning collective
apartments and kitchens, 23
sheets, collages, printed
documents, tourist brochures,
postcards, 6 wooden panels,
printed documents
Overall h. 298 cm, w. 925cm, l.
2125 cm
Installation, Espace Lyonnais pour
l'Art Contemporain, Lyon, 1996
Collection, Espace Lyonnais pour
l'Art Contemporain, Lyon

below, right, Installation detail

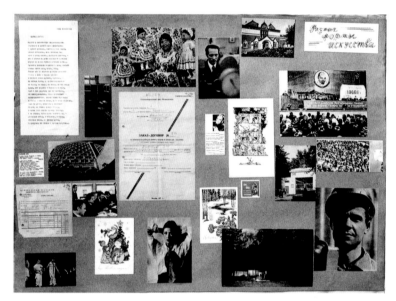

between the two, and the spaces of his installation are half-private, half-public – intermediate areas in which these kinds of violence reach an equilibrium. As usual, Kabakov projects his anxieties and hopes equally upon them.

He particularly focuses on the tension between private and public space in his installation *Toilet*, which he constructed for Documenta IX (1992). This toilet, erected by Kabakov as a separate building in the courtyard of the Fridericianum Museum (a former palace), where the majority of the Documenta works were shown, is similar in construction to the toilets, primitive and uncomfortable to say the least, that are still to be found in the south of Russia. But inside this toilet private spaces were installed, resembling a normal family apartment. This, then, is a family living quietly and unworried in a public toilet – without dramatizing the fact. In his own comments on this installation Kabakov refers to a memory from childhood: his mother had to live for a time in a former toilet (unused at the time, of course) of a children's boarding school. The installation also comments on Documenta itself: as in every large exhibition, stands are installed in the vast space of the Fridericianum, each of them serving as a private space for individual artists to exhibit their work, and viewers are free to enter for a short time, and then leave, having answered their aesthetic 'call of nature'. A certain edginess in the metaphor reveals the fact that Kabakov looks back with some nostalgia to the time when he welcomed visitors to his studio or his apartment, as a householder who was able to dictate the conditions under which they were to see his art. In the installations that he has made in the West, Kabakov tries to wrest back that control with purely aesthetic means – through direct or indirect instructions that guide the viewer's eye in one direction or another, and establish the sequence in which the installation should be seen.

Kabakov often describes his installation works as 'total installations'.[21] By this he means first of all that when he builds them he is not simply putting his art in an existing space, but completely transforming the space in visual terms and turning

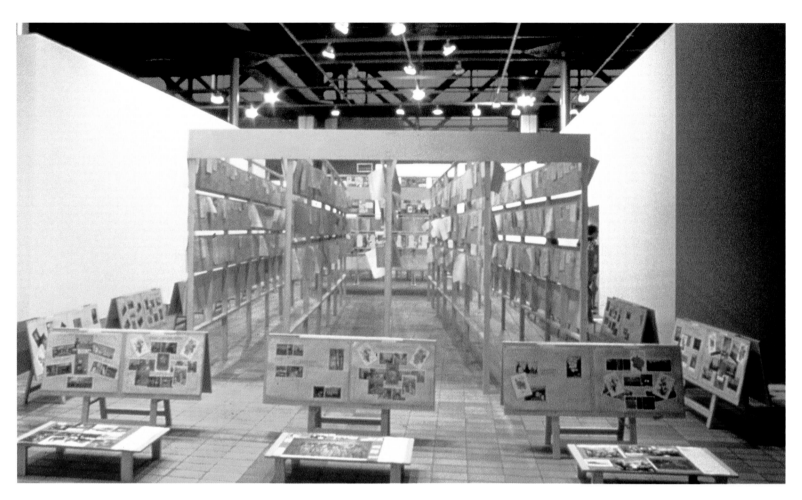

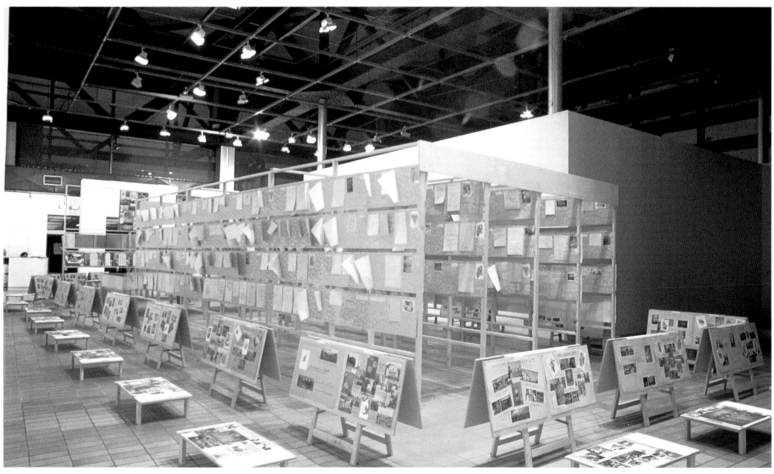

The Red Wagon, with musical
arrangement by Vladimir Tarasov
1991
Wood, steel, board, paint
construction, 'train wagon',
Socialist Realist style paintings
and mural by the artist, garbage
Overall h. 700 cm, w. 350 cm, l.
1700 cm
Installation, MAK-
Österreichisches Museum für
Angewandte Kunst, Vienna, 1994

Vladimir Tatlin
Model for a Projected Monument
for the III International
1919–20
Wood, wire
Approx. h. 670 cm

it, albeit temporarily, into an environment of his own. Secondly these installations repeatedly evoke a larger, totalitarian project of omnipresent control and a system of direct and indirect orders recalling the collapsed Soviet power – an impression reinforced by the frequent use of typically Soviet materials and designs. Kabakov's relationship with totalitarianism is in turn dichotomous and ambivalent: he sees the Soviet communist project as gloomy oppression doomed to failure. On the other hand he cannot ignore the fact that his artistic urge to control and guide the viewer's gaze is internally related to the totalitarian political project.

Many of Kabakov's 'Soviet' installations make visual this ambivalence. It was in this way, for example, that he constructed his massive installation *The Big Archive* (Stedelijk Museum, Amsterdam, 1993). Visitors are first asked to fill in hundreds of different forms, then proceed into a space resembling a Kafka-esque court-room, where a sentence appears to be passed, either dispatching them to the dustbin of oblivion or to the archive of collective memory. The space recalls Soviet official buildings – shabby, boring, depressing. The questions in the huge pile of forms are contradictory, inconsistent and inconclusive. The archive collapses in on itself because, in claiming to register every aspect of the whole person, it permits no criteria that would enable us to distinguish the essential from the irrelevant. The closing judgement can therefore only be random and absurd.

This randomness is further underlined by the fact that it is a temporary installation which, once dismantled, will only remain as a vague memory, at best, captured in the catalogue. Kabakov repeatedly thematizes the transitory quality of the installation, and in this case, the collapse of the Soviet Socialist order repeatedly acts as a metaphor for this transience. In the installation *The Red Wagon* (Dusseldorf, 1991)[22] the visitor enters through a futuristic entrance recalling Tatlin's famous *Monument to the III International* (1919–20), walks through the space in which the dreams of the Stalinist period are presented, and finds himself at the exit on a garbage pit. In *The Red Pavilion* (Venice Biennale, 1993), Kabakov transformed the old Soviet exhibition pavilion in the Giardini into a hybrid between a building-site and a lumber room, erecting a small, temporary, wooden pavilion at the back, constantly playing the optimistic Soviet music of the Stalin era. Neither pavilion is really accessible: the old will collapse, and the new is merely a voice. The huge installation *We Are Living Here* (Centre Pompidou, Paris, 1995) suggests the abandoned building-site of an enormous palace of the future; all that one finds is the unfinished buildings and the temporary, shabby dwellings of the builders.

In the installations in which Kabakov most explicitly engages with the collapsed Socialist dreams he explores the fluid transition between construction and collapse, the moment between emergence from garbage and dissolution into it. Civilization is shown as an unfinished building, a transition from one state of garbage to another – or as a temporary installation of uncertain duration, which could dissolve away at any moment without leaving a trace. Soviet civilization

The Big Archive
1993
Wood, steel, board, paint
construction, 4 rooms, 4
corridors, desks, notices, forms
Dimensions variable
Installation, Stedelijk Museum,
Amsterdam

is actually the first thoroughly modern civiliz-
ation to have died before our eyes; all other
dead civilizations known to us were pre-modern.
The Soviet Union vanished as it did, ending up so
irrevocably on the refuse dump of history, because
it could not leave behind any clearly identifiable,
original 'monuments'; it simply decayed back into
the modern garbage from which, like any other
ready-made civilization, it was made. Again and
again Kabakov stages this decline of Soviet civiliz-
ation into ahistorical garbage. Again and again he
presents the sight of it as embarrassing, cheap,
unpleasant – and at the same time sublime. Indeed
the appearance of decline is always sublime. And
the more radical and relentless
the decline, the more sublime its image.

The history of the Communist utopia –
which had originally made the greatest possible
historical claims and greatest possible effort to
free humanity from its historical distress – ended
in poverty, filth and chaos and presents the most
extreme case of historical defeat. It therefore
provides, perhaps, the most sublime historical

image. Kabakov's installations illustrating the
fate of Soviet power look, with their heavily
emphasized, 'Orwellian' shabbiness and quasi-
bureaucratic ugliness, like monuments to past
glory and thus radiate a particular fascination.

For Kabakov, all attempts at civilization,
whether utopian, messianic or otherwise, are
transient. For Kabakov, the museum is just as
transient. If he erects his short-lived installations
within the apparently stable institution of the
museum, he doesn't let anyone forget that the
museum is itself an installation; it too will finally
collapse into garbage. Thus, in *Incident at the
Museum, or Water Music* (Museum of Contemporary
Art, Chicago, 1993) he stages the decaying space
of a provincial Russian museum containing works
by a rather conventional, little-known painter.
The roof of the museum has collapsed, water is
dripping from above, and various pots and pans
are set out over the floor to catch the drops.
The museum is turned into a kind of chaotic,
communal kitchen. As always, this image of
decline also suggests cause for hope: the drops

We Are Living Here, with musical
arrangement by Vladimir Tarasov
1995
Wood, steel, board, paint
construction, train-wagon
'apartments', paintings,
household objects, furniture,
printed ephemera, texts
Dimensions variable
Installation, Centre Georges
Pompidou, Paris

above and opposite, **We Are Living
Here**, with musical arrangement
by Vladimir Tarasov
1995
Wood, steel, board, paint
construction, train-wagon
'apartments', paintings,
household objects, furniture,
printed ephemera, texts
Dimensions variable
Installation, Centre Georges
Pompidou, Paris

right, Drawing for installation
Graphite on paper
29.5 × 42 cm

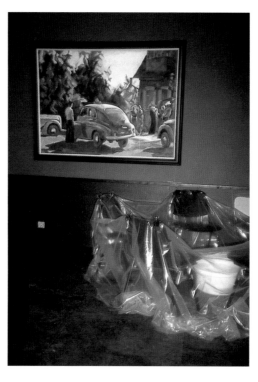

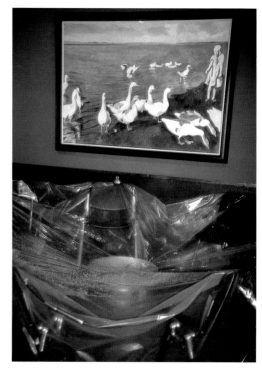

Incident at the Museum, or
Water Music, with sound
composition by Vladimir Tarasov
1991
Wood, board, paint construction,
2 rooms, oil paintings in style of
fictitious Socialist Realist painter
of 1920s and 1930s, Stepan
Yakovlevich Koshelev, chairs,
plastic sheeting, water, buckets,
sound installation
Dimensions variable
Installation, Hessisches
Landesmuseum, Darmstadt,
Germany

of water fall in accordance with a special apparatus
which causes their splashing into the pots and
pans to suggest a particular melody. Art survives
every disaster, every collapse, because we are able
to see everything with which we are confronted,
as art. This ability is not a total 'aestheticization'
that would anaesthetize us to reality, but merely
another opportunity to practise art under all
possible circumstances.

Kabakov's works are almost entirely
autobiographical. He barely deals with themes or
images other than those of his own life. Now and
again he is accused of being unable to get away
from his Russian, Soviet themes; rather, he cannot
get away from his own life, because he mistrusts

the social, political and aesthetic themes that are
not his own. His work continues to move forward,
however, because he is constantly calling his
memories into question, recontextualizing them
and checking their reliability. Accordingly, he
repeatedly uses his earlier works in new contexts,
both relativizing them and, in some cases,
rescuing them. Again and again, Kabakov discovers
that even his own memories are preserved only as
inscriptions, but inscriptions whose meaning is
threatened with erasure.[23]

For this reason, at every stage in his artistic
development Kabakov has recapitulated and
rewritten his own past. After developing the form
of the albums in the early 1970s, he integrated

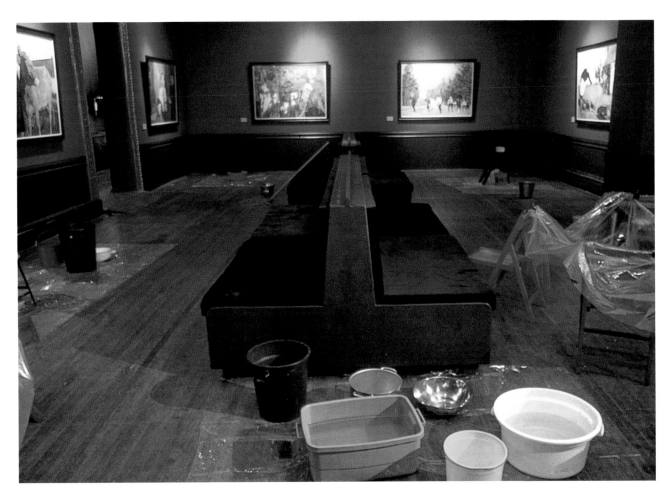

Incident at the Museum, or **Water Music**, with sound composition by Vladimir Tarasov
1991
Wood, board, paint construction, 2 rooms, oil paintings in style of fictitious Socialist Realist painter of 1920s and 1930s, Stepan Yakovlevich Koshelev, chairs, plastic sheeting, water, buckets, sound installation
Dimensions variable
Installation, Hessisches Landesmuseum, Darmstadt, Germany

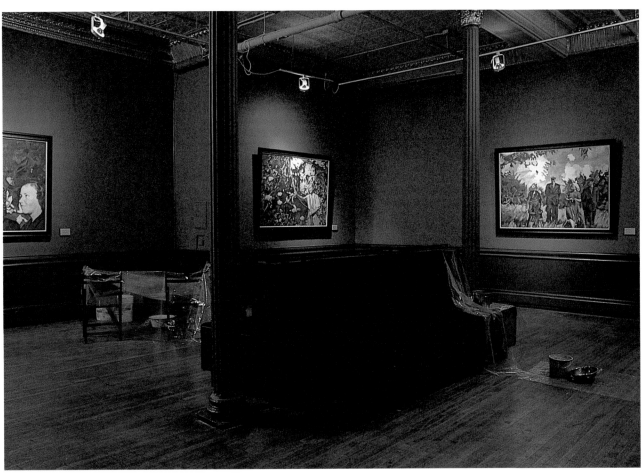

We Were in Kyoto, with Emilia
Kabakov
1997
Wood, plastic, construction, silk
flower petals, confetti, 5 blowing
machines, 5 plastic tubes, 3
artificial stones
Dimensions variable
Installation, 47th Venice
Biennale, Venice

seen, they are treated like garbage, overlaid with other, everyday objects, and so on. Their visibility is lost, their worth destroyed, their meaning negated – and yet they are rendered contemporary, and given their place in the present, even if that place does not seem to be quite as advantageous as the old one.

Almost since the very beginning Kabakov has pursued one essential question (or rather he has been pursued by it): how can an artist make his work in such a way that it can be rescued from historical oblivion and decay? Or: how, in the conditions of the secularized modern age, which has lost its faith in the immortality of the soul, can the work achieve at least a limited immortality in the archive of historical memories, whose relative durability is nowadays promised by modern historicism rather than divine memory?

Soviet Communism was a religion of historicism par excellence, and this is another reason why the Soviet experiment is of such great importance to Kabakov. Over time, however, as the Soviet Union is increasingly succumbing to historical oblivion, the Soviet myth that Kabakov repeatedly evokes in his paintings, texts and installations is becoming a personal one for Kabakov. If, not so long ago, certain artistic procedures and stylistic devices employed by the artist could be identified as typically Soviet, at least by a Soviet viewer, they now appear 'typically Kabakovian'. Kabakov survived Soviet power – and not only physically and psychologically. His private myth has swallowed up the great Soviet myth and gradually digested it.

The paradigmatic Platonic hero of European

many of his earlier drawings within this new form. In the process, these drawings forfeited their original artistic autonomy: the written comments appended to them in the albums, and the whole structure of the albums, neutralized and weakened their effect. On the other hand, this saved them from being overtaken by time and received in a new, contemporary context. Later, Kabakov did the same thing with his earlier paintings, which he integrates in his installations. In the process, these paintings not only lose their autonomous position and their original context, but endure a whole series of humiliations and torments: they are put in dark corners where they can hardly be

metaphysics begins his journey by leaving the communal cave which he has to inhabit with others, able only to follow the shadow of the real world outside, unable to discern the true form of this world. One day the hero breaks his chains and walks out into the sunlight, in which things present themselves to him as they really are. But interestingly – and without any reasonable explanation – the hero finally returns to the cave, to be killed by its inmates, since his eyes can no longer recognize the shadows that had for so long been familiar to him. Like this Platonic hero, Kabakov spent almost his whole life dreaming of the real world outside the Soviet cave, when all he could see was its shadow. But unlike his Platonic counterpart, Kabakov developed a certain dislike for the sun, along with the suspicion that the shadows might be more interesting than the things themselves. This insight protected him from later disappointment – and also from the danger of returning to the cave. Instead, he constructed murky installations, which act in the long term as Platonic caves, even if they are penetrated by the sun from time to time. He never really left the cave of his communal memories – rather he carries it around with him and exhibits it over and over again.

Kabakov never attempts to resurrect either his own or a collective past in its former glory, to 'make it present'. His work acknowledges that the past was only ever a shadow. He is, rather, completely unsparing in his depiction of every possible wound, every sign of waste, age and decay, every distortion, every loss of meaning, every accrued absurdity. His strategic concessions to the power of time, his polite, ritual bows to its

lordly whims, have but one single purpose: to outwit time, to smuggle, beneath the veil of an officially promulgated submissiveness, a few small left-overs – in the form of meaningless, unprepossessing, paltry garbage – from the past into a possible future. The strategy of dialectical reason, formulated by Hegel, seeks to triumph over history; yet there also exists a more modest strategy: that of the unreasonable individual, whose ambition is no greater than to save the very least.

Translated from German by Shaun Whiteside

Destroyed Altar
1996
Wood, board, paint construction, printed ephemera, text panels, triptych painting
Dimensions variable
Installation, Deichtorhallen, Hamburg

Painting used in the installation:
Hello, Morning of Our Homeland!
1981
Enamel on masonite
Triptych, 260 × 190 cm each panel

above and opposite, **The Artist's Library**
1997
Framed drawings, books,
albums, tables, chairs
Dimensions variable
Installation, Satani Gallery,
Tokyo

1 The best survey of Russian art during this period is in the seven issues of *A-Ya* magazine, Paris (Russian/English), published from 1980–85. Also: *Ich lebe – ich sehe: Artists of the 1980s in Moscow*, Kunstmuseum, Bern, 1988; *Contemporary Russian Artists/Artisti Russi Contemporanei*, Museo d'Arte Contemporanea Luigi Pecci, Prato, 1990; *Between Spring and Summer: Soviet Conceptual Art in the Era of Late Communism*, Tacoma Art Museum, MIT Press, 1990. On the art-historical context, see Groys, Boris, *The Total Art of Stalinism: Avant-Garde, Aesthetic Dictatorship, and Beyond*, Princeton University Press, 1992

2 See for example the commentary on the painting *Explaining Signs* (1965), in Groys, Boris, 'Ilya Kabakov – Der Künstler als Erzähler', in *Ilya Kabakov 'Am Rande'*, Kunsthalle, Bern, 1985, p. 6 ff.

3 Some of these are illustrated in *Ilya Kabakov: Five Albums*, The Museum of Contemporary Art, Helsinki, 1994

4 From the 1950s–80s a strong structuralist school emerged as a part of the University of Tartu in Estonia. Many leading protagonists of the school, however, were predominantly based in Moscow, hence the general description of this group, in Western Slavic studies, as the Moscow-Tartu School of structuralism.

5 On the totalitarian radicalization of the friend-enemy relationship see Schmitt, Carl, *Der Begriff des Politischen*, Berlin, 1991; and commentary on Schmitt in Derrida, Jacques, *Politiques d'amitié*, Paris, 1994, p. 107 ff.

6 The term Moscow Conceptualism came into general use after publication of the article 'Moscow Romantic Conceptualism', Groys, Boris, in *A-Ya* magazine, Paris, 1979. It is now routinely used for characterization of the artists in this circle, but it was not used by the artists themselves at the time.

7 Ratcliff, Carter, *Komar & Melamid*, New York, 1988; also, *Sots Art*, New Museum of Contemporary Art, New York, 1986

8 See for example Bourdieu, Pierre, *Les règles de l'art*, Paris, 1992

9 Kabakov, Ilya, in foreword to Jolles, Paul R., *Memento aus Moskau*, Cologne, 1997

10 The first exhibition in which a 'Black Square' painting was shown was, incidentally, entitled *0.10* (1915), signifying: ten artists who had gone beyond the point one, i.e., beyond death.

11 Bakhtin, Mikhail, *Problemy poetiki Dostojevskogo*, Moscow, 1963

12 Bakhtin, Mikhail, *Tvorcestvo François Rabelais*, Moscow, 1965

13 On the 'white' paintings see Kabakov, Ilya and Boris Groys, *Die Kunst des Fliehens*, Munich, 1991, p. 93 ff.

14 The interpretation of 'Suprematist' white as Russian snow was relatively widespread in the Russian art of the 1970s, for example in the work of Francisco Infante, or the Collective Action Group.

15 Kabakov, Ilya, 'On the White Background', in *A-Ya*, No. 6, Paris, 1984

16 Plato, *Parmenides*, trans. Jowett, Benjamin, Prometheus Books, New York, 1996

17 Groys, Boris and Ilya Kabakov, 'A Conversation about Garbage', in Kabakov, Ilya, *The Garbage Man*, Museet for Samtidskunst, Oslo, 1996

18 Kabakov, Ilya, Memoirs, *The 1970s* (unpublished)

19 Nancy, Jean-Luc, *The Inoperative Community*, University of Minnesota Press, 1991

20 Kabakov, Ilya, *NOMA, oder der Kreis der Moskauer Konzeptualisten*, Kunsthalle, Hamburg, 1993

21 Kabakov, Ilya, *Über die totale Installation/ On 'Total Installation'*, Stuttgart, 1995

22 *Sowjetische Kunst um 1990: Binationale Israel – USSR*, Kunsthalle, Düsseldorf, 1991

23 For parallels with Paul de Man's understanding of autobiography, see 'Autobiography as De-facement', in de Man, Paul, *The Rhetoric of Romanticism*, Columbia University Press, New York, 1984, p. 67 ff.

Contents

Going to Heaven

'When I began to show paintings of hell to the inhabitants of paradise, I quickly heard from them that there was nothing new in this, that these stories and paintings from a life in hell were already familiar to them ... I understood that at first you have to scare and confuse the angels a bit so that they forget about their angelic life ... ' – Ilya Kabakov[1]

We were out walking in Münster on a breathless, white summer's day. After a stop at Woolworth's for supplies, we set off to navigate the complex meanderings of a shopping centre. At its furthest edge roared a four-lane highway. Pausing briefly at the roadside, we ran to an island, waited and ran again, reaching its far bank high on carbon monoxide. On the verge, we discovered a car park for heavy-goods vehicles, which we set about exploring. Eventually we found ourselves entering a delightful park. It was here that we received the message.

What makes parks so dreamlike? They are at once soporific and exhilarating. They take us back in time to adolescence, when the park was available for thrillingly illicit activities such as loitering, kissing and smoking. In fact, they take us back still further to childhood. Innocence is certainly the metaphoric meaning of the garden in literature. The pastoral genre offers an oasis, detached from time, the corruptions of the city, society and the flesh. As John Barrell has pointed out, the dictionary definition of landscape – 'a view or prospect of natural scenery' – has its source in theatre. 'The word "scene", applied to a landscape, assumed also that what was being described lay opposite the observer, *en face*, and this sense came with it from its theatrical origin – the flat and square shaped "skene" behind the orchestra in a Greek theatre ... '[2] The landscaped garden is a kind of pre-Lapsarian Arcadia, a 'no-place' that has provided poet and playwright with a *tabula rasa* against which are set the actions and temptations of their protagonists. Simon Pugh comments, 'The metaphoric reference point ... is the idea of the garden as paradise, the site of a travesty, a falling away from bliss ... As a lost state that is recreated through representation, the garden is the site of desire'.[3]

Landscaped gardens, such as the park we had discovered, present nature as a scopic experience. Their planning centres on looking: on views, prospects and panoramas unfolding along a single perspective taken from a high vantage point, as inspired by

Donald Judd
Untitled
1977
Concrete
ø 15 m
Permanent installation, City of Münster, Germany
Collection, Westfälisches Landesmuseum für Kunst und Kulturgeschichte, Münster, Germany

painting. This movement away from the observer towards the horizon is given an outline, a frame, by our field of vision. Inspired by the conventions of painting, therefore, a view becomes a landscape. From Claude to Caspar David Friedrich, it is the horizon that is 'at once the climax and the starting point of the composition'[4] moving the viewer in a transcendent dynamic towards the infinite, towards an experience of the sublime. Within this frame, classical statuary and architectural 'follies' were traditionally deployed as aesthetic and mnemonic devices. Through public art projects and sculpture parks, contemporary works of art have taken their place in Arcadia. We had entered a theatre of the mind and eye.

Big Skies

'It is only when you are lying flat on the earth – in a flop house, for instance – that you begin to look at the sky: the man who lies in the dirt looks on high … ' – Ilya Kabakov[5]

On the edge of a lake we found two large concrete rings, laid flatly open to the sky. About fifteen metres in diameter, their tilted rims gently rearing up to a height of two metres, they were made by Donald Judd in 1977. Rather than constituting solids, these sculptures create outlines, encircling the ground to invoke surface and space rather than mass. Their horizontal repetition implies a kind of infinity – they could potentially duplicate across the park and on into the horizon.

We understood that these works were not representations or abstractions, but they did echo the lake, implying that it was simply part of their series. Their most profound impact lay, however, in their transformation of the Münster heavens into a Texan-style Big Sky. It happened that Ilya Kabakov had seen this work and decided to pay it a tribute: ' … a connection between the earth and sky occurs in this place thanks to the work of a great artist.'[6]

We continued walking, drawn skywards. And suddenly there it was, some kind of giant aerial or radar. Horizontal parallel lines floated in the sky, radiating out from the top of a thirteen-metre high mast comprising a delicate cross-hatched steel structure. The metal 'aerial' was anchored by six bracing wires attached to the ground, each ten metres from the mast. Like the Judd, the dynamic of this structure was vertical, skyward. The faint, steamy

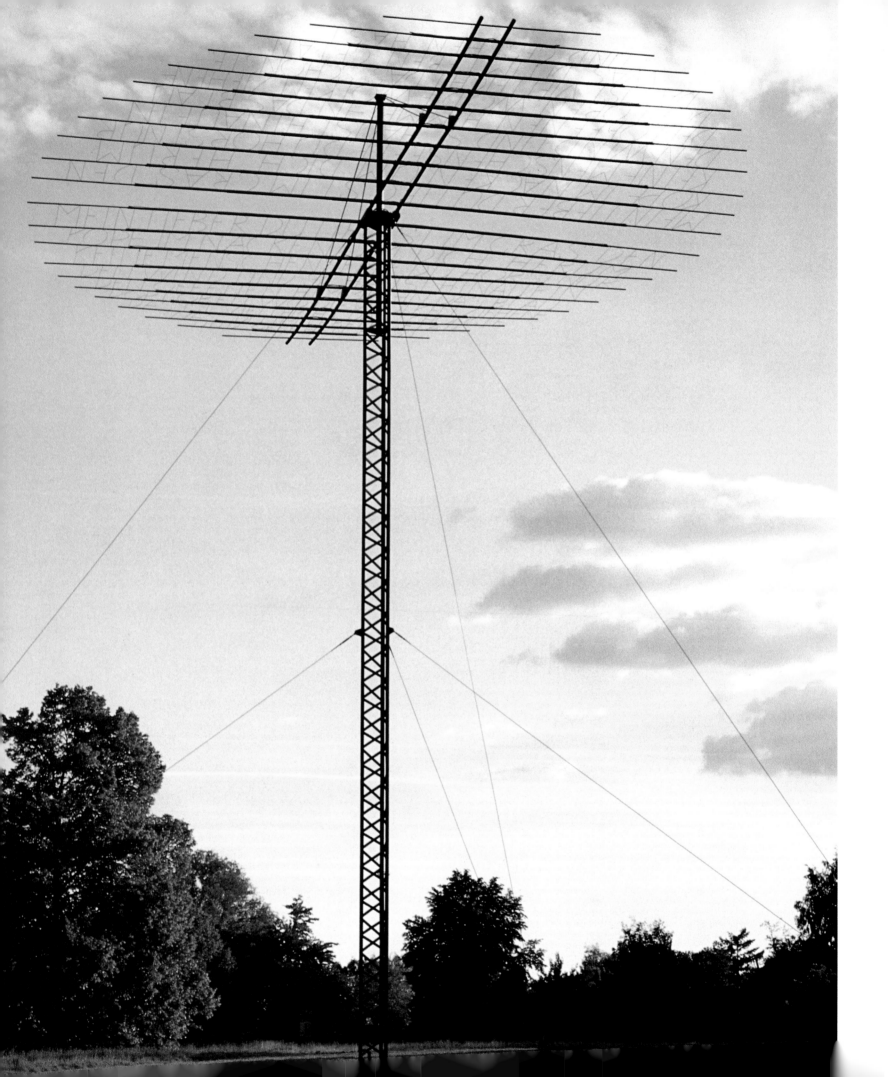

warmth of the day, the slight giddiness of walking without purpose, our aching necks, conspired to make us abandon ourselves to the 'transmitter'; we lay on the grass, throwing our heads back.

Looking up. Reading the Words, made for Skulptur Projekte in Münster, 1997, is the exact opposite of any other work made by Kabakov. His installations are usually dimly lit, often claustrophobic, interiors, articulating the architectonics of communal misery. Traces of incidents unfold room by room or, in a way, chapter by chapter. Objects are tentatively made from the poorest of materials; subjects are tiny figures or invisible occupants, traced by their obsessive scribblings, their absence a poignant reminder of a tendency among Soviet citizens to disappear. Sometimes his subjects are merely flies. By contrast, the transmitter's construction and siting is open, singular, transparent and permeable – to the light, the wind, the landscape, its metal structure a wonder of engineering. Unlike the ghosts who haunt Kabakov's other installations, the people who visited this sculpture through the summer of 1997 were robust, well-fed citizens, present in the flesh. Yet, in his earlier 'rooms from hell', Kabakov always incorporated an escape route. This work is dialectically implicated in all his installations to date. The sky is our necessary heaven. Its boundlessness is a sign of escape and eternity, a way of jettisoning the weight of our bodies, the failure of our societies; a way also of cheating death. As Robert Storr has pointed out, it has a particular significance both in Kabakov's work and in Russian art in general: 'People and things in Kabakov's world have nowhere to go except up – and so they do. But these levitations also obey a special aesthetic law of gravity applying to Russian art. There, traditionally, one finds that angels, peasants and pure geometries fly with great frequency and the greatest of ease.'[7]

The steel architectonics of the work align it with the structures of technology to suggest upward mobility as a paradigm, not only for individual transcendence but also for the onward and upward dynamics of progress. Implicit within this 'frontierist' impulse – symbolized in the 1960s by jet planes and space travel and in the 1990s by cyberspace and the ever-receding horizons of video games – is the principle of never actually arriving. A dynamic of unfulfillable desire also characterizes the logic of consumption, which creates a vampiric image of the self as lacking, only to find completion through purchase or escape. We were apparently in the presence of a sleek monument to modernity.

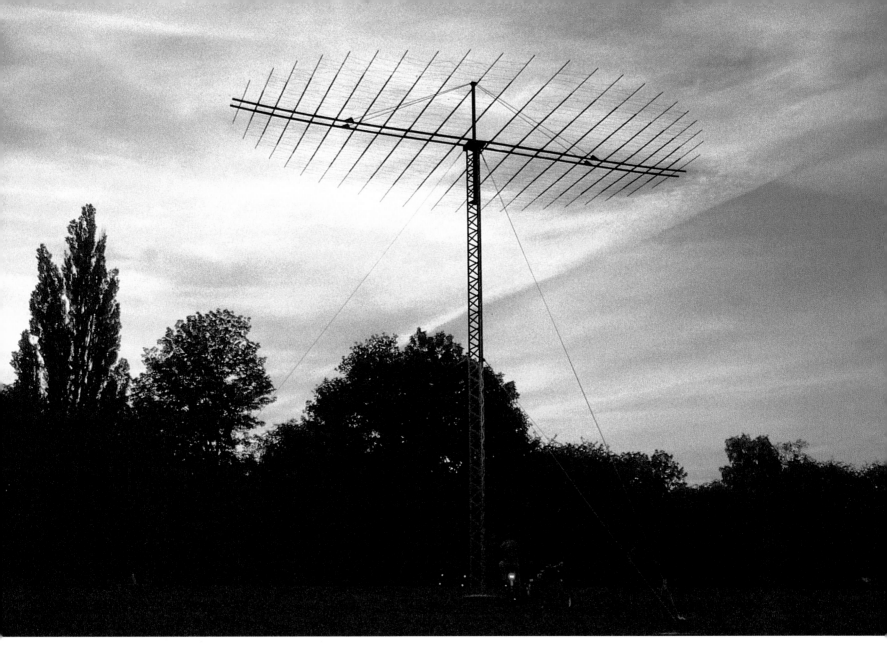

But before we succumbed to the thrill of take-off, something grounded us. The structural typology of this work is evocative of pylons, created for the transmission of energy, be it electricity or radar. We realized that it was in fact a conduit or cypher, a kind of metallic Gabriel conveying a message.

The Invisible Book

' … Whenever we look up at the sky, we involuntarily have a presentiment; unconsciously we anticipate some sort of 'communication' from there; it seems that 'something' will be addressed directly to me … ' – Ilya Kabakov[8]

Almost imperceptibly at first, we saw a sign. Despite the high-tech structure, no diodes glowed, no fantastical, *Close Encounters*-type chord structures were emitted. In fact, once

we had managed to focus on it, its medium seemed surprisingly prosaic, not unlike a very good pupil's handwriting, neat capital letters all straight and touching the top and bottom of the ruled lines. A German text was written in metal. It read:

'My Dear One! When you are lying in the grass, with your head thrown back, there is no one around you, and only the sound of the wind can be heard and you look up into the open sky – there, up above, is the blue sky and the clouds floating by – perhaps this is the very best thing that you have ever done or seen in your life.'

All at once I was alone. I was being addressed personally, in frankly affectionate terms, as if I were reading a fragment of a love letter, or the dedication of a romantic novel. A direct address from the sky is also divine: I was going to receive a revelation.

In the context of the West, this linguistic device also resonates with the rampant individualism addressed by advertising: every billboard looks you in the eye and speaks to your narcissism or your neurosis. In the context of the morbid collectivism of the Soviet East, where communal living and decision by committee once made solipsism seem like an island paradise, it expresses a poignant form of wish fulfilment.

The text not only isolated me, it situated me phenomenologically. I felt what it described: the grass under my head, the wind across my face. It had persuaded me to look up and lie down. The text was itself a physical substance and at the same time an exact description of its own material context. In its tautological and literal transparency – the sky and the clouds could indeed be seen through it, just as the wind played around it – it seemed to have attained a state of pure autonomy.

The work of this Russian artist in many senses parallels the American Minimalist ethos. He presents specific objects that may be fabricated by someone else, in places he has constructed, to be experienced not as representations but in real time and space.

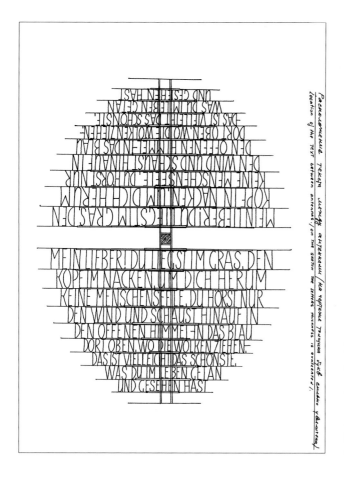 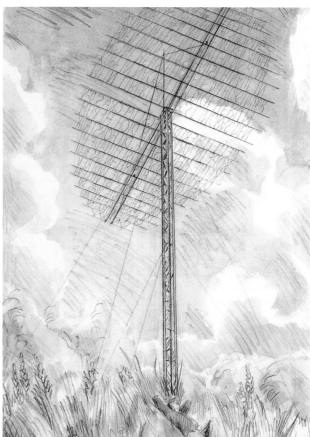

Kabakov's installations are complete in themselves, enmeshing the spectator in a series of complex formal and critical relations. However, by adding a narrative dimension to constructions of form, they create a kind of three-dimensional discourse.

Was this simple text as transparent as it appeared? Jean François Lyotard has written, 'Limpid writing is … turbid, disturbed by the "presence" of the other in itself. This other erases its readability. The erasure can even infiltrate into the readability itself: confusion can lurk in clarity; the feature of the sentence can be lost in the philosopher's coherent proposition'.[9] The transmission crackled with irony. Why was such an exquisite piece of new technology devoted to something so simple as a handwritten text? It delivered no news flash about the end of the world, no close encounter, not even a weather report. This piece of 'technology' *détourned* me, back into the real world and into my sense of being. The pleasure of that return was overwhelming. Wasn't the utopia that we were all drawn to by this divine receiver, the very thing that we were running away from: a *horror vacui*, the void?

Commenting on the dominance of literature in Russian culture, Kabakov writes, 'The emptiness is behind everyone, behind everything that happens to them – but they talk

nonetheless. They talk so as to fill up this emptiness, so that they will not disappear into the noiselessly resounding awfulness of the void. They must talk, they must weave an unbroken net from words, phrases and opinions which even from the very beginning have been devoid of sense'.[10] Rather than downloading superfluities of information, *Looking up. Reading the Words* emphasizes stillness and introspection, a simple breeze rather than the wind of change. It situated us in the here and now.

Yes, lying there in the grass looking at the sky was the very best thing that I had ever done or seen in my life. An anxious something pulled at the last part of the message, triggered by that 'perhaps'. Imminent to the limpid state of work and beholder was the fall from grace. I was not, after all, alone. My solipsistic reveries were framed by noisy chatter. I was surrounded by other dreamers. Soon, I would have to get up and walk out of the park, this best of all possible worlds, out of the small green island to re-enter the plains of autobahns, suburban houses and light-industrial estates, spreading out towards the horizon. We had come here to escape but, with his tender irony, Kabakov had reconnected us with the pains and the neglected pleasures of reality.

1 Ilya Kabakov, interview with Boris Groys, *Parkett*, No 34, Zürich, 1992, p. 37

2 John Barrell, *The Idea of Landscape and the Sense of Place, 1730–1840*, Cambridge University Press, Cambridge, 1972, p. 23

3 Simon Pugh, *Garden-Nature-Language*, Manchester University Press, Manchester, 1988

4 John Barrell, ibid., p. 23

5 Ilya Kabakov, dialogue with Boris Groys, *Die kunst des fliehens*, Haiser Verlag, Munich, 1991, p. 27

6 Ilya Kabakov, artist's statement, *Skulptur Projekte in Münster 1997*, Westfälisches Landesmuseum, Germany, 1997, p. 237

7 Robert Storr, 'The Architect of Emptiness', *Parkett,* No 34, Zürich, 1992, p. 43

8 Ilya Kabakov, artist's statement, op cit, p. 236

9 Jean François Lyotard, 'Foreword: After the Words', in Joseph Kosuth, *Art after Philosophy and After*, MIT Press, Cambridge, Massachusetts, 1993, p. xvi

10 Ilya Kabakov, *Das Leben der Fliegen*, Kölnischer Kunstverein/Edition Cantz, Germany, 1992, p. 237

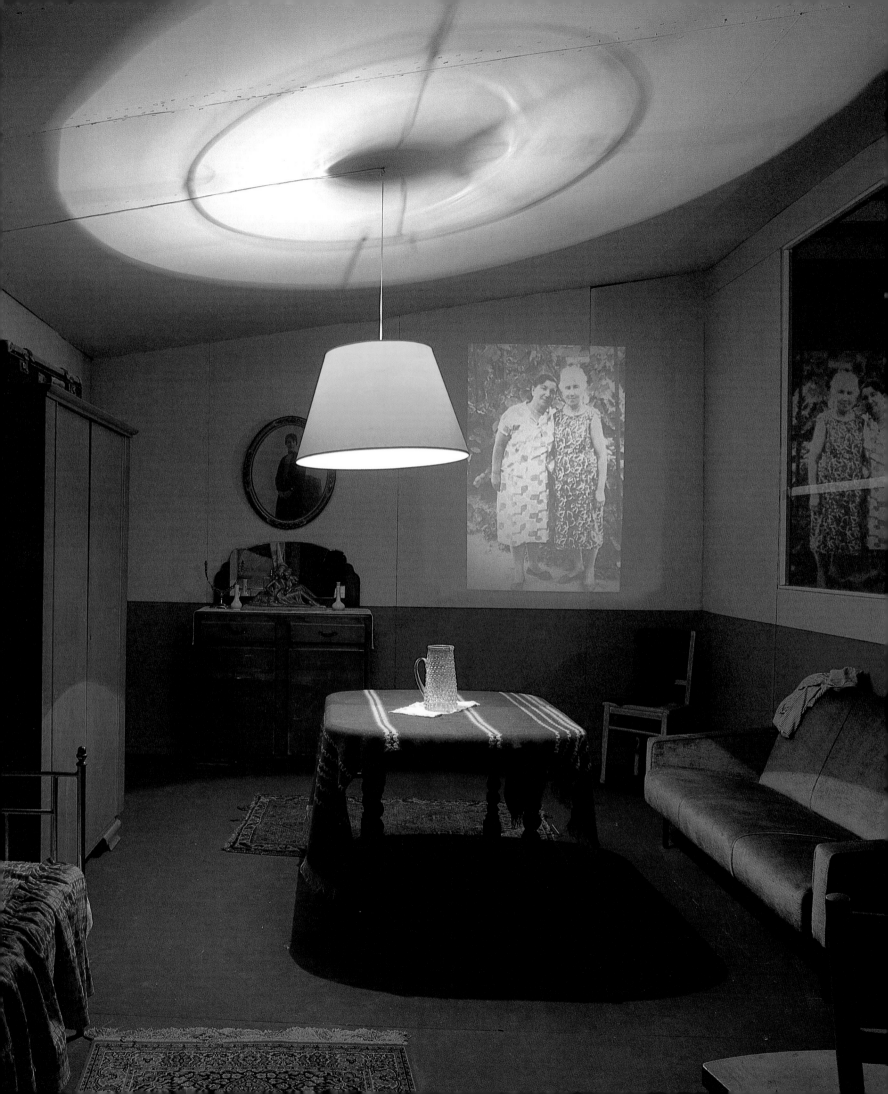

Contents

The Story of a Journey

[I]

On an early July morning a dilapidated springless carriage –
one of those antediluvian britzkas now used in Russia only by
merchants' clerks, cattle-dealers and poor priests – drove out of
N., a sizeable town in Z. County, and thundered along the post
road. It rumbled and squeaked at the slightest movement, to the
doleful accompaniment of a pail tied to the back-board. These
sounds alone, and the wretched leather tatters flapping on the
peeling chassis, showed just how decrepit, how fit for the scrap
heap it was.

Two residents of N. occupied the britzka. One was Ivan
Kuzmichov, a clean-shaven, bespectacled merchant in a straw
hat, who looked more like a civil servant than a trader. The other
was Father Christopher Siriysky, principal priest at St. Nicholas'
Church – a short, long-haired old man wearing a grey canvas
caftan, a broad-brimmed top hat and a brightly embroidered
belt. The former was absorbed in his thoughts, and kept tossing
his head to keep himself awake. On his face a habitual business-
like reserve was in conflict with the cheerfulness of one who has

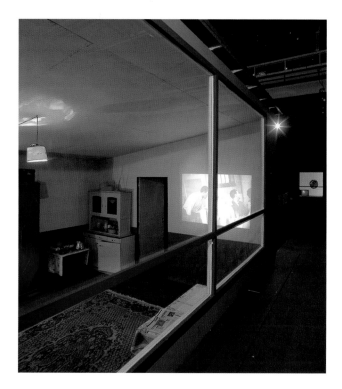

just said good-bye to his family and had a drop to drink.
The other man gazed wonderingly at God's world with moist eyes
and a smile so broad that it even seemed to take in his hat brim.
His face was red, as if from cold. Both Kuzmichov and Father
Christopher were on their way to sell wool. They had just been
indulging in cream doughnuts while taking farewell of their
households, and they had had a drink despite the early hour.
Both were in excellent humour.

Besides the two already described, and the coachman Deniska
tirelessly whipping his pair of frisky bay horses, the carriage had
another occupant: a boy of nine with a sunburnt, tear-stained
face. This was Kuzmichov's nephew Yegorushka. With his uncle's
permission and Father Christopher's blessing he was on his way
to a school of the type intended for gentlemen's sons. His
mother Olga – Kuzmichov's sister and widow of a minor official –
adored educated people and refined society, and she had begged
her brother to take the boy on his wool-selling trip and deliver
him to this institution. Understanding neither where he was
going nor why, the boy sat on the box by Deniska's side, holding
the man's elbow to stop himself falling, and bobbing about like
a kettle on the hob. The swift pace made his red shirt balloon
at the back, and his new coachman-style hat with the peacock
feather kept slipping to the back of his neck. He considered
himself extremely unfortunate, and was near to tears.

As they drove past the prison Yegorushka looked at the sentries
slowly pacing near the high white wall, at the small barred
windows, at the cross glittering on the roof, and remembered the
day of Our Lady of Kazan, a week earlier, when he and his mother
had attended the celebrations at the prison church. Before that
he had visited the gaol at Easter with Deniska and Lyudmila the
cook, taking Easter cakes, Easter eggs, pies and roast beef.
The convicts and thanked them and crossed themselves, and one
had given the boy some tin studs of his own manufacture.

While the boy gazed at the familiar sights the hateful carriage
raced on and left them all behind. Beyond the prison black,
smoke-stained forges flashed past, and then the tranquil green
cemetery with the stone wall round it. From behind the wall
cheerful white crosses and tombstones peeped out, nestling in
the foliage of cherry trees and seen as white patches from a

On the Roof
1996
Wood, board, paint construction,
rooftops, chimneys, 10 rooms,
furniture, household objects, slide
projections of photographs in
each room in chronological
sequence, relating to biographical
memories of the artist and Emilia
Kabakov
Dimensions variable
Installation, Palais des Beaux-
Arts, Brussels

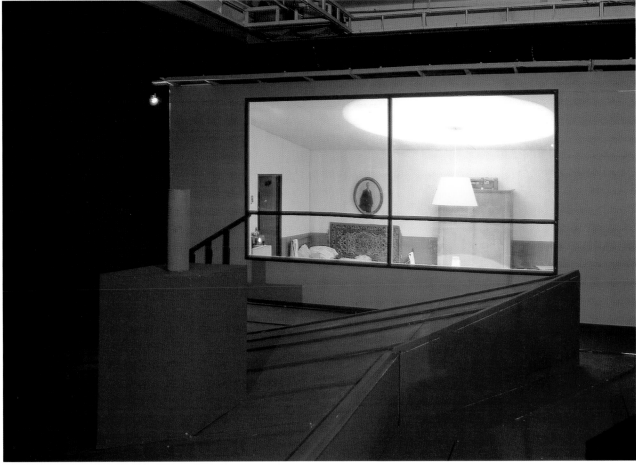

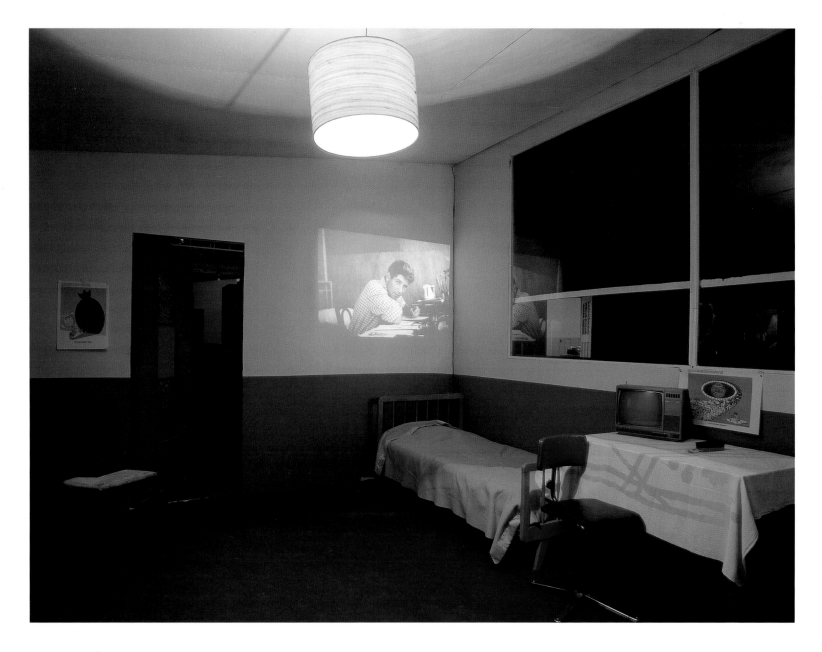

distance. At blossom time, Yegorushka remembered, the white patches mingled with the cherry blooms in a sea of white, and when the cherries had ripened the white tombs and crosses were crimson-spotted, as if with blood. Under the cherries behind the wall the boy's father and his grandmother Zinaida slept day and night. When Grandmother had died she had been put in a long, narrow coffin, and five-copeck pieces had been placed on her eyes, which would not stay shut. Before dying she had been alive, and she had brought him soft poppy-seed bun rings from the market, but now she just slept and slept.

Beyond the cemetery were the smoking brickyards. From long thatched roofs, huddling close to the ground, great puffs of thick black smoke rose and floated lazily upwards. The sky above the brickyards and cemetery was dark, and the great shadows of the smoke clouds crept over the fields and across the road. In the smoke near the roofs moved people and horses covered with red dust.

With the brickyards the town ended and open country began. Yegorushka took a last look back at the town, pressed his face against Deniska's elbow and wept bitterly […]

[V]

[…] During the meal general conversation took place. From this Yegorushka gathered that, despite differences of age and temperament, his new acquaintances all had one thing in common – each had a glorious past and a most unenviable present. To a man, they all spoke of their past enthusiastically, but their view of the present was almost contemptuous. Your Russian prefers talking about his life to living it. But the boy had yet to learn this, and before the stew was finished he firmly believed that those sitting round the pot were injured victims of fate. Pantely told how, in the old days before the railway, he had served on wagon convoys to Moscow and Nizhny Novgorod, and had earned so much that he hadn't known what to do with his money. And what merchants there had been in

On the Roof

1996

Wood, board, paint construction,
rooftops, chimneys, 10 rooms,
furniture, household objects, slide
projections of photographs in
each room in chronological
sequence, relating to biographical
memories of the artist and Emilia
Kabakov
Dimensions variable
Installation, Palais des Beaux-
Arts, Brussels

those days! What fish! How cheap everything was! But now the roads had shrunk, the merchants were stingier, the common folk were poorer, bread was dearer, and everything had diminished and dwindled exceedingly. Yemelyan said that he had once been in the choir at Lugansk, had possessed a remarkable voice, and had read music excellently, but had now become a bumpkin living on the charity of his brother, who sent him out with his horses and took half his earnings. Vasya had worked in his match factory. Kiryukha had been a coachman to a good family, and had been rated the best troika driver in the district. Dymov, son of a well-to-do peasant, had enjoyed himself and had a good time without a care in the world. But when he was just twenty his stern, harsh father – wanting to teach him the job and afraid of his becoming spoilt at home – had begun sending him out on carrier's work like a poor peasant or hired labourer. Only Styopka said nothing, but you could tell from his clean-shaven face that for him too the past had been far better than the present.

Recalling his father, Dymov stopped eating, frowned, looked sullenly at his mates, and then let his glance rest on Yegorushka. 'Take yer cap off, you heathen', he said rudely. 'Eating with yer cap on – I must say! And you a gentleman's son!'

Yegorushka did take his hat off, not saying a word, but the stew had lost all relish for him. Nor did he hear Panteley and Vasya standing up for him. Anger with the bully rankled inside him, and he decided to do him some injury at all costs.

After dinner they all made for the carts and collapsed in their shade.

'Are we starting soon, Grandad?' Yegorushka asked Panteley.

'We'll start in God's good time. We can't leave now, 'tis too hot. O Lord, Thy will be done, O Holy Mother. You lie down, lad.'

Soon snoring proceeded from under the wagons. The boy meant to go back to the village, but on reflection he yawned and lay down by the old man.

[VI]

The wagons stayed by the river all day and left at sunset.

Once more the boy lay on the bales while his wagon quietly squeaked and swayed, and down below walked Panteley – stamping his feet, slapping his thighs, muttering. In the air, as on the day before, the prairie music trilled away.
The boy lay on his back with his hands behind his head, watching the sky. He saw the sunset blaze up and fade. Guardian angels, covering the horizon with their golden wings, had lain down to sleep – the day had passed serenely, a calm, untroubled night had come on, and they could stay peacefully at home in the sky. Yegorushka saw the heavens gradually darken. Mist descended on the earth, and the stars came out one after the other.

When you spend a long time gazing unwaveringly at the deep sky your thoughts and spirit somehow merge in a sense of loneliness. You begin to feel hopelessly isolated, and all that you once thought near and dear becomes infinitely remote and worthless. The stars that have looked down from the sky for thousands of years, the mysterious sky itself and the haze, all so unconcerned with man's brief life – when you are confronted with them, and try to grasp their meaning, they oppress your spirits with their silence, you think of that solitariness awaiting us all in the grave, and life's essence seems to be despair and horror.

The boy thought of his grandmother, now sleeping under the cherry trees in the cemetery. He remembered her lying in her coffin with copper coins on her eyes, remembered the lid being shut and her being lowered into the grave. He remembered, too, the hollow thud of earths clods against the lid. He pictured Grannie in the dark, cramped coffin – abandoned by all, helpless. Then he imagined her suddenly waking up, not knowing where she was, knocking on the lid, calling for help and – in the end, faint with horror – dying a second death. He imagined his mother, Father Christopher, Countess Dranitsky and Solomon as dead. But however hard he tried to see himself in a dark grave – far from his home, abandoned, helpless and dead – he did not succeed. For himself personally he could not admit the possibility of death, feeling that it was not for him [...]

Translated from Russian by Ronald Hingley

270

120 130 70
1,30 12о. 25

3,50 нечто 55 4

150

140 90

130

1. В шкафу
2. Нащ ревную
3. Лучшельзы...
4. Анна Петровна
5. Украшень
6. Универсальн...
 сцена...
 изображён...
 всего

Contents

The Man Who Never Threw
Anything Away (detail)
1985–88
Album, books, household objects,
string, labels
Dimensions variable
The artist's studio, 6/1 Sretensky
Boulevard, Moscow

– Pick it up, you dropped something there …
Nikolai Vasilyevich Gogol, 'The Nose', *c.*1835

… He never threw anything away.

… He sat in his corner (he lived all his life in a small room located in the very farthest corner of a large communal apartment). He almost never went out anywhere, except to work, from which he quickly returned home. He lived completely alone. Spending all of his time in his room, he went to the kitchen and other common areas only when it was extremely necessary. What he did in his little room remained unknown to all the inhabitants of the overcrowded communal apartment.

The communal apartment was located in an old building which hadn't been renovated in years, and it was occupied, as a rule, by occasional tenants, many of whom moved to new apartments, and then their places were taken by others. Despite continual and regular cleaning – both weekly and major – in the corridors, kitchen and the common room (that's what the small room was called where the tenants stored oversized things that wouldn't fit in their rooms, like chests of drawers, trunks, old refrigerators, etc.), there was always a pile of discarded things. No one knew to whom these things belonged or what they were for, nor was it known whether the owners of these things still lived in the apartment or if they had left already.

These things were scattered in all the corners, hung on all the walls, stood near the door and lined the entire hallway. Because of this the apartment acquired the appearance of a mysterious cave, full of stalactites and stalagmites, with a narrow passageway between them leading to the always open kitchen door in the distance, illuminated by a twenty-watt bulb.

But many such incidental things, which were left, discarded and forgotten by no one knows whom, were always lying around the stairways – two main stairways and two back stairways – of our four-storey building.

Near the large discarded things – big wardrobes, cast-iron stoves, couches and other household junk – smaller things were piled up on all sides and on top – pipes, crates, boxes, old buckets, bottles, both broken and whole … The line of these things, like some sort of uninterrupted procession, reached the semi-circular gateway of our building and even spilled out onto the street. It was as if this mixed crowd of things was peeking outside, as though it were expecting someone, as though hoping to set off on some kind of journey …

That's why no one in our building, and even more so in our apartment, could be

The Man Who Never Threw
Anything Away (detail)
1985–88
Album, books, household objects,
string, labels
Dimensions variable
The artist's studio, 6/1 Sretensky
Boulevard, Moscow

amazed by any kind of garbage – neither by its appearance nor its size. Nevertheless, there came a time when even the tenants of our apartment, No. 8, Building No. 4, on Pryanishnikov Lane, were truly shocked.

This happened under the following circumstances.

For many years a plumber lived in our apartment. This was known to be a fact, although no one had ever seen him, but the children who misbehaved and ran screaming through the corridor were threatened that he would jump out at any moment and 'eat' them […] Once, when it had already got quite cold and it was necessary to 'check the heat', we were visited by three grease-covered men with wrenches in their hands who demanded that we tell them where the plumber was located. Uncle Misha, who was the chief tenant 'responsible' for the apartment, pointed to the door where the plumber supposedly lived. The door was locked. The grease-covered men were 'on duty' and they had to 'start up the heat', and since the chief tenants and witnesses were present, it was decided to break down the door, and this was done in an instant.

There was no plumber in the room. The men with the wrenches left, but all those who had entered with Uncle Misha couldn't regain their wits for a long time and stood still, transfixed, looking around in amazement.

The entire room, from floor to ceiling, was filled with heaps of different types of garbage. But this wasn't a disgusting, stinking junkyard like the one in our yard or in the large bins near the gates of our building, but rather a gigantic warehouse of the most varied things, arranged in a special, one might say carefully maintained, order. Flat things formed a pyramid in one corner, all types of containers and jars were placed in appropriate boxes along the walls. In between hanging bunches of garbage stood some sort of shelving, upon which myriads of boxes, rags and sticks were set out in strict order … Almost all the shelves where these things were placed were accurately labelled, and each item had a five- or six-digit number glued on it and a label attached to it from below. There were also lots of things – piles of paper, manuscripts – on a big table standing in the middle of the room, but these didn't have numbers or labels on them yet … Chief tenant Uncle Misha bent over one of the manuscripts and read: 'Garbage' (an article).

Garbage
Usually, everybody has heaps of accumulated piles of paper under their table and their desk, magazine and telephone notices which stream into our homes each day. Our

home literally stands under a paper rain: magazines, letters, addresses, receipts, notes, envelopes, invitations, catalogues, programmes, telegrams, wrapping paper, and so forth. These streams, waterfalls of paper, we periodically sort and arrange into groups, and for every person these groups are different: a group of valuable papers, a group for memory's sake, a group of pleasant recollections, a group for every unforeseen occasion – every person has their own principle. The rest, of course, is thrown out on the rubbish heap. It is precisely this division of important papers from unimportant that is particularly difficult and tedious, but everyone knows it is necessary, and after the sorting everything is more or less in order until the next deluge.

But if you don't do these sortings, these purges, and you allow the flow of paper to engulf you, considering it impossible to separate the important from the unimportant – wouldn't that be insanity? When is that possible? It is possible when a person honestly doesn't know which of these papers is important and which is not, why one principle of selection is better than another, and what distinguishes a pile of necessary papers from a pile of garbage.

A completely different correlation arises in his consciousness: should everything, without exception, before his eyes in the form of an enormous paper sea, be considered to be valuable or to be garbage, and then should it all be saved or thrown away? Given such a relationship, the vacillations in making such a choice become agonizing. A simple feeling speaks about the value, the importance of everything. This feeling is familiar to everyone who has looked through or rearranged his accumulated papers: this is the memory associated with all the events connected to each of these papers. To deprive ourselves of these paper symbols and testimonies is to deprive ourselves somewhat of our memories. In our memory everything becomes equally valuable and significant. All points of our recollections are tied to one another. They form chains and connections in our memory which ultimately comprise the story of our life.

To deprive ourselves of all this means to part with who we were in the past, and in a certain sense, it means to cease to exist.

But on the other hand, simple common sense tells us that, with the exception of important papers, memorable postcards and other letters which are dear to the heart, the rest is of no value and is simply rubbish […] But where does this view come from, cast from the sidelines onto our papers? Why must we agree with this detached view and allow it to determine the suitability or uselessness of these things? Why must we look at our past and not consider it our own, or what is worse, reproach or laugh at it?

Yes, but who can, who has the right to look at my life from the outside, even if that

Garbage Box
1985
Wooden box, household objects
Dimensions variable
The artist's studio, 6/1 Sretensky
Boulevard, Moscow

other is me? Why should common sense be stronger than my memories, stronger than all the moments of my life which are attached to these scraps of paper which now seem funny and useless?

Here, of course, one might object that these memories exist only for me, while for others who don't know my memories, these papers are simply trash. Yes, but why do I have to part with my memories; memories that are contained in such a state of scrap that externally they resemble garbage?

I don't understand this.

Grouped together, bound in folders, these papers comprise the single uninterrupted fabric of an entire life, the way it was in the past and the way it is now. And though inside these folders there appears to be an orderless heap of pulp, for me there is an awful lot in this garbage, almost everywhere. Moreover, strange as it seems, I feel that it is precisely the garbage, that very dirt where important papers and simple scraps are mixed and unsorted, that comprises the genuine and only real fabric of my life, no matter how ridiculous and absurd this may seem from the outside.

Uncle Misha raised his head and, bewildered, looked around the small room. He saw his neighbours swarming in the diverse garbage. He mechanically went up to the shelf where brown folders were tightly packed together, the kind that are usually used for files in book-keeping departments. He pulled out one of these at random and read: 'Garbage Novel', volume XIX. It consisted of carefully bound pieces of paper on which were glued the most diverse nonsense – receipts, envelopes, simple scraps of paper or cardboard, string, etc. Under each scrap there was a number, and above it an asterisk.

Uncle Misha glanced at the back of the book, and saw that the last pages were devoted to commentaries on these scraps of rubbish. So, there was a note corresponding to the tram ticket under No. 8 that read: 'I went to Maria Ignatievna's with things. It was raining and I didn't have a raincoat, I left it at home.' A needle, glued, along with a thread, under No. 48, corresponded to this commentary: 'I found this on 17 February under the table, but I didn't need it any more' …

Uncle Misha began to understand what was happening around him. Now, going up to the large bundles of old boots, tin cans and similar junk hanging on long ropes attached to a nail which was driven deep into the wall, he could already guess what might be written on the white square tied to each of these things.

These were also commentaries: under a pair of old shoes was written, 'I took these from Nikolai last year but I didn't return them, I forgot for some reason … '; under an old

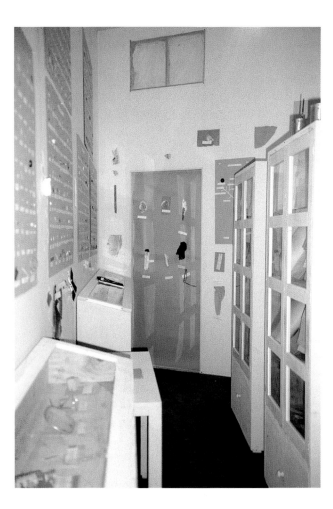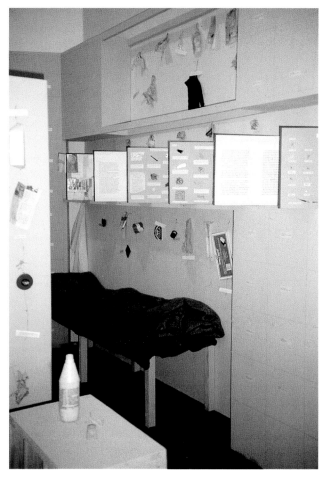

rusty can which contained sprats in tomato sauce was this: 'Volodya and I had lunch last year when he was passing through on his way from Voronezh.' For some reason the chief tenant felt not quite himself. He looked around. There was no one left in the room but him. The tenants of the communal apartment, apparently not considering the affairs of the other tenants to be interesting enough, had wandered back to their own corners. The chief tenant also decided to leave quickly, especially since it was getting dark, and less and less light was penetrating the dusty, though large window of the room. But near the door, struggling through dozens of cardboard boxes filled with innumerable papers, documents, certificates and the like, he found one on which was scribbled: 'Book of Life', volumes XVIII–XXVI. He again stopped near an enormous pile of manuscripts. Having decided to satisfy his curiosity for the last time, Uncle Misha again took out his glasses, leaned over and read the following:

A Dump
'The whole world, everything which surrounds me here, is to me a boundless dump with no ends or borders, an inexhaustible, diverse sea of garbage. In this refuse of an enormous city one can feel the powerful breathing of its entire past. This whole dump is full of twinkling stars, reflections and fragments of culture: either some kind of book, or a sea of magazines with photographs and texts, or things once used by someone … An enormous past rises up behind these crates, vials and sacks; all forms of packaging which were ever needed by man have not lost their shape, they did not become some-thing dead when they were discarded. They cry out about a past life, they preserve it … And this feeling of a unity of all of that past life, and at the same time this feeling of the separateness of its components, gives birth to an image … It's hard to say what kind of image this is … maybe an image of some sort of camp where everything is

The Man Who Never Threw Anything Away, from **Ten Characters**
1985–88
Wood, board, paint construction, 2 rooms, furniture, household objects, labels, texts
Dimensions variable

above, Installation, Kunsthalle Bonn, 1994

opposite, Drawing for installation
Ink on paper
42 × 29.5 cm

following pages, Installation, National Museum of Contemporary Art, Oslo, 1995
Collection, National Museum of Contemporary Art, Oslo

doomed to perish but still struggles to live; maybe it's an image of a certain civilization slowly sinking under the pressure of unknown cataclysms, but in which nevertheless some sort of events are taking place. The feeling of vast, cosmic existence encompasses a person at these dumps; this is by no means a feeling of neglect, of the perishing of life, but just the opposite – a feeling of its return, a full circle, because as long as memory exists that's how long everything connected to life will live.

… But still, why does the dump and its image summon my imagination over and over again, why do I always return to it? Because I feel that man, living in our region, is simply suffocating in his own life among the garbage since there is nowhere to take it, nowhere to sweep it out – we have lost the border between garbage and non-garbage space. Everything is covered up, littered with garbage – our homes, streets, cities. We have no place to discard all this – it remains near us.

I see all of life surrounding me as consisting of only garbage. Since it just moves from place to place, it doesn't disappear. In the entrance to our building, a person goes downstairs with the garbage pail, losing half of its contents along the way, and he himself can't quite understand where and why he was carrying it, and he throws away the pail, having never reached his goal … And this merging of the two spaces – the place from which garbage must be taken, and the place to which it must be taken – this kind of 'unity of oppositions' which they told us about when we were still in school, acts as a real unity. How does a building site differ from a rubbish heap? The building across the street has been under construction for eighteen years already, and it is impossible to tell it apart from the ruins of the other buildings which they took down in order to build this new one. This new one, which for a long time now has been a ruin in which some men occasionally swarm about, may at some point be finished, although they say that the blueprints are very outdated and have been redone many times and it even seems that they have been lost, and the first floor is flooded with water … Looking at it, it is difficult to understand whether it is being built or torn down, and it may be both at the same time…

Of course, one may look at the whole unity from an optimistic point of view. A dump not only devours everything, preserving it forever, but one might say it also continually generates something: this is where some kinds of shoots come from new projects, ideas, a certain enthusiasm arises, hopes for the rebirth of something, though it is well-known that all of this will be covered with new layers of garbage […]

Ten Characters, Institute of Contemporary Arts, London, 1989, n.p.

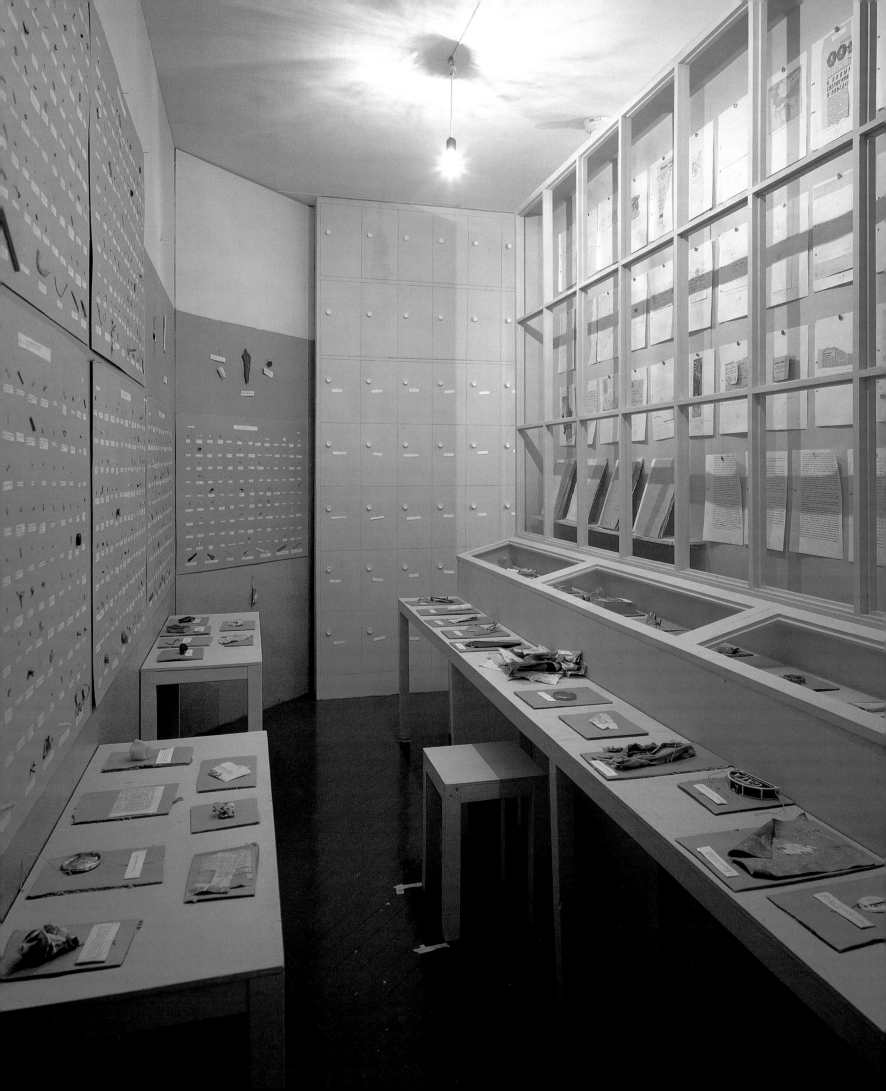

'You can't even describe Malevich: a great artist; an inspirer of awe; a great master', said the headmaster of our school, a stern, formidable man, as the end of the spring term approached: 'Only those who have deserved it will go to the school's Young Pioneer camp for the summer; the others will remain here.'

Everything broke apart inside me. Everything depended on the master: what he could do I could not do; what he knew, I did not know.

We had many masters at school: headmaster Karrenberg, head of studies Sukiasyan, the poet Pushkin, head of military studies Petrov, the artists Repin and Surikov, the composers Bach, Mozart, Tchaikovsky… If you didn't obey them, if you didn't do what they said or recommended, you were told, 'you will remain here'.

Not everyone will be taken into the future.

This chilling sentence signifies a primordial division of all people into three categories, like children:

1. Those who are the takers.

2. Those who are taken.

3. Those who will not be taken.

… I shall not be taken.

… A great, epoch-making picture appears in my imagination: 1913. Europe. A high mountain. Not even a mountain, but a kind of plateau. A small gathering of grim leaders is standing at the very edge of the plateau, where it falls away like a sliced-off piece of cheese. Before them, right at their feet, where the land, going downhill, breaks off, a sea of mist is spread out. How are they to go forward? Frightened, huddled humanity stands at a respectful distance, not daring to interfere with this conference. What will the leaders decide? Silence. A great historical moment.

If, trembling all over, you draw close to this small, elevated meeting, there, among the other great helmsmen, you can see Malevich: calm, self-controlled, fully prepared for the immense responsibility that has fallen upon him.

He recommends that they go on, straight towards the sky. He regards the edge of the precipice at his feet as the end of the past. The entire past history of mankind, all of its affairs, its art, has ended right here and now. The end of the old country is in sight; ahead is the new land, the breath of the cosmos, a new state of being.

He is totally gripped by this new spirit, of which he himself is the embodiment. At this great moment the horizon is opened up for him in both directions. The future is clear and so, therefore, is the past. He has completely mastered the old existence and knows it; he has squeezed it in his fist. There it lies, fallen, quiet, wrinkled, a small

El Lissitzky
Von zwei Quadraten (Story of Two Squares)
1920
Skythen Verlag, Berlin, 1922

Heads
1968
Coloured pencil on paper
19 × 28 cm each

square on his broad palm. There will be no repeat. Ahead is only the 'Other'.

A small group of people will accompany him into this new, precipitous world. They will live in the future, closely united around their teacher, given wings by his spirit, his ideas. How to join this select company? How to buy a ticket for the departing train?

There is a system of tests for this, to determine your preparedness for spiritual flight. For those left behind, a square is simply a square and five coloured rectangles are five rectangles. For those who have grasped, and entered into, the new spirit, these squares and rectangles are signs of a new spiritual domain; they are like gates beyond which lies the new land; they are like koan [the paradoxical puzzles of Zen Buddhism], whose solution leads to a new, unprecedented plane.

Those in touch with this new life will work to transform the old world into the new, re-conceiving their clothing, their furniture and everyday objects under the sign of Suprematism, imbuing everything with energy, so that nothing on this earth or in the surrounding cosmos shall remain without the vivifying force of supreme consciousness.

But what would happen to the 'unpromising' citizens who were left behind? One more recollection from my schooldays. I lived in a dormitory at school. When the headmaster said, at the assembly I mentioned earlier, that not everybody would go to the Young Pioneer camp, but only the best, one of the pupils asked quietly whether he could stay in the dormitory for the summer.

'No', the headmaster replied. 'The dormitory will be closed all summer for repairs and it will be forbidden to stay there.'

In conclusion: The way ahead is with Malevich alone, but only a few will be taken – the best; those whom the headmaster chooses – *only he knows which ones*. It is also impossible to remain; everything will be shut up and sealed after *les supremes* fly away into the future.

Of Two Squares
Two squares fly to the earth
And they see that it is black and troubled there.
A blow. Everything is scattered.
The blackness is covered with redness, brightness.
It's finished here. Go forward.
– El Lissitzky

A-Z, Paris, 1982, pp. 34-35. Translated by K.G. Hammond, revised 1998.

Artist's Writings

Mental Institution, or Institute of Creative Research 1991

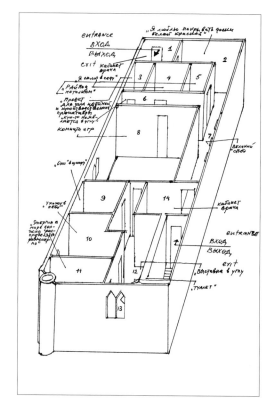

Respected Visitors!

Our clinic, specializing in the treatment of psychiatric illnesses, which from here on will be called the 'Institute of Creative Research', or simply the 'Institute', was opened in 1972 by special permission of the Academy of Medical Sciences and its opening was made possible as a result of the many years of productive work by Doctor Lublin and his assistants […]

1 The full validity and creativity of mental illness

At the basis of any mental illness or trauma lies heightened and continually active creativity (a productive creative ability), which for various reasons (family, social, cultural, etc.) isn't recognized and is rejected by the surrounding environment. This negative, and in some cases, aggressive, reaction is reinforced in the consciousness of 'patients', leading to their negative evaluation of their own talents. On the strength of this self-evaluation there arises a deceleration or even a full halt in personal creativity, resulting in constant stress and other extreme symptoms that are usually understood as mental illnesses. The deepening conflict with the environment on this basis, the appeal to the clinic and the resulting 'patient-doctor' situation, and the 'treatments' by procedures and medications used in these cases result in a change in the direction of the creative process, in the complete deformation of it, and, in the majority of cases, the mental death of the patient.

Given such an understanding of psycho-illnesses, according to Doctor Lublin's method, the doctor-patient relationship is replaced by a relationship between two colleagues who help to reveal this creative process, to give it the maximum positive, affirmative status, and to create the atmosphere of two close people who are working on a common, fascinating task […] In this way, the first fundamental supposition of this new method is the extraction of creativity from its primal, undefined phase, to reveal and give form to the tendency embedded in it, and then to develop it until it produces a result that is clearly recognizable by 'patients' themselves. Doctor Lublin calls such creativity the 'individual project'.

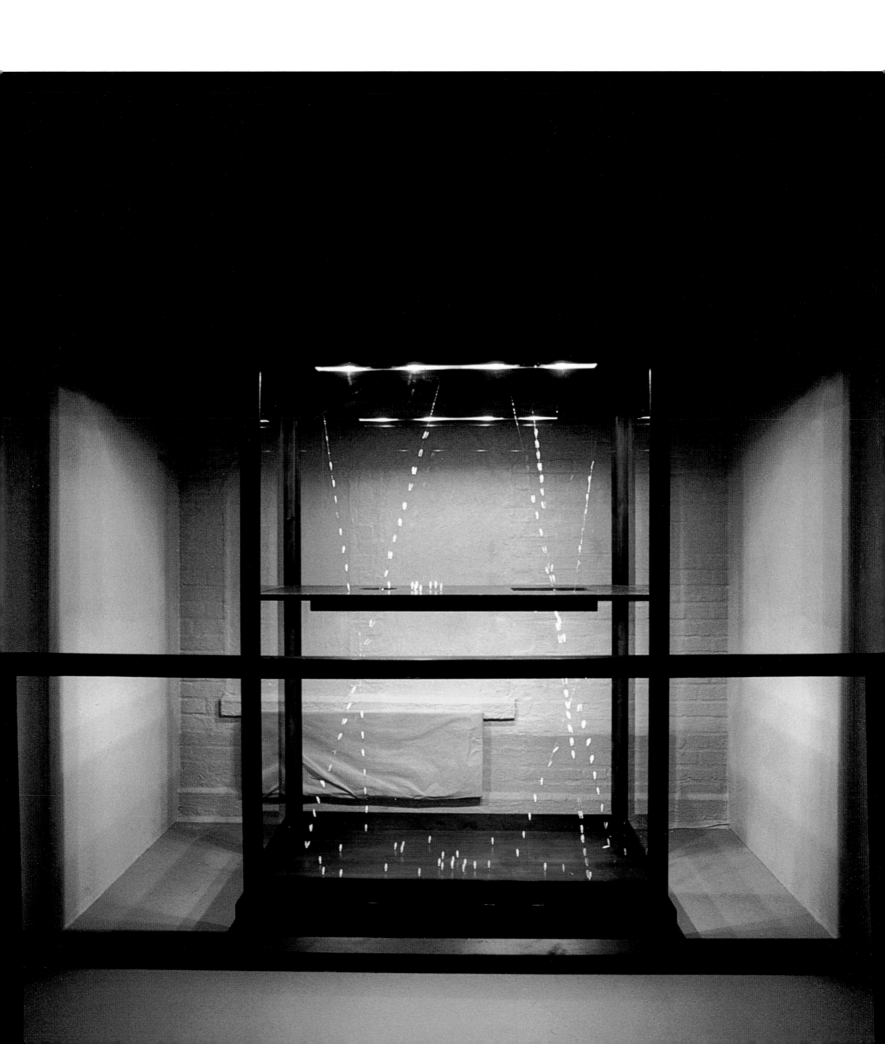

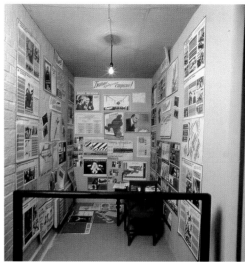

2 Treatment by the disease of the 'patient'

All the necessary conditions are created by the Institute for the realization of such a 'project'. Each of the many rooms of the Institute is a place for the functioning of such a 'project'. The 'patient', who in the Institute is called the 'author', and the doctor, along with assistants who are called 'collaborators', work in these areas – 'laboratories' – and their personnel are provided with the necessary materials (often most unexpected ones), as well as reference books, subscriptions, and other documentation needed to carry out the patient's 'idea' […]

3 The role of the environment and visiting

Of utmost importance in Doctor Lublin's method is close personal contact between the 'patient' and the external world. We are speaking here about close friends and relatives, as well as outside visitors, whose acquaintance with the work of the clinic is not only not forbidden, but rather encouraged as extremely desirable by the Institute's administration in various ways. Most importantly, the style and nature of visits to the 'author' must be noted. The traditional attitude toward the 'patient' as someone who has suffered a misfortune is categorically forbidden (during a preliminary meeting with the relatives); the entire atmosphere of tragedy, concern and sympathy is renounced and reversed. Those who are close to the 'authors' come to visit their relatives as though they were visiting those who contentedly and joyfully realize their dreams, and they visit the hospital as a place where those dreams are turned into reality. Thus, the happy, unconstrained atmosphere of these visits resembles visits to the offices of architects, art exhibitions, or musical concerts, where 'authors', surrounded by their assistants, display their 'child'.

Project: Paradise

Author of the project: Malyshev, Aleksandr Lvovich, 1932
Entered the Institute: 17 December 1981
Cheery personality, sociable, likes to play the mandolin, sings beautifully. Likes to cook and serve food to others. (Work begun on the project January 1982)

Malyshev's Story

Since childhood I have been tormented by one agonizing question, the answer to which I can't find at all: if everything here in the world around me is so bad, which I have seen myself and which people close to me have always claimed with shouts and heated emotions, then why is that other world, where none of this grief exists, none of this pain and failure, where everyone lives together peacefully and happily, so far away? It is

described in all the books and everyone says the same thing: that it doesn't exist and never will in this world; what you are asking about exists in another world, which is revealed only after death, and then only to a few. But I could never believe this – I was certain that this world was right here, close by, next to us – but for some reason we couldn't see or touch it. Maybe you just needed to make a special effort …

Unexpectedly one night I suddenly felt the presence of this world next to me; it was in my peripheral vision, but as soon as I tried to see it straight ahead, it would once again move to the side … Then I almost saw it; it would only take one more effort … Finally everything turned out to be so simple that I gasped when it happened: I simply had to raise my eyes and then I could see where it was located: *under the ceiling*! Lord, it had always been right there; why hadn't I figured out that I only had to raise my eyes?! All I had to do was to stand on a ladder and as soon as I got out of bed I was there, in that wonderful world of joy and goodness! Soon after that I placed a lamp there so that it would be brighter and so that the kind, hairy animals didn't freeze. For some reason this didn't please my wife, even though I took her there with me and I bought her a comfortable and sturdy ladder … Fortunately, I soon met my new friends who help me with everything and with whom I can meet and talk in our paradise.

Mental Institution, or Institute of Creative Research, text in the installation, Rooseum Centre for Contemporary Art, Malmö, Sweden, 1991.

The Life of Flies (extract) 1992

Flies and Economics

A group of scientists from Yale University involved in the programme 'The Study of the Z-Factor' conducted multi-faceted research during the summer seasons of 1986–90 based on observations of the behaviour of fly concentrations in the area of the Cleveland coast (North Dakota). The research was prompted by the active conglomeration of insects during the summer season on certain days and the complete disappearance of them on the next for no apparent reason. As a result of the observations, which were conducted during May to October 1986, it was possible to establish a schedule of the activity of the flies during that period.

There were no reasons for such fluctuations evident in either the climatic conditions or in any other immediate environmental factors. Similar changes also occurred during the 1987–88 season. A different set of observations, in part facilitating the revelation of the causes for such developments, showed the changes in the economic conditions of that same region beginning in the spring of 1987. Here are comparative graphs charting the changes in the behaviour of fly-groups and the economic recessions and booms in this same region. The diagrams are presented with a shift for one year.

As can be seen from a comparison of the graphs of changes in the economy and in the behaviour of the flies, they coincide to a striking degree. However, since the processes taking place in the world of flies occur a year earlier than in the economy of the region, the scientists have come to what they consider to be irrefutable conclusions about the possible influence of flies on the economic conditions of that region. Analyses of both graphs from 1986 to 1990 lead to similar conclusions. Research, begun in other regions of the country, has entirely confirmed this conclusion. If other scientists reach similar conclusions in the next few years […] then we can establish as fact the theory of global and well-organized control over the world economic system by a similar and also well-organized system of fly groups.

Flies and Fine Art

The subject of flies and fine art, a topic that in itself has numerous aspects, is particularly interesting from two points of view: in the first place, the fly and its role as the centre of any work of art, be it a painting, sculpture or the interior of some dwelling; and secondly, the fly and the pliant work, taken as a pure construct, as the interrelationship between the lines of force.

opposite, **A Concert for a Fly**
1992
Drawing
Ink on paper
29.5 × 29.5 cm

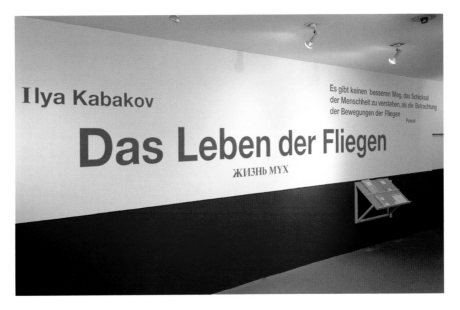

From **The Life of Flies**
1992
Wood, board, paint construction,
4 rooms, ink and coloured pencil
drawings on paper, plastic flies,
models, wood and glass display
cases, chairs, music stands
Dimensions variable
Installation, Kölnischer
Kunstverein, Cologne

left, Entrance of installation

overleaf, top, **Hall I**
1 Flies and Economics
2 Flies and Finance
3 Flies and Politics
4 Flies and Fine Art

overleaf, bottom, **Hall II**
Civilization of Flies

following page, top, **Hall III**
2 Flies and 'Tabular Poetry'

following page, bottom, **Hall III**
1 Concert for a Fly

opposite, **Untitled**
1992
Drawing
Ink, coloured pencil on paper
42 × 29.5 cm

The Fly as the Pliant Centre of a Work

[…] Scientists of the Middle Ages continually turned their attention to the fact that the fly knows neither top nor bottom, can sit freely on the ceiling as well as on the walls, and as a result turns out to be surrounded by a total spherical cosmos, where it represents both the centre and a point on the circumference. This 'centricity' of the fly, which is immanently programmed into it, forced many thinkers […] to consider this insect as a particular physical (for this world) incarnation of the idea of a centre, and because of its small size, this centre was thought of as an ideal point in a mathematical sense as well. And, as is well-known, this characteristic, this 'centricity' of the fly, could not help but attract the attention of artists. Many painters of the Renaissance – Holbein, Masaccio, Tintoretto, Bosch – continually include a fly in the subject of their paintings, forcing not only the people depicted in the painting to look intensely at it, but also the viewer standing in front of the painting. (In the paintings of Holbein and Bosch, flies are often depicted under magnifying glasses.) In paintings of a later period, the fly begins to occupy a more significant place, often being positioned in the very centre of the painting (Polke, Salomé, the author of this text). Two things can be observed as a result of such a positioning: in the first place, the flight of the fly into the depth of the painting as if into infinite space; and in the second place, the movement of the fly along the very surface of the canvas and its stopping in the very middle. The interaction of the first and the second notions, the turning of the fly body into a point and back again, almost literally illustrates the 'centricity' (discussed above) of the position of the fly in the world that surrounds it.

A Concert for a Fly

Many think that the buzzing of a fly is monotonous and tiresome, almost unbearable to the human ear. And the idea that between the monotonous humming of a fly and Bach's Fugue in B Major there may be direct blood-relations, of course, could not occur to anyone without at first appearing to be utter blasphemy. But no matter how we wish not to, eventually we must accept this conclusion.

At the University of Massachusetts, an interesting experiment was conducted by Professor Adamson and his group. The sound of the buzzing of a fly was passed through a laser-separating computer and then recorded on a special cassette. The result turned out to be unexpected. That which we consider to be monotonous humming, when prepared in this way, turned out to be a combination of twelve to sixteen voices of various timbres, together forming a complex polyphonic sound. In this multi-

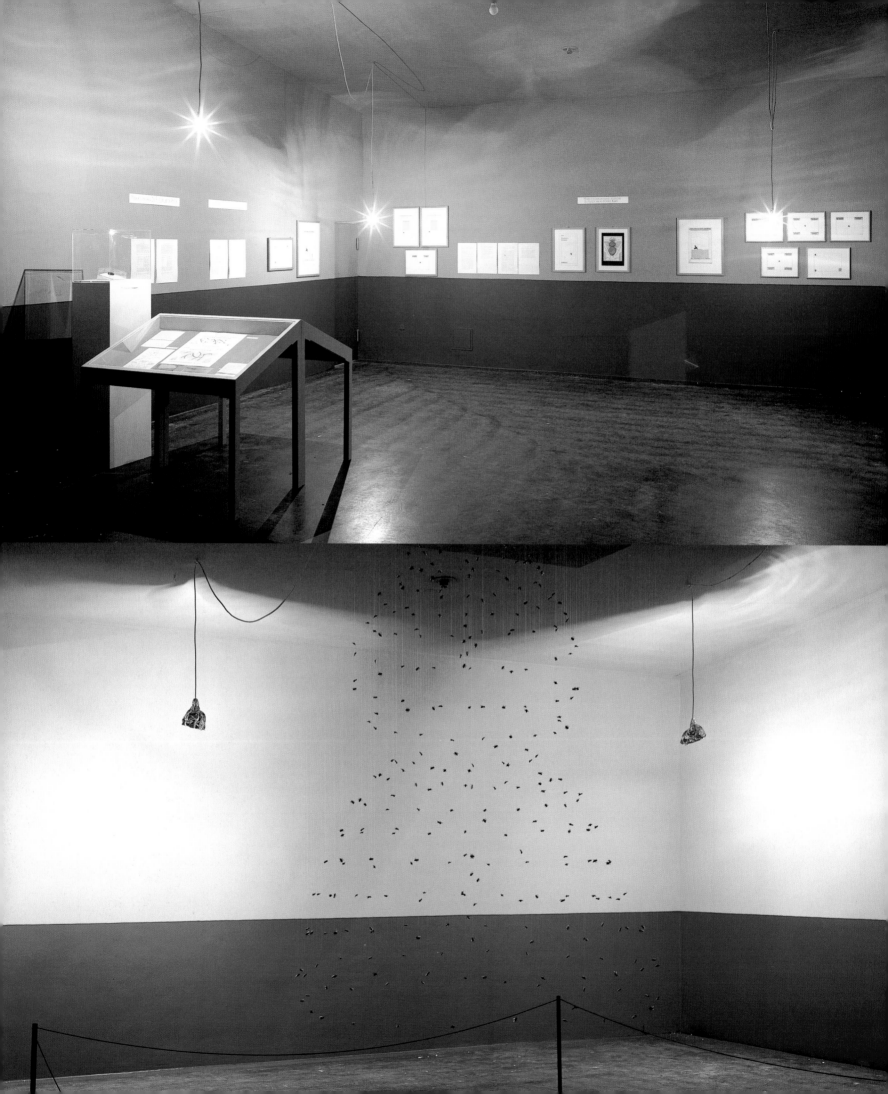

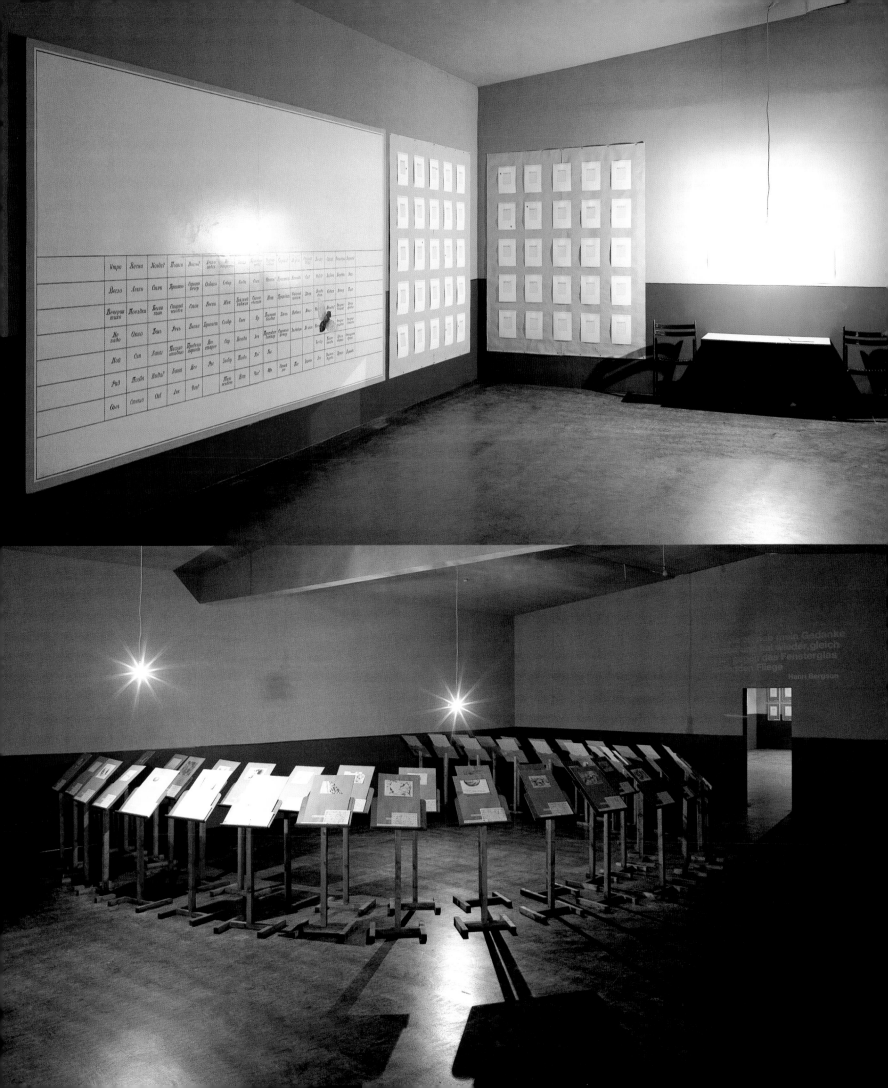

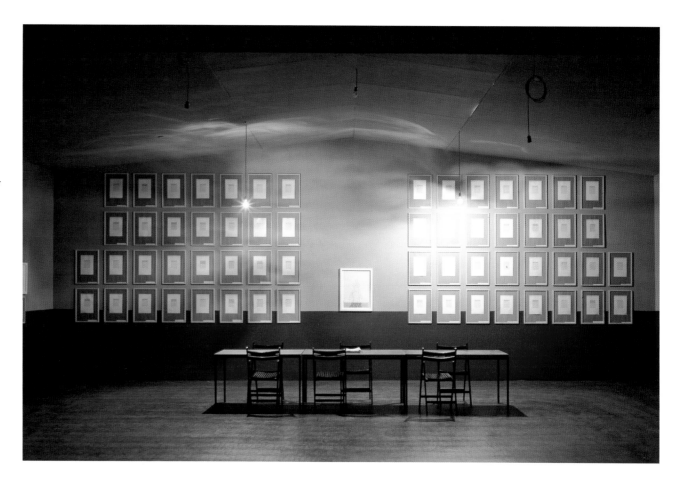

voicedness, a person with sufficient musical training can, without difficulty, hear
Georgian folk singing wherein six to eight to twelve voices are combined in polyphony.
Most interesting is that the underwings serve as the instrument for generating sound in
a fly, and it is the position of these that determine the pitch and diversity of the timbre
of the fly 'voices'. It is interesting that specialists who were given the recorded cassette
to listen to succumbed to the provocation quite easily. Some considered one of these
'plays' to be a variation of a Svansky folk chorale *Garruttsy-navy*, and another of them
took it for an unknown chorale prelude that without a doubt belonged to Bach.

It is still too premature to draw conclusions from such a discovery. But one thing is
becoming clear – and it is still difficult to believe this – that the musical influence of the
world of these little insects became linked long ago to the complex musical compositions
of human culture, no matter how unpleasant it may be for us to learn this. What is
more, this is so of its highest and most difficult to reproduce forms, and although this
appears to be virtually unbelievable today, in the future it may be possible to project
these forms (which human science is still incapable of identifying) through special
transmitters […]

Description of the Installation
The installation *Life of Flies* is to be exhibited in the Cologne Kunstverein in January
1992. The long space of the Kunstverein is divided into four halls, which follow each
other like a suite.

Hall I
This hall is thematically divided into sections: 1) Flies and the Economy; 2) Flies and
Finance; 3) Flies and Politics; 4) Flies and Fine Art.

The first three sections are located on two slanted tables; the fourth is near the

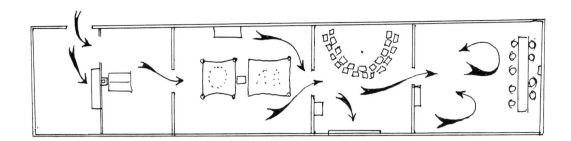

above, **The Life of Flies**
1992
Plan of installation
Ink on paper
7 × 29 cm

paintings and drawings that are hung along the walls.

In the entrance there is a pillar on which is affixed a small podium bearing a fly covered by a glass case.

Hall II

The theme of this hall is 'The Civilization of Flies'. In the middle of the hall on the other side of a barrier, the viewer sees two structures hanging in the air, made from five hundred flies, arranged in a special way. Along the walls are two stands with explanations and sketches and a glass showcase with exhibits.

Hall III

This hall is devoted to two themes: 'A Concert for a Fly' and 'Flies and Tabular Poetry'. On the long wall to the right of the entrance hangs a large painting (2.6 × 4 metres) accompanied by forty drawings/commentaries.

In the corner of the opposite wall there is something like a concert going on. This arrangement is called 'A Concert for a Fly'. Closer to the corner is a fly hanging in the air (cut out of paper and coloured) and around it is arranged an amphitheatre and music stands with sheets of music, text and drawings. The fly, as often happens in chamber orchestras, is performing the role of both the conductor leading the musicians and of a soloist playing along with them.

Hall IV

This final Hall is devoted to the theme 'Flies as a Subject and Basis for Philosophical Discourse'.

The entire installation consists of one large drawing, *Fly* (55 × 45 cm) and 132 pages of framed typed text. The installation was intended especially for the White Hall of the Pushkin Museum in Moscow, and therefore that exhibition will be described. The layout of the White Hall is similar to that of an ancient church and in the wall opposite the entrance is a semi-circular indentation resembling a distinctive altar where a sculpture or important work might be located. It is here that *Fly* hangs in a thick, dark-brown frame. On either side are sixty commentaries – viewers' observations on the drawing. The side walls of the hall are also filled with texts (each page in a separate *passe-partout* and under glass). Since all the texts are grouped into articles, there are larger intervals between each 'group-article' than between the individual pages. At the right of the entrance hangs a poster of the exhibit, and on the left, a diagram.

Where Are They?
1979
Enamel on masonite
40.5 × 27 cm each

right, Where Is the Big Plate?
Where Is the Tea-kettle with a bell?
Where Is the Portrait of Rosalia?
Where Is the Precise Clock?
– Petrovich Took Them All with Him

centre right, Where Is Marina
Zakovojt?
Where Is Mikhail Ignatievich?
– They Are Not Here

far right, Where Is Victor
Shapovalov?
Where Is Nadja Pjamgina?
Where Is Inna Borisova?
Where Is Alesha Masinevich?
Where Is Alla Brazun?
Where Is Volodja Govorov?
Where Is Vladimir Isaevich?
Where Is Promorenko-Leh?
– They Are Long Gone …

A few words about the general atmosphere that reigns in the installation: the space represents a series of halls in a boring, not heavily visited, badly lit, Soviet provincial museum. There are no windows, all of the exhibits and texts are intentionally illuminated with dull, yellow electric light-bulbs. The ceiling and lower part of the walls, usually painted dark-brown in official offices, are grey. Everything together creates an atmosphere of hopeless boredom, a boredom about which it is said that 'even flies die from it'.

Similar exhibitions were arranged in our country under the banner 'New Advances in Soviet Science and Technology'. The slogans and epigraphs in large letters in the anteroom as well as in the centre of each hall refer particularly to this pathos, as if concisely summarizing the idea behind these exhibitions.

Visitors' Commentaries
… Seems to me there's no fly there at all, just the contour stretched in transparent crêpe, easily penetrated by light coming from behind; and this film must be flat like a membrane because of the voluminousness of the light itself coming from behind …
[…] The fly, without any doubt, is an image of banality. Here, at the same time, it has pretensions to the artistic as it were, to being an exhibit. I understand that that must be banal. But with a slight difference, not all of it, just a small part, or else it becomes an irritating slogan, like here …
… Why is there a note there? It's obvious that it's a fly …
… I could draw that myself. If he had enlarged it so that it covered the whole wall then you could see a 'Czar Fly' and the irony would be comprehensible …
… Little fly, little fly, yellow, yellow, yellow belly, diddle dee di, diddle dee di …
… Victor Stepanovich, the simple idiocy of the description is interesting, obviously playing with our tendency to allegorize, to see a subtext and a context in everything. The artist, as it were, by his inscription emphasizes that here is just a fly …
… Well now you see what they have in exhibitions these days, and you go around telling me to draw, draw, draw from life …
… Seems to me, looking at this white, that there's a flow of delicate, blessed energy coming in to me, a light, and the representation is as though it were wrapped up in it, swimming in it …
[…] He started to put his foot down, the road was bad, slippy, we scraped the whole

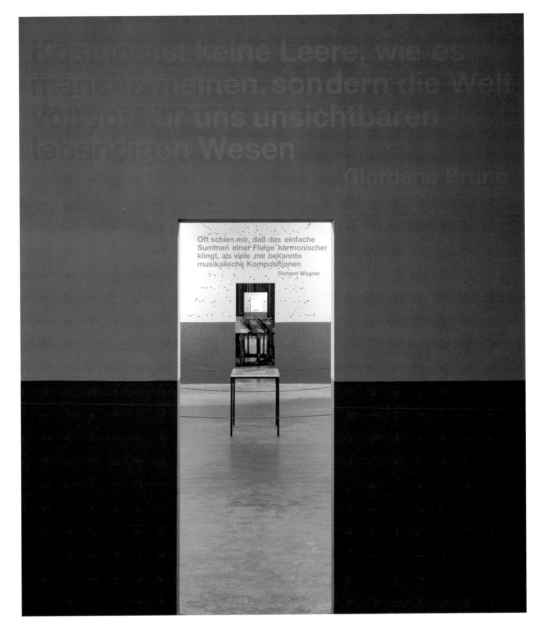

From **The Life of Flies**
1992
Wood, board, paint construction,
4 rooms, ink and coloured pencil
drawings on paper, plastic flies,
models, wood and glass display
cases, chairs, music stands
Dimensions variable
Installation, Kölnischer
Kunstverein, Cologne

View of installation from entrance

door and the wing …

… I think that this is a stage in a variety show and the fly is dancing like a ballerina …

… Look, your stocking's got a ladder in it …

… It's like listening to a joke told badly, everyone feels completely awkward, everyone who sees this …

… In the summer we will go to the country cottage and we'll make a herbarium with lots of plants and insects …

… This tendency in art is called 'sub-art'. It comes to this country ten or fifteen years after it's been 'over there' …

… All these trendy exhibitions will soon disappear and nobody will be able to remember anything about them …

… I think I know where the solution to the riddle is. Do you see how the fly isn't flying but rather standing; and not in any fly-like way, but on two legs like a human being …

[…] Such rubbish, when you look at it you feel boredom and torpor in equal amounts, they are the most powerful of everyday emotions …

Das Leben der Fliegen/Life of Flies, Edition Cantz, Stuttgart, 1992, pp. 215-16, 218-19, 220, 225-26, 256-57.

Translated by Keith Hammond.

The Communal Kitchen 1992

I'm going to start ironing now …

She put that tank there and it's dripping into the food, but don't dare say anything …

Olga Isaakovna, you know that Kostya and Marina got married …

I started to whisper, but my voice went hoarse and he didn't understand anything …

When summer comes, we'll open the windows and then we'll wash everything …

Wash your feet and change your socks, I'll come in a minute and get you a shirt, tell your father to get the string-bag …

Hey, don't play in the corridor, do you hear me? You should go out and play, why are you sitting in this stuffiness, look how beautiful the weather is! …

Oh it's nothing, nothing, it will heal, why are you crying so, boys don't act like this …

Well, what's wrong with you, how many times do I have to call you, are you deaf or what? Here eat a tomato …

They forbid it there because of the milk store and it attracts flies, you can't …

That's why it's full, because everyone uses ours …

I saw yesterday how they were carrying full buckets after the repairs – boards, gravel – and they put all of it in ours, in our bin – boom! How could it not be full … ?

Ah, that one, from the fourth room, I look and she's pouring everything next to it, not

into the bin, not into the bucket – right on the ground – I cursed her out and she turned around and went on her way …

That's why there's such a stench in here, you can't open the door or the window …

Just take a look at the stairs, it's all littered up … what kind of pigs are they, who dumped these newspapers and rinds here? You can't even get by …

And the Korov kids, did you see them, they've taken to playing in this heap … I told their grandma three times already, they run around there all day …

In Building 4 they built a partition around the bin with a lock and key, and outsiders don't go there anymore … that's what we need to do …

Put it down, put it down, I'm cleaning up now …

Oh no, Anna Yakovlevna, I just don't understand how people have the mind and conscience to …

No, as soon as I see someone throwing it next to the bin, I'll go right to their apartment, I won't be shy, and I'll cause them such a …

And we also should have posted an announcement with a fine …

What are you saying, Maria Ignatievna, we have already written more than once to the newspaper and everywhere, but what's the point? … You can't guard it, you can't stand there with a stick …

And all the ruffians it attracts … yesterday all day some guy was digging and digging through it all, what was he looking for?

No, our building throws out its trash very neatly …

She wants to establish order, yet look at her own table, there are three unwashed frying pans, she should get her own things in order first …

The Communal Kitchen, text in the installation, 1992.

Cézanne 1995

The name Cézanne returns us to the mists of that distant era when the word 'artist' signified someone who painted, drew or sculpted from nature, and who endeavoured to represent nature with exactitude. In an even more distant period, the schools of painting taught methods of transferring this nature onto the canvas according to processes and rules similar to the laws that govern harmony and counterpoint in music. In order to achieve this transfer of nature onto canvas, the painter had to learn to train his eye, as we say to train a voice, correctly. This training of the eye enabled the artist to see the subject even before setting the first brushstroke on the canvas. The skill was to see the subject not on the surface of the canvas, but in its depth. In the place of the canvas, the artist saw a window and through it, the subject. Once the painter had a trained eye, he or she was able to translate this perception onto the canvas. Learning this skill until it came automatically was the first lesson taught in the schools, just as the beginner pianist is taught to train the hand in order to master the subsequent stages of piano playing. Those who mastered these processes were called professionals; the others, amateurs.

The Cézanne phenomenon inverted this seemingly intangible law. Cézanne did not want to explore the reality beyond the canvas: he kept his eye on the flat, rectangular surface of the canvas and fixed nature onto it. How did he succeed in transferring three-dimensional stereoscopic nature onto a two-dimensional canvas? He invented a method that no-one had considered before. Cézanne forced his eye to see nature as a two-dimensional object. Losing its spatial qualities in this way, nature also lost its reality and was transformed into a rich patchwork of colour and tone.

But here, unexpected difficulties arose. The harmony and relationship of the areas of colour, line and tone on the canvas had to represent as faithfully as possible the corresponding harmonies of colour, line and tone that the eye perceives in nature. The canvas became the site of an exhausting labour, a painstakingly monotonous process, like carrying heavy sacks from one place to another, breaking your back in the constant effort of co-ordinating and re-adjusting each sack in relation to the ones around it.

However, rather than resulting in a bizarre Sysiphian task, something miraculous occurred: the world, which had seemed unmoveable, suddenly spun on its axis. In the same shift, the correctly trained academic eye, which until then had also appeared unchangeable, vanished as well. Of course, a new method for transferring nature onto the canvas was now required. The un-academic painter searched for, and eventually discovered, a new kind of system, similar to the example of solitary persons who slowly and methodically build themselves a unique dwelling or edifice in which they seem to

Paul Cézanne
Viaduct
1885–87
Oil on canvas
92 × 73 cm

The Path
1982
Enamel on masonite
260 × 180 cm

Oh, don't run, my child!
Let your face lose the colour of the
rose,
But still your spirit, your entire
being
Will seize such a full life!
While the whole world sleeps
around you;
It will then wake up suddenly, and
begin to speak;
Your soul will merge in bliss with
it;
Then you will find a friend in it;
He will laugh if you are crying,
And the stars of the evening will
show you
Your secret meaning, you will
suddenly understand,
What the leaves and flowers
whisper at night;
And divine tears will wet your
eyes;
You will hear – the world will
whisper to you: 'I love you.'
And this sound will pierce your
breast,
And your breast, your lips and your
eyes will say:
'And I love you … '
– 1846, A. N. Maikov

I was late – and how I regret it.
The sun had already hidden in the
night,
I didn't see when into the alley
It tossed us some rays.

But the passing day did not whirl
away
All the power of the summer
radiance,
The shadow of night did not
extinguish
Its gratifying farewell.

Yet before the smokey fog
I stand enchanted,
Still in the fragrant dawn
I recognize the breathing of the
sky.
1882, A. A. Fet

… Oh forest! oh, life!
Oh, sunlight!
1871, A. K. Tolstoy

have found a universal system of representation. Two concepts emerged, two symbols of a new artistic religion: 'Cézannism' and pure painting, which became synonymous.

Our generation in the Soviet Union also experienced the influence of this religion, but in an exhausted, weakened form, partially because of our cultural politics. Turning the wheel of history backwards, official Soviet culture declared war on 'Cézannist' formalism, and tried to return to the style of Courbet and the Barbizon school. The Russian 'Cézannists' – Falk, Chevtchenko, Osmerkine and others – ended their lives lonely and forgotten. A widespread refusal to paint from nature brought on a totally new artistic period. With this new era, the wars between draftsmen and painters disappeared into the mists of history. Even the word 'painter' disappeared, although it had once conceptually defined art. 'Cézannism' has also disappeared, not only in Russia but equally in Eastern Europe, where before the Second World War everyone was a 'Cézannist', i.e., a painter, with an inherent passion for 'professional' problems, for spending all day in pursuit of exactly the right colour. All this evaporated and dissolved like smoke, whilst the art of the founder, Cézanne himself, has endured […]

Libération, Paris, 30 September 1995, p.4. Translated by Elizabeth Manchester.

In conversation with Robert Storr (extract) 1995

[...] **Minimalism and Installation Art**

Robert Storr The person who created the opportunity for your most recent project was Donald Judd, who was associated with a kind of abstraction that is very foreign to your own work. Can you describe how that project came about, and how Judd understood what you were doing?

Ilya Kabakov **I should begin by describing a paradox. A person from the West who is burned by society and can't escape from it dreams about having even a tiny corner of his own existence. It's the same for a person living in a Russian communal apartment. He's charred, burned from all sides in this social, communal body, and he dreams about being alone in his own small corner with his own constructs of a personal utopia. He dreams not only of a social project where we will all be happy, but he also dreams of having his own individual project where he will build something for himself.**

 It seems to me that a person like Donald Judd, who has continually lived alone, who has built his own individual project just as he wanted it to be, eventually discovers that he cannot fully realize his project without close friends and neighbours. He wants the people who understand him to be there, to be his co-workers. In essence it is the old problem of creating a utopia, a place in which people can be close to one another but with everyone remaining an individual. The question is, what path can we follow to get there? I would say that Judd, with his personal 'country of art' in Marfa, was a lot closer to this utopia than the dwellers in the Soviet communal apartment.

Storr How did Judd find you?

Kabakov **We met in 1991, at the time of the Judd exhibition in Vienna at the Museum of Applied Art [Museum für angewandte Kunst]. Earlier I think we saw each other at the Cologne Kunstverein during my exhibition 'The Life of Flies'. I was elated that he had seen some of my installations, because for me Donald Judd was a kind of legend, a consummate, great American artist like Barnett Newman. And of course I was astounded by his invitation to come to Marfa and make a work.**

 When I first went to Marfa, my biggest impression was the unbelievable combination of estrangement, similar to a holy place, and at the same time of attention to the life of the works there. For me it was like some sort of Tibetan monastery; there were not material things at all, none of the hub-bub of our everyday lives. It was a

School No. 6
1993
Constructed and found school
objects
Dimensions variable
Installed, disused barracks
building, Chinati Foundation,
Marfa, Texas

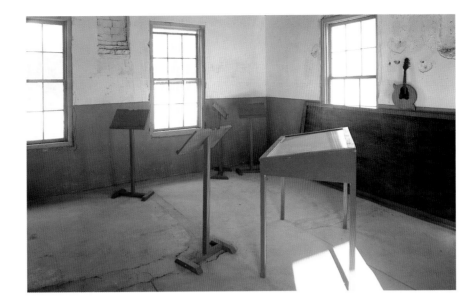

Donald Judd
Permanent installation of works,
Chinati Foundation, Marfa, Texas

world devoid of all trivial and banal existence – a world for art.

Storr What did you do? Were you trying to bring some of the banality of life to this place by re-creating the atmosphere of a Soviet schoolroom?

Kabakov **Yes, but it is a banality that is already dried out. Of course there was nothing more awful than the Soviet school, with all of its discipline, abomination and militarization. But now that that system has collapsed and left behind only ruins, it evokes the same kind of nostalgic feelings as a ruined temple.**

Storr In that regard I want to ask you about the general theory of installation. When Minimalism was first attacked in this country by critics like Michael Fried, they said that unlike the great, self-contained art of the past, which was unaltered by the presence or absence of spectators, Minimalism required the participation of the viewer in a space that was theatrical. The interesting point is that recent attacks on installation art repeat exactly the same argument. I'm struck by the fact that Judd, who represents the great Minimalist tradition, found common ground with you. The two of you represent very different things aesthetically, but what you share is a notion of the necessary circumstance of participation.

Kabakov **You could say it this way: Minimalism is therapeutic and at the same time educational. That is, a person is supposed to move from a state of chaos to inner equilibrium and focused attention. He should be more inside himself.**

Storr Would you say that the challenge of installation is to present a chaotic situation, but one that moves the viewer's imagination to some kind of concentrated understanding?

Kabakov **There are many kinds of installations. At Marfa there is an enormous installation of Donald's work, and when you visit it you feel unbelievably liberated from all that is chaotic; you have an enormous sense of an almost cosmic order. My installations are oriented towards the viewer as well, but a viewer who is standing before a broken vase and thinking, 'This vase existed, and now it is no more. Why did it break? Was it a good vase?' There is uncertainty, and a melancholic question to which there is no answer. I imagine the viewer as a child who is facing an ocean of questions and doesn't know how they are connected to each other or where to find the answers.**

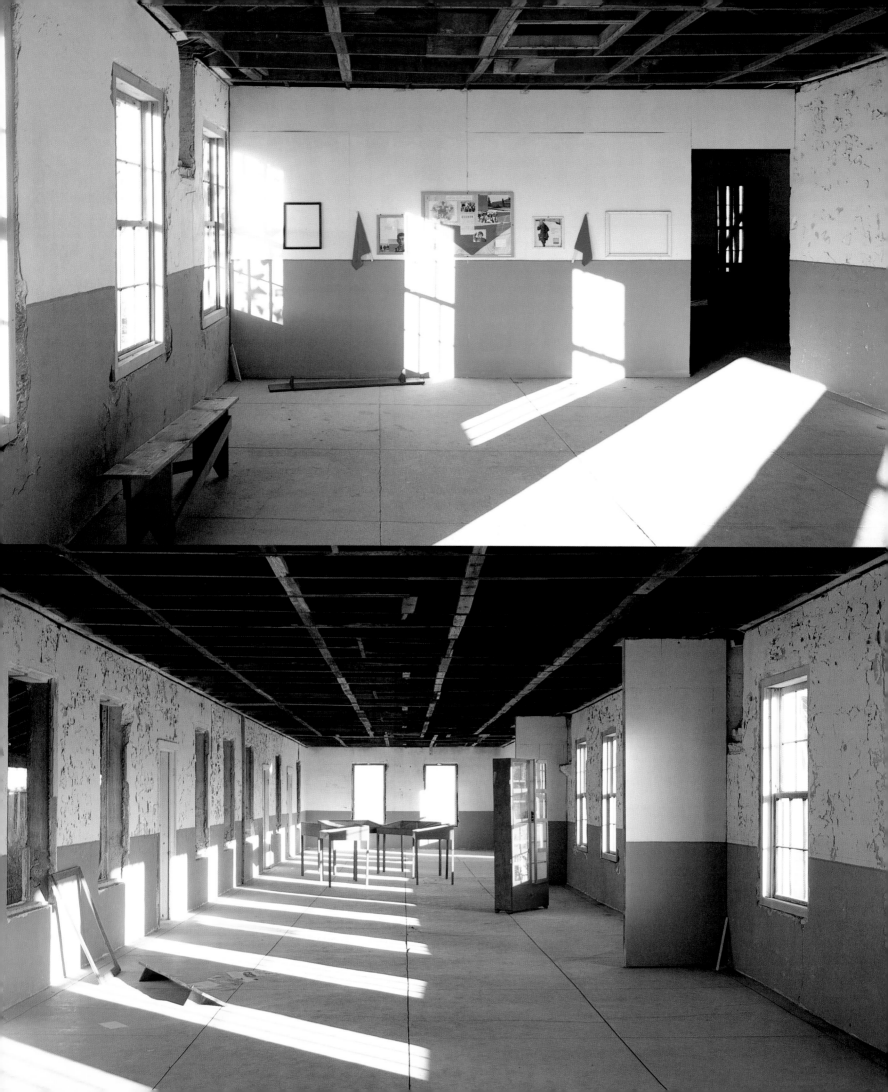

School No. 6
1993
Constructed and found school
objects
Dimensions variable
Installed, disused barracks
building, Chinati Foundation,
Marfa, Texas

right, Installation detail

Storr There are people who happily spend hours with allegorical or Surrealist paintings, figuring out the relation of the parts within the picture, but the same people are often disinclined to think about a three-dimensional installation in the same way. Is there something in the nature of the experience that is so different?

Kabakov **I think that today everyone familiar with art knows how to look at a painting. Even if a nail is hammered into it or a stool is hanging before it, everyone knows that it is a painting and there exists a means for looking at it, one developed historically and gained individually by education and a lot of experience. Painting is like a senile grandmother living in a family. She has been crazy for a long time, she urinates and defecates, but everyone in her own family knows how to treat her, how to talk to her. No one is surprised at what she does.**

Allan Kaprow
Yard
1961
Rubber tyres
Dimensions variable
Installation, New York

Claes Oldenburg
The Store
1961
Cardboard, burlap, newspaper
papier-maché, paint
Installation, 107 East 2nd Street,
New York

It is a completely different situation with installation art, which is like a little girl who has just been born; she is still an infant, and no one knows what she will grow into. Moreover, she has been born into a family in which the grandmother is still living, and everyone says, 'We know everything about your grandmother, but where did you come from, what new things can you tell us? And if you behave badly we'll just throw you out because we don't know if you'll even survive'. In the same way, people just don't know what installation art is; they don't realize that this little girl has moved in with us forever.

I know from experience that virtually no one knows how to see the installation as a work of art. The spatial elements pose the same problems as in painting. But these problems have long been studied in painting: a canvas smeared with yellow paint is immediately seen as the face of a person. But when viewers see a special combination of light and space, they think that it is either an architectural feature or a poorly painted room.

The task is complicated further by the fact that the origins of the Western and Eastern European installations are different. As far as I can judge, the roots of Western installation lie in Happenings and Actions; the installation is actually the remains of events frozen in time, like the installations of Beuys, Kounellis and Merz. The origins of the East European installations lie in painting. Here the viewer falls into the painting, makes the passage to the other side of the glass, enters into the painting. The Western installation is oriented towards space, towards the atmosphere of a particular situation.

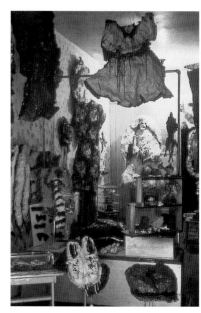

Storr When I organized 'Dislocations' at The Museum of Modern Art in 1991, some people said that there should have been explanatory placards at the entrance to each installation so that people would know how to look at them. My assumption was that the whole point of encountering installation work is to enter a space where you don't know where you are and you have to learn how to put it together imaginatively. That's something that once had to be done with modern painting. But now the surprise of modern painting has been made official, whereas the surprise of installation art has not. In a way, learning how to look at installations might teach people what they have forgotten to see in paintings.

Kabakov **You are touching upon the most important dilemma facing any viewer of a work of art: whether to gain concrete knowledge and then leave, or to immerse yourself in what is offered. To receive information and then depart is the first temptation, and what aids in this departure are the explanations and inscriptions that**

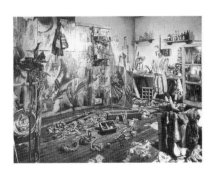

accompany the work. The important thing is that when we read, we are probably doing it so that we don't have to look anymore. As pertains to the tendency to immerse oneself, for this there cannot be explanatory texts. For this it is crucial that you are alone and that you are near the work of art in solitude.

Works of art, I think, consist of a series of traps, or concealments, through which the viewer has to pass. There is a naive notion that past art was easy to understand but today's art is too closed and yields poorly to discovery. Old paintings, however, are just as closed as today's; it's just that they have been discovered many times and a method now exists for revealing them. But there are still a lot of good closed things. I stood before *Las Meniñas* recently, and it was like standing in front of many closed doors.

Storr Then installation may save painting rather than kill it off.

Kabakov **Absolutely. In installations people actually stand and look at the paintings contained within them.**

Storr So you make these rooms that are filled with the evidence of people, in order that one person can be there alone, can discover a kind of isolation in that room full of the presence of others.

Kabakov **Yes. It may sound bombastic, but this is what happens in a temple. We are all together, and each of us feels good because of the presence of the thing in whose name we are standing here.**

Storr The irony of the situation today is that people read newspapers, watch television and read books at home, and they go to museums to be alone. Their public thinking is done in private and their private thinking is done in public.

Kabakov **Brilliant. A person goes to a public place to be alone. And at home we do our public thing.**

Art in America, New York, January, 1995, pp. 68-69.

This interview was conducted in English and Russian with the assistance of the artist's wife, Emilia Kabakov. Ilya Kabakov's taped responses were translated by Cynthia Martin. Robert Storr is an artist and critic who is also a curator in the department of painting and sculpture at The Museum of Modern Art, New York.

Carolee Schneeman
Eye Body/Four Fur Cutting Boards
1963
Mixed media
Installation, New York

Jannis Kounellis
Untitled
1969
Gas burners
Dimensions variable

Mario Merz
l. to r., Appoggiati (Leaning)
1970
Glass, neon, paint
Numeri cancellati (Erased numbers)
1970
Metal, fabric, neon
Dimensions variable
Installation, Sonnabend Auxiliary Space, New York, 1970

Healing with Paintings 1996

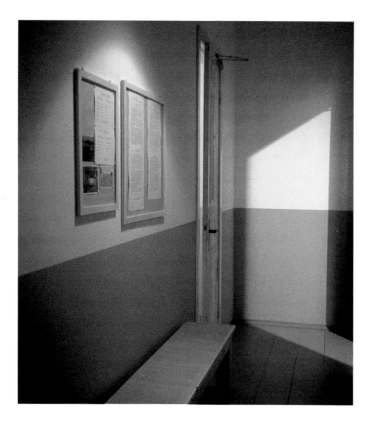

About the Main Principle of Healing

Healing with paintings, discovered and developed by Professor I.D. Lunkov in the city clinic of the State Medical Academy of the City of Orel, is a new, effective method for treating nervous and neurasthenic conditions. The treatment makes use of the special quality of certain paintings to affect in a positive and calming way the ill, agitated or exhausted psyche of the patient.

The methodology developed, however, is based not only on the aesthetic nature of these paintings, on their subject and the quality of their execution, but primarily on a special way of displaying them to the patient, which includes an entire complex of supplementary conditions: the illumination of the painting, a specially prepared space, and music accompanying the display.

The first condition deserves particular attention. It is the intensive illumination of a painting in a darkened space that is the key to the desired therapeutic effect (and herein lies the discovery of I.D. Lunkov that won him an award at the Oslo medical conference in 1984). Spending a certain time in complete solitude in a small, darkened space, with the accompaniment of specially selected music, the patient derives strong and long-lasting benefits from the effects of the 'glowing' painting. This method, widely practiced in Russia, is now being employed in many other countries in the treatment of neurasthenia, manic-depressive psychosis, nervous breakdowns and many other nervous-psychiatric illnesses.

Healing Methodology

Healing with paintings is performed in special clinics where there are no fewer than two to three separate wards designed for this purpose. The patient undergoing prophylactic healing should lie down, completely undressed, in the bed. A landscape painting, for example, or a painting with a subject, is recommended by the doctor on the basis of the patient's diagnosis, and should be located in direct proximity to the bed at a slight inclination so that its effect spreads evenly. The light is slowly turned on, illuminating the painting, and simultaneously the overhead light is turned off. The specially selected

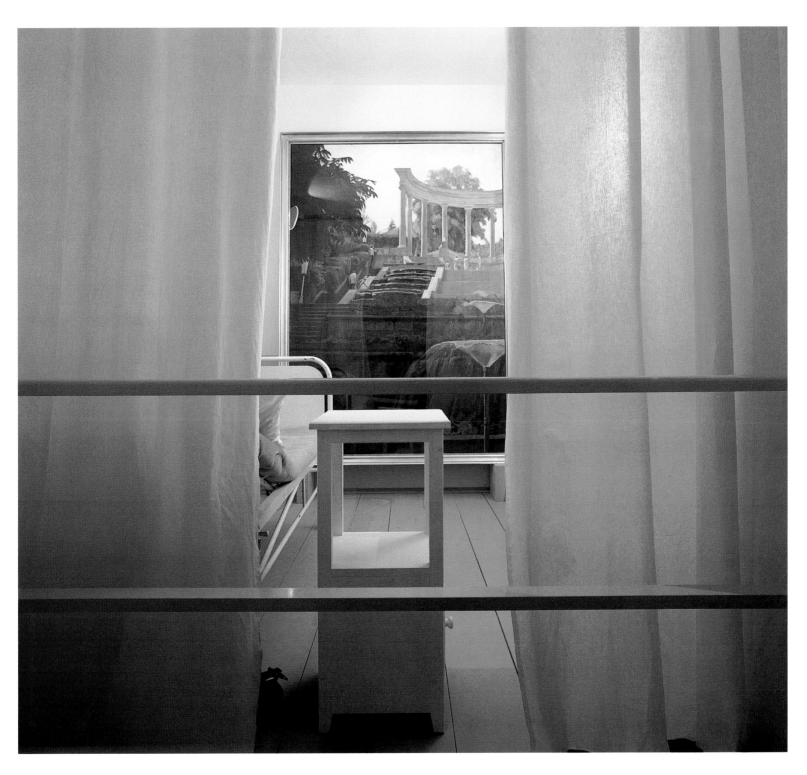

music begins to play (an appropriate musical accompaniment is selected by the doctor for each painting).

The light falls on the painting in such a way that only its surface is illuminated; the frame and the entire wall is entirely in shadow. The person undergoing treatment can escape completely into the imagination, exploring it according to inner desire. This brief escape into the depths of the painting, loosening the sense of one's actual location, this unique 'waking dream', is the very concept and goal of the treatment.

To achieve maximum benefit, the healing should be repeated two to three times a week. The entire treatment is designed to last two to three months depending on the patient's initial condition.

Healing with Paintings, 1996, text in the installation, revised 1998.

Monument to the Lost Glove (extract) 1996

Monument to the Lost Glove
1996
Red leather glove, music stands,
texts
Dimensions variable
Installation, Corner of Broadway
and 23rd Street, New York

[…] It is well known that writing poetry was an obligatory part of the curriculum in the seventeenth to eighteenth centuries. The ability to create a sonnet, a eulogy, or an epigraph, was appreciated as highly as aptitude at a musical instrument. But the ability of people to shroud their thoughts in poetic form was not the property of the 'gallant' epoch alone. Over the course of the nineteenth century, the skill was also widespread – verses were written, re-written, sent in the mail, read aloud at rendez-vous, not to mention at popular literary evenings … Unfortunately, towards the end of the 'iron' twentieth century, this wonderful tradition – in which verses existed not as the endeavour of only a chosen few, but as the 'air of existence for each and every person' – was lost … To resurrect it is the goal of our project as outlined below.

In beautiful corners of a park or at the intersection of busy streets, the following unusual 'sculpture' should be erected: attach to the ground an old, woman's glove (a plastic imitation, of course), and place a semi-circle of metal music stands around it, each bearing texts by invented characters who have seen this glove unexpectedly on the ground and have expressed the resulting associations that came into their heads. These are the recollections of a woman who lost a glove just like this one, in her youth; a man who recalls a recent affair; a detective; and a lover of cleanliness … But what is very important is that each of these texts is expressed in poetic form: some are rhymed, some 'blank' verse. The social meaning of such a sculpture can be guessed immediately: a passer-by who approaches these stands and reads the texts one after another, will definitely ask: 'What could I say about this? Shouldn't I try to say it in verse as well?'

What a beautiful glove that was – I will buy myself one just like it,
I saw it on rue Voges. I will buy an umbrella to match.
How pretty that is – long red gloves, a black suit, a small black hat …
It's settled – this summer I am going to visit Jean's parents in that outfit.
As always, there will be an outing in the carriage before supper …
But stop: Jeanine wore those exact same gloves last summer.
Four red ones in one carriage will look a bit strange.
But perhaps she'll come in different ones, or she'll leave them at home or lose them …
Gloves are not in fashion this season. And what if she sees me wearing them?
Nonsense, I will think of something when I get there. For example:

I will say that Jean gave them to me as a gift just before I left,
And I didn't dare refuse to put them on.

No, I can't understand where the park administration is, what is it doing –
After all, someone should be looking after cleanliness!
The question is, why is there all kinds of junk scattered all over the place,
Dry branches, rocks on the paths, gloves lost by someone?
It's obvious that it is the responsibility of those who are riding all around in
Special little carts to look after cleanliness, but nonetheless,
They don't see what is lying right before their eyes.
They don't understand that it's shame on the city, especially if guests come to visit us,
As they say, presidents of other countries – I heard about that,
But it's somehow hard to believe something like this –
What could they say about us, about the residents, if they
See garbage, like this at their feet, – I think
That they couldn't say anything good.
Of course, I could pick it up myself and throw it away,
But why should I do the work for them when they are getting paid for it?

[…] A red spot on green – a strong, bright hit, what freshness!
Oh, how the entire landscape resounds from this spot on the grass!

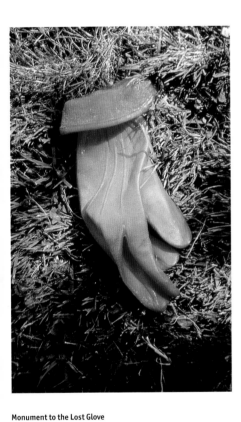

Monument to the Lost Glove
1996
Red leather glove, music stands,
texts
Dimensions variable
Installation, Espace Lyonnais pour
l'Art Contemporain, Lyon, 1996

All the flowers immediately come to life, begin to talk, the entire colourful palette all around has become visible:

The white T-shirts of the joggers, the yellow strips of the pathways, the yellow and red roses on the blooming bushes.

Only a small red spot – but oh, how it shimmers –

Against the background of a green world, green, fresh grass, dark shadows from the trees …

Monet, Pissarro, Renoir – how they could have set up

Just such a point in the landscape, so that everything becomes animated …

The harmony of pure colours played on their canvases.

It's a shame that the time of drawing from nature has passed forever,

No one needs this now – there are only 'concepts' all around,

Abstractions, 'installations' and other such talentlessness and frivolities.

[…] I bent down, took a closer look … I thought the glove was leather, it turns out it's plastic, an imitation …

And again the same old pain, the same thoughts that torment me all the time:

Everything is now an imitation, there is nothing real, nothing is genuine, everything is fake.

My daughter made the walls 'like Wood' – but it is painted paper;

The parquet in the kitchen is done 'like rocks' – but it's linoleum;

Flowers I saw in one home were artificial;

They say that somewhere they are laying artificial grass on the ground,

So it won't dry out and will be bright, like live grass …

They say all of this is cheaper – what's the difference, everything looks real and is even more practical.

And so what? Interest in the genuine, the real was lost long ago

And will unlikely ever return …

But don't those who talk like this think that everything will become second rate because of this,

And that our nature is being replaced by mere appearances, by deceit,

Our values, our attitudes, and even to ourselves we are becoming

Merely ghosts, murky shadows among other shadows in the world surrounding us?

[…]

Monument to the Lost Glove, 1996, text in the installation, revised 1998.

The Palace of Projects (extracts) 1998

3. A Room Taking off in Flight

Kh. Sabirov, Vitebsk

Our entire private life, if there is such a possibility, occurs in our apartment or our room. Even if our thoughts and fantasies are sometimes elevated (whenever possible) and we try to overcome depressing everyday existence, all that surrounds us in this existence doesn't permit us to do so. And here, a significant portion of the blame lies in the situation in our apartment or room, where we spend the greater part of the day. We are not talking about the people, the family with whom you live, but about those things that you bump into without noticing it – the couch, tables, closets – but primarily, the very box of the room, where all of this is located, the constant 'atmosphere' reigning in the space surrounding you. It makes no difference whether it is in a chaotic or organized form. This atmosphere, this 'order', even if you have arranged it yourself in your own image and likeness, will start to affect you. Its daily presence forces the very same thoughts to go round in your head, and with its weighty, material immobility the same thoughts and feelings press towards the 'earth', remain within the confines of the low, 'room' horizon.

But there is a simple means for breaking away, for escaping from this horizon without changing anything in the arrangement of your room: to escape upwards, to evaporate into a different, new space of being. You only have to do a small thing. In one part of the room – best of all in the centre – you should remove the parquet, uncover the beams that hold up the floor, and saw out some of them so that a deep hole downwards opens up. You will see that everything around you has suddenly become transformed. In the presence of a bottomless pit, the room, which until now seemed to be sturdy, will acquire the qualities of the inside of a balloon or a rocket rushing upward. Everything around you will become light and transparent, and even heavy things that seemed completely immobile will become your close and light friends in flight. Living in this room, this sensation of taking off will not abandon you again.

Of course, we are talking here about a house in the country. In urban conditions, where underneath the parquet floors is solid cement, such a 'breakthrough' is not so easy to achieve. The solution consists in making a second, artificial, floor up above. Despite the fact that this will reduce the height of the room, the result described above will repay this with interest [...]

The Palace of Projects, with Emilia Kabakov
1998
Wood, steel, fabric construction, spiral staircase, partitioned rooms, constructed and found objects, school furniture, texts
Overall l. approx. 25 m
Public project, Artangel, London

opposite, Installation, the Roundhouse, London

left, Plan of installation
Ink on paper
20.5 × 29.5 cm

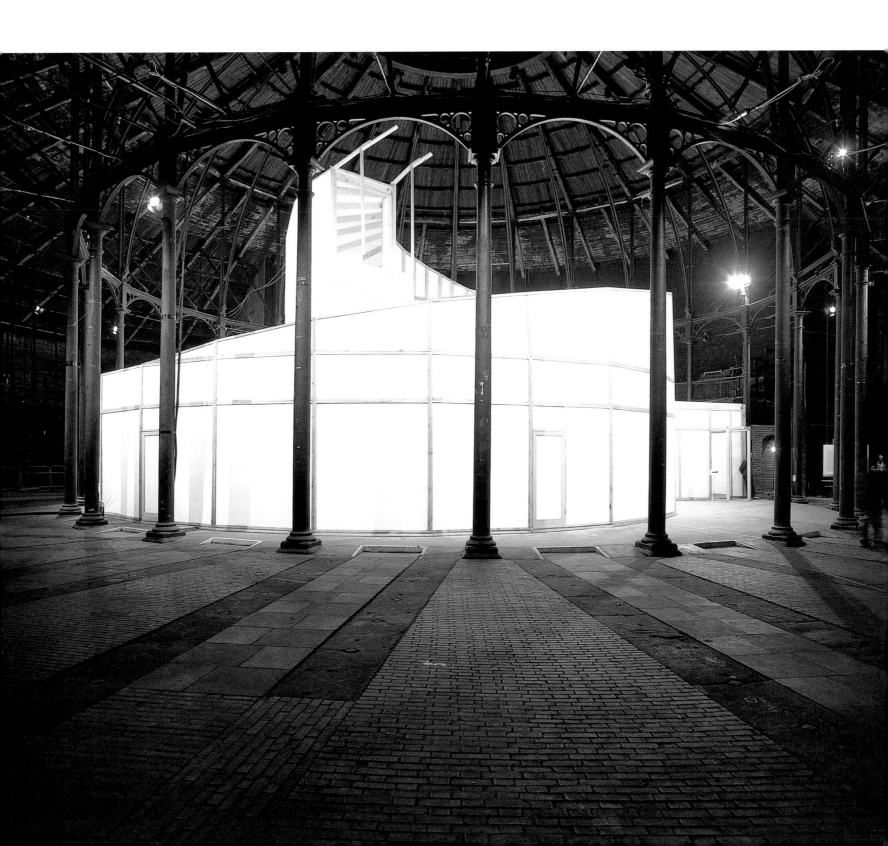

**Looking Upward; Closets of
Solitude**, from **The Palace of
Projects**
1997
Sample pages, artist's book
20.5 × 29.5 cm
Artangel, London; Museo Nacional
Centro de Arte Reina Sofía, Madrid

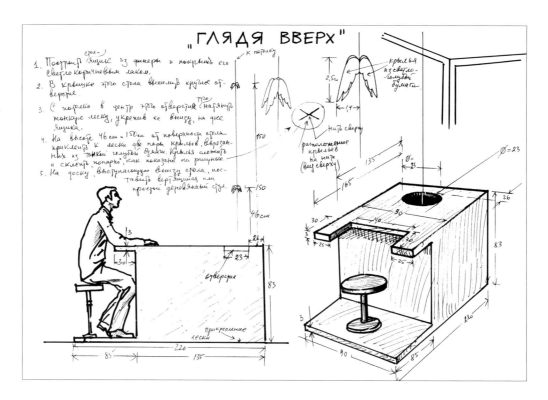

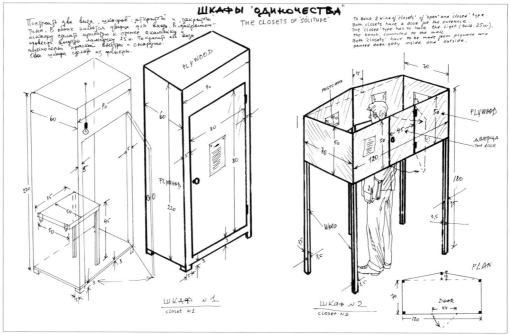

10. Looking Upward

V. Pokolevoy, Housepainter, Simbirsk

All possible kinds of mechanical machines for physical training are extraordinarily
fashionable today – people exercise on them for hours at home or they go to specially
equipped gyms to tone their muscles, to make their figures athletically fit. But there are
very few who worry about their internal mental state, which usually swings from
extreme nervous excitement to a subsequent depression. Wouldn't it make sense to
propose some similar method of auto-training of one's inner world with a sufficiently
efficient coefficient of action? The proposal for such a device is attached below. The
principle of its action can be reduced to the following postulate: 'Look up!' Actually,
observations have indicated (an experiment was conducted at Manchester University in
October of 1989), that for 42% of the day our head is aimed directly forward, 56% of the

time downward, and only 3% upward. At the same time, it was noted that it is precisely in this last instance that an outflow of negative emotions occurs, a calming of the mental processes, an inflow of lofty ennobling thoughts and feelings. The device stimulating such emotions, and which is accessible for installation in home conditions, looks like a table with protruding armrests. A small, round, narrow opening is made in the table opposite the person seated, from which a fine fishing line is stretched to the ceiling. Little wings are glued to three points on this line, four at each point. A person sitting in front of such a device concentrates all attention on any one of these groups of wings and according to the law connected with the proportions of the distances between these groups, equal to 2:6:12, attention, and consequently the head, will rise higher and higher all by itself without any conscious effort, moving from one group of wings to the next. As has been said above, one's mental state will change correspondinglyl. This training will yield positive results given daily repetition […]

43. Closets of Solitude

E. Lidina, 4th grade student, Moscow

Our cities today represent virtually uninhabitable environments. We are not talking about isolation inside one's house – every person can see to this independently, after all, it is 'his' house. But from the moment we enter 'public' space, the environment is impossible. A lot has been said about the smog, noise, numerous advertisements that terrorize our attention and make it impossible to concentrate on anything. Now, at the end of the century, one more ingredient has been added to this ensemble – ourselves. The streets are overcrowded: whether we are hurrying somewhere for business, heading home, or just out for a walk, we can barely push ourselves through the crowd. And this presence everywhere of an enormous quantity of people is bad for our sense of well-being on the street.

The project 'Closets of Solitude' solves this problem, which could be catastrophic in the near future. In various overcrowded parts of the city, especially at busy intersections or under trees, small closets are placed and a person can walk in, close the door and spend some time in solitude. Ventilation is provided by a special system, and the closet is made of sound-proof materials. Hence it can provide five to eight minutes in a quiet, dark place. This solitude completely restores the nervous system and helps one to concentrate. The closets can be placed close to one another, in rows of two, three or four, forming unified complexes […]

The Palace of Projects, Artangel, London; Museo Nacional Centro de Arte Reina Sofía, Madrid, 1997, n.p.

The Boat of My Life 1993

Birth. Dnepropetrovsk

30 September, 1933

I was born in the city of Dnepropetrovsk, USSR, and lived there until the age of 7.

September 1933

Mother had to go right back to work, as was done at that time.

Summer 1934

I was lying in the carriage in the yard. Suddenly the carriage rolled down the hill and turned over. I fell out on the pillow.

Summer 1935

Mother said that I would run away all the time, and that it was difficult to catch me. Our street was called Bojkaya Street.

Winter 1935

I can see transfer pictures being soaked in water in a white saucer. It is a bright sunny day.

1935

I don't remember either mother or father. I don't remember their faces.

Summer 1937

I had lobar pneumonia. We rented a room near the 'pine forest' for treatment.

Summer 1937

I was given a live, white rooster. I never left him, I would always carry him in my arms.

Autumn 1937

I would always ask for bread at lunchtime in the nursery school. The teacher, in order to break the habit, would place a full plate of it in front of me and not let me have any of it until I ate everything else.

Autumn 1938

There was a stuffed Misha bear, a small one. Sawdust was spilling out of him, but I still wouldn't part with him ... I cannot remember anything else.

1938

The waiting area in the cinema. The organizer of activities comes out before the show and asks, 'Who wants to come up on stage and sing?' I run to the stage and sing a song. Everyone sings with me.

1940

I come home (from school). I open the small window. I pour out the lunch that was left for me on the table. Revulsion toward food made at home.

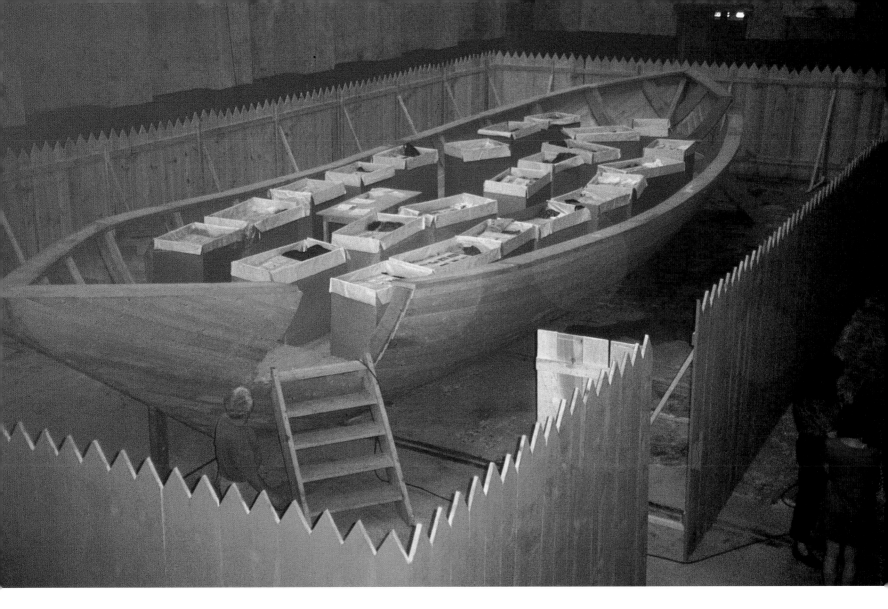

The Boat of My Life
1993
Wood construction, boat, steps,
25 cardboard packing boxes,
found objects, photographs, texts,
relating to different periods in the
artist's life
Boat, 260 × 550 × 1740 cm

above, Installation, Festspielhaus
Hellrau, Dresden, Germany, 1995

opposite, Pre-production drawing
Ink on paper
42 × 29.5 cm

The Beginning of the War. Evacuation
Summer 1940
We have already piled onto the cart. The neighbours are looking at us merrily. We are
waiting for mother. She's not there.
Summer 1941
Hot summer in the Kuban region, the Kamennobrodka village. I go to school there.
Little white cottages bathed in sunlight on the steppe. I can't remember anything else.
Summer 1941
We are crossing the Dnieper in a dense crowd of people. Bomber pilots are attacking
from above.
Summer 1941
My father gives me a toy air-gun as a present.
Summer 1941
Everyone would jump out of the carriages during the bombings of the train. I am
standing in a puddle of something. A puddle is burning on the other side.
Summer 1942
We are on our way to the port of Makhach-Kala. There is an open bread store. There is
bread on the shelves. You can just take it – there's no-one around.
Summer 1942
We are travelling at night along an open platform with grain on it. I am crawling down
from this crumbling pyramid. It's night time.
Summer 1942

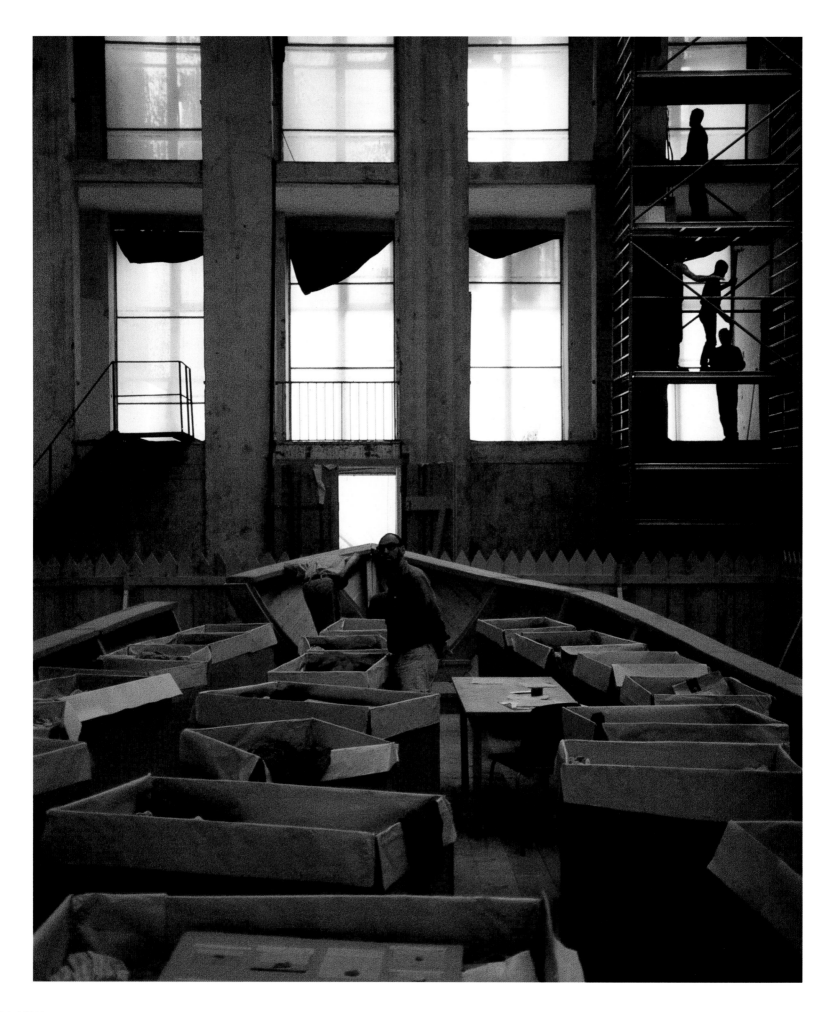

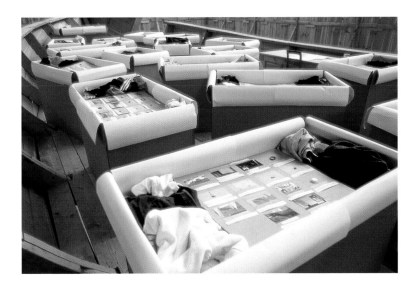
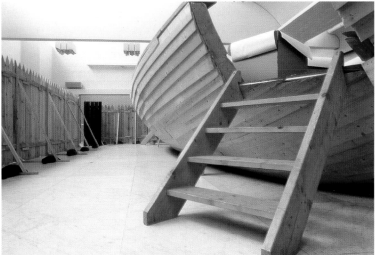

I am running around barefoot somewhere in the white dust. There is terrible heat.

Summer 1942

The train from Kislovosk to Tashkent. At a stop I am showing my air-gun to two boys through the window. The train moves. I see my gun in their hands – they are showing it to me. There's no way ever to get it back. Horrible, protracted hysterics.

Fall 1942

A ship full of people is at the dock in Makhach-Kala. First father throws me on, then mother falls onto it. That's how we were saved.

Life in Evacuation in Samarkand

Spring 1943

In Tashkent we all sleep on suitcases in some room.

Spring 1943

I am in the yard of a large preserves factory. Blinding sun. Thousands of cans of preserves are sparkling.

Spring 1943

I am in the shop of the preserves factory where my mother works. There are really tasty cold meat preserves with rice and vegetables.

Autumn 1943

I go to an Uzbek school. I still remember today how to count to twenty in Uzbek.

Autumn 1943

I find myself in a dark corridor. From afar, coming towards me, is a dark figure that looks like a bird.

Autumn 1943

There are a few people at the table in the room. They are looking at the drawings that I did in half an hour. Among them is the 'bird'. It is the council of the Leningrad Art School. They accept me.

Winter 1943

I am sitting with two Uzbek boys on a clay fence, dangling our legs. It's hot. You can see gardens, trees.

Winter 1943

Classes in the first grade of the Art School. Plywood carrels divide the wide corridor. There are four pupils at two desks, the teacher at a third.

I can't remember anything else.

The Boat of My Life, 1993, text in the installation.

The Boat of My Life
1993
Wood construction, boat, steps, 25 cardboard packing boxes, found objects, photographs, texts, relating to different periods in the artist's life
Boat, 260 × 550 × 1740 cm

above, Installation, Culturhaus, Copenhagen

opposite, Installation in progress, Festspielhaus Hellrau, Dresden, Germany, 1995

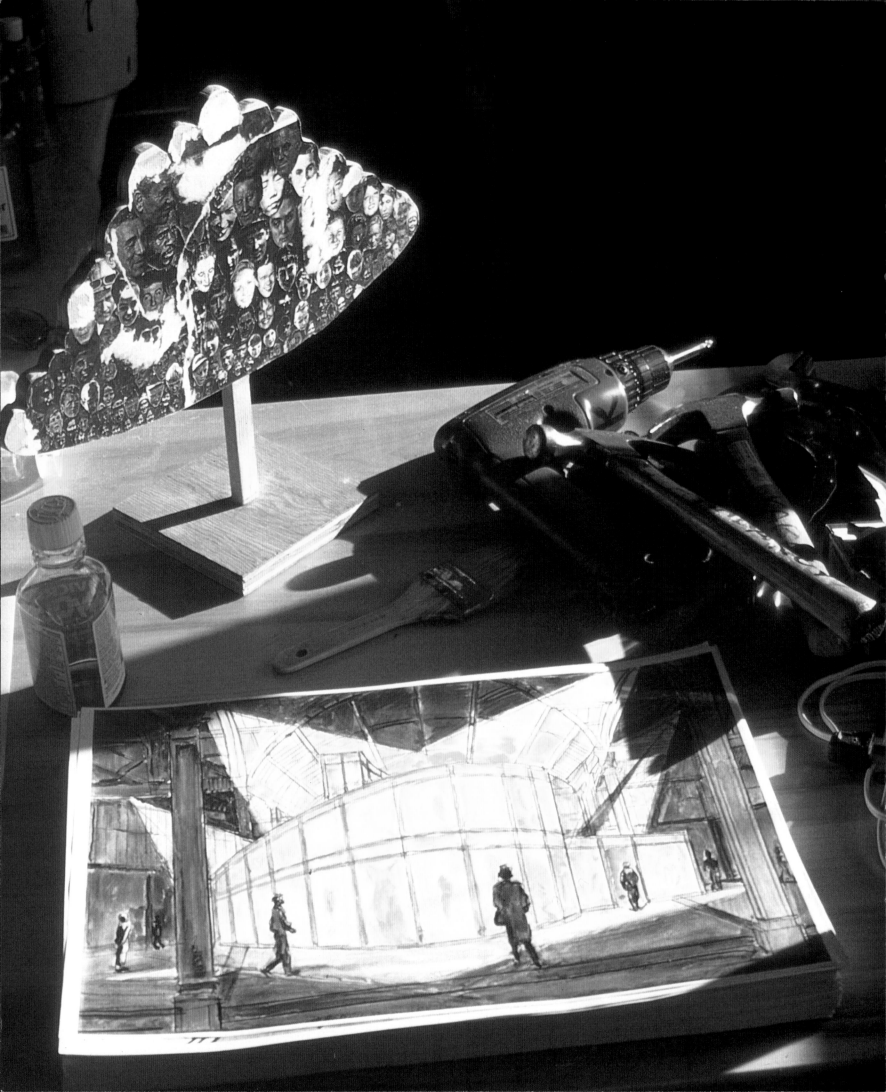

Contents

Chronology Ilya Kabakov Born 1933, Dniepropetrovsk, Russia, lives and works in Moscow and New York

Selected exhibitions and projects
1941-73

1941
When his father is drafted to the front, the artist and his mother are evacuated to Samarkand (Uzbekistan)

1943
Accepted into the school of Leningrad's Institute of Painting, Sculpture and Architecture of the All-Russian Academy of Arts, which has been evacuated to Samarkand

1945
Transfers to the Moscow Art School

1951
Graduates from Moscow Art School. Enters the Graphics Department of the V.A. Surikov Art Academy, Moscow, studying under Professor B. Dekhterev

1955
Begins to make 'drawings for myself': drawings in the spirit of Abstract Expressionism, landscapes 'from nature' and still-lifes in the style of Cézanne

1956
Begins to illustrate children's books for the publishers 'Detskaya Literatura' (Children's Literature) and 'Malysh' (Little One), Moscow, and for the magazines *Murzilka*, Moscow, and *Veselye Kartinki (Happy Pictures)*, Moscow

1957
Receives Diploma as a graphic designer from V.A. Surikov Art Academy

1962
Begins a series of 'absurd drawings' (later published in *Vytvarné umeni*, No 1, Prague, 1969)

1965
'Contemporary Alternatives/2',
Castello Spagnolo, L'Aquila, Italy (group)

1966
'Exhibition of Sixteen Moscow Artists',
Sopot-Poznan, Poland (group)

1968
Exhibition with Erik Bulatov,
Café Sinjaya ptica (The Blue Bird), Moscow (group)

1969
'The New Moscow School',
Pananti Gallery, Florence (group)

1970
'New Tendencies in Moscow',
Fine Arts Museum, Lugano, Switzerland (group)

1973
'Russian Avant-garde: Moscow-73',
Dina Vierny Gallery, Paris (group)

Selected articles and interviews
1941-73

1965
Crispolti, E., 'First Documents on Contemporary Avant-garde Painting and Plastic Arts in the Soviet Union', *Uomini e Idee*, No 1, Naples, January/February, 1966

1966
Konecny, D., 'The Problem of Technique in the Young Moscow Experimental School', *Prague-Moscow*, No 2, Moscow

1969
Asiaticus, 'Painters of Dissent', *L'Espresso*, No 11, Rome, 16 March

Konecny, D., 'Ilya Kabakov', *Vytvarné umeni*, No 1, Prague

1970

1973
Chalupecky, J., 'Moscow Diary', *Studio International*, No 11, London

Selected exhibitions and projects
1974-85

1974
'Progressive Tendencies in Moscow (1957–1970)',
Bochum Museum, Freiburg (group)

1975
'Russian Nonconformist Artists (Glezer Collection)',
Artists' Union, Vienna, toured to **Braunschweig,
Freiberg**, West Berlin; **Artists' Union**, Konstanz,
Germany; **'Die Fahre' State Gallery**, Saulgau, Germany
(group)

1977
'New Art from the Soviet Union',
The Herbert F. Johnson Museum of Art, Cornell
University, Ithaca, New York (group)

'Unofficial Russian Painting',
Institute of Contemporary Arts, London (group)

1978
'From Nature to Art, From Art to Nature',
XXXVIII Venice Biennale (group)
Exhibition, 'New Soviet Art: An Unofficial Perspective'
Cat. *From Nature to Art, from Art to Nature, XXXVIII
Venice Biennale*, texts Richard Diebenkorn, et al.

'Russian Nonconformist Painting',
Saarland Museum, Saarbrucken (group)

1979
'Twenty Years of Independent Art from the Soviet
Union',
Bochum Museum, Bochum, Germany (group)

'New Art from the Soviet Union: An Exhibition of Non-
Conformist Art from the 1960s and 1970s',
St Mary's College, Washington DC (group)
Cat. *New Art from the Soviet Union: An Exhibition of
Non-Conformist Art from the 1960s and 1970s*, St Mary's
College, Washington DC

1980

Tested!, 1981, in progress, studio, Moscow, 1980

1982
Exhibit of Paintings, 28 Malaja Gruzinskaja, Moscow
(group)

1984
'Photography and Art',
State Museum of Tartu, Estonia (group)

1985
'Kabakov',
Dina Vierny Galerie , Paris (solo)
Cat. *Kabakov*, Galerie Dina Vierny, Paris, text Bertrand
Lorquin

Bulletin boards, studio, Moscow, 1985

Selected articles and interviews
1974-85

1974

1975
Moncada, G., 'Three Other Paintings of Dissent: New
Experience and Research in Russia', *Il Giorno*, Bologna,
8 July

1977
Glueck, Grace, 'Art People', *The New York Times*, 7
October

Wierzchowska, W., Wroblewska, P., 'In the Studios of
Moscow Graphic Artists', *Projekt*, No 4, Warsaw
Forgey, Benjamin, 'A Look at Unofficial Soviet Art … ',
Washington Star, 13 October

1978

Sabo, A., 'Ilya Kabakov: Glebovics Leo Trefari', *Új
Müvészetért*, No 2, Budapest

1979

1980
Groys, Boris, 'Ilya Kabakov', *A-Ya*, No 2, Paris

1982

Groys, Boris, 'I. Kabakov's Albums', *A-Ya*, No 2, Paris
Pacukov, V., 'I. Kabakov', *A-Ya*, No 2, Paris

1984

1985

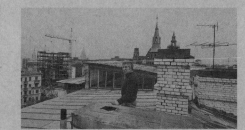

above, views of Ilya Kabakov's studio, 6/1 Sretensky
Boulevard, Moscow, 1982

Selected exhibitions and projects
1985-88

'Am Rande (Along the Margins)',
Kunsthalle, Bern, toured to **Musée Cantini**, Marseille;
Kunstverein für die Rheinlande und Westfalen,
Dusseldorf; **Centre National des Arts Plastiques**, Paris
(solo)
Cat. *Am Rande*, Kunsthalle, Bern, texts Jean-Hubert
Martin, Boris Groys

Book, *Das Fenster/The Window*, Benteli Verlag, Bern,
texts Jean-Hubert Martin, Claudia Jolles

1986
'Concert for a Fly',
Neue Galerie, Schlossli Gotzental, Dierikon,
Switzerland (solo)
Artist's book, *The Window*, Benteli Verlag, Bern

1987
'The 60s-70s', (with Ivan Tschuikov)
Kunstmuseum, Basel (solo)

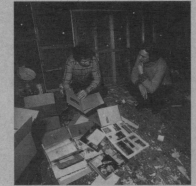

Ilya Kabakov, Andrei Monastyrsky, studio, Moscow, 1986

1988
Begins to work with Emilia Kanevsky whom he will
marry in 1992

'Ilya Kabakov and Erik Bulatov',
Kunstverein, Bonn (solo)

'Before Supper',
Kunstverein, Graz, Austria (solo)
Cat. *Before Supper*, The Graz Opera House, text Peter
Pakesch

'Ten Characters',
RFFA, New York (solo)
Cat. *Ten Characters*, RFFA, New York, text Ilya Kabakov

'10 Alben (10 Albums)',
Portikus-Austellung 9, Portikus, Frankfurt (solo)
Cat. *10 Alben*, Portikus-Austellung 9, Portikus,
Frankfurt, text Ilya Kabakov

'Aperto',
XLIII Venice Biennale (group)
Installation, *Before Supper*
Cat. *XLIII Venice Biennale*, texts Louise Bourgeois, et al.

Selected articles and interviews
1985-88

Grout, Catherine, 'Ilya Kabakov: Along the Margins',
Flash Art, No 132, Milan, February/March (1987)
Pely-Audan, Annick, 'Ilya Kabakov at Centre National
des Arts Plastiques', *Cimaise*, Vol 34, Paris, January/
February (1987)
Meier-Rust, K., 'Schickt uns Ethnogen!', *Du*, No 1,
Zurich

1986
Tupitsyn, Margarita, 'Ilya Kabakov', *Flash Art*, No 126,
Milan, February/March

1987

Jolles, Claudia and Misiano, Viktor, 'Eric Bulatov and
Ilya Kabakov', *Flash Art*, No 137, Milan, November/
December
Tupitsyn, Margarita, 'From Sots Art to Sovart', *Flash
Art*, No 137, Milan, November/December

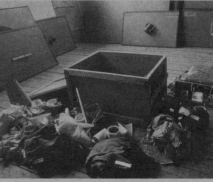

Box with garbage, studio, Moscow, 1986

1988

Vettese, Angela, 'Eric Bulatov, Ilya Kabakov', *Flash Art*,
No 138, Milan, January/February

Gookin, Kirby, 'Ilya Kabakov', *Artforum*, No 1, New
York, September
Heartney, Eleanor, 'Ilya Kabakov at Ronald Feldman
Fine Arts', *Art in America*, No 9, New York, September
Tupitsyn, Margarita, 'Ilya Kabakov', *Flash Art*, No 142,
Milan, October
Woodward, Richard B., 'Other Places, Other Rooms',
ARTnews, New York, September
Russell, John, 'Ilya Kabakov Portrays Communal Soviet
Life', *The New York Times*, 20 May

Huther, Christian, 'Ilya Kabakov', *Das Kunstwerk*, Vol
41, Stuttgart, February (1989)

Cooke, Lynne, 'Aperto ma non troppo', *Art
International*, Paris, Autumn

Bonito Oliva, Achille, 'Neo-Europe (East)', *Flash Art*,
No 140, Milan, May/June
Groys, Boris, et al., 'L'Art au Pays des Soviets', *Les
Cahiers du Musée national d'art moderne*, No 26, Centre
Georges Pompidou, Paris, Winter
McCoy, Pat, 'Ilya Kabakov', *Tema Celeste*, No 17/18,
Milan, October/December

Selected exhibitions and projects
1989-90

1989
Receives DAAD Fellowship, Berlin, and lives in Berlin, 1989-90

'Qui sont ces petit hommes? (Who Are These Little Men?)',
Galerie de France, Paris; **Institute of Contemporary Art**, Philadelphia (solo)
Cat. *Qui sont ces petit hommes?*, Galerie de France, Paris, text Ilya Kabakov

'The Untalented Artist and Other Characters',
Institute of Contemporary Arts, London (solo)
Cat. *Ten Characters*, Institute of Contemporary Arts, London, text Ilya Kabakov

'Ten Albums 1972-1975',
Riverside Studios, London (solo)
Cat. *Ten Albums 1972-1975*, Riverside Studios, London, texts Ilya Kabakov, Kate MacFarlane, Zoë Shearman

'Magiciens de la Terre',
Centre Georges Pompidou, Paris (group)
Installation, *The Man Who Flew into Space from His Apartment*
Cat. *Magiciens de la Terre*, Editions du Centre Pompidou, Paris, texts Jean Hubert Martin, et al.

'Das Schiff (The Ship)',
Kunsthalle, Zurich; **Neue Galerie , Museum Ludwig**, Aachen, Germany (solo)
Cat. *Das Schiff*, Kunsthalle, Zurich, text Claudia Jones

'Ausstellung Eines Buches ',
Daadgalerie, Berlin (solo)
Cat. *Ausstellung Eines Buches*, Daadgalerie, Berlin, texts Ilya Kabakov, Boris Groys, Josef Bakstein

1990
Ludwig Prize, Friends of the Museum Ludwig, Aachen, Germany

'He Lost His Mind, Undressed, Ran Away Naked',
RFFA, New York (solo)
Cat. *He Lost His Mind, Undressed, Ran Away Naked*, RFFA, New York, texts Ilya Kabakov, Boris Groys, Josef Bakstein

Selected articles and interviews
1989-90

Wallach, Amei, 'Pace Quickens in US-Soviet Cultural Exchange', Part II, *Newsday*, New York, 9 February

1989

Hall, James, 'Rooms with a View', *Arena*, London, Spring
Hilton, Tim, 'Portraits of Mother Russia', *The Guardian*, London, 1 March
Graham-Dixon, Andrew, 'Comrades in Art', *The Independent*, London, 28 February
Watkins, Jonathan, 'Ilya Kabakov', *Art International*, No 8, Paris, Autumn
Shepherd, Michael, 'Ilya Kabakov: ICA', *Arts Review*, Vol 41, London, 7 April
Furlong, William, 'The Unofficial Line: Ilya Kabakov', *Art Monthly*, London, April

Morgan, Stuart, 'Kabakov's Albums', *Artscribe*, London, May
Renton, Andrew, 'Ilya Kabakov: Riverside Studios, London', *Flash Art*, No 147, Milan, Summer

Bourriaud, Nicolas, 'Magiciens de la Terre', *Flash Art*, No 148, Milan, October
Martin, Jean-Hubert, 'The Whole Earth Show', *Art in America*, No 5, New York, May
Bertrund, Anne, 'L'Installation dans L'Installation dans ... ', *Connaissance des Arts*, No 13, Paris, June

Wulfen, Thomas, 'Malerei ist Illustration', *Kunstforum*, Vol 110, Cologne, November/December (1991)

Gambrell, Jamey, 'Perestroika Shock', *Art in America*, No 2, New York, February
Lloyd, Jill, 'The "Untalented Artist" – A Schizophrenic Way of Life', *Art International*, No 8, Paris, Autumn

1990

Kachur, Lewis, 'Ilya Kabakov: He Lost His Mind, Undressed, Ran Away Naked', *Art International*, No 11, Paris, Summer
Heartney, Eleanor, 'Nowhere to Fly', *Art in America*, No 3, New York, March
Tupitsyn, Victor, 'Ilya Kabakov', *Flash Art*, No 151, Milan, March/April
Cembalest, Robin, 'The Man Who Flew into Space',

Selected exhibitions and projects
1990

'Artisti Russi Contempornei',
Museo per l'arte Contemporanea Luigi Pecci, Prato,
Italy (group)
Installation, *The Underground Golden River*
Cat. *Soviet Art*, Museo per l'arte Contemporanea Luigi
Pecci, Prato, Italy, text Claudia Jolles

'Ten Characters',
Hirshhorn Museum and Sculpture Garden,
Smithsonian Institution, Washington DC (solo)
Cat. *Ten Characters*, Hirshhorn Museum and Sculpture
Garden, Washington DC, text Ned Rifkin

'The Readymade Boomerang: Certain Relations in 20th
Century Art',
8th Biennale of Sydney (group)
Cat. *The Readymade Boomerang: Certain Relations in
20th Century Art: 8th Biennale of Sydney*, Museum of
Contemporary Art, New South Wales, text René Block

'Sieben Ausstellungen eines Bildes',
Kunstverein, Kassel, Germany (solo)
Cat. *Sieben Ausstellungen eines Bildes*, Kunstverein,
Kassel, Germany, text Heiner Georgsdorf

'Between Spring and Summer: Soviet Conceptual Art in
the Era of Late Communism',
Tacoma Art Museum, Washington; **Institute of
Contemporary Art**, Boston; **Des Moines Art Center**,
Iowa (group)
Cat. *Between Spring and Summer: Soviet Conceptual Art
in the Era of Late Communism*, MIT Press, Cambridge,
Massachusetts, texts David A. Ross, et al.

'New Works for Different Places: TSWA Four Cities
Project',
Orchard Gallery, Derry, Northern Ireland (solo)
Installation, *Fly with Wings*
Cat. *New Works for Different Places: TSWA Four Cities
Project*, Television South West, England, texts Tony
Foster, Jonathan Harvey, James Lingwood

'In de USSR en erbuiten',
Stedelijk Museum, Amsterdam (group)
Installation, *The Rope of Life and Other Installations*
Cat. *In de USSR en erbuiten*, Stedelijk Museum,
Amsterdam, texts Wim Beeren, Jan Hein Sassen

'Rhetorical Image',
New Museum of Contemporary Art, New York (group)
Cat. *Rhetorical Image*, New Museum of Contemporary
Art, New York, texts Milena Kalinovska, Deirdre
Summerbell, Friedrich Dürrenmatt, et al.

Selected articles and interviews
1990

ARTnews, No 5, New York, May
McCoy, Pat, 'Ilya Kabakov', *Arts Magazine*, No 8, New
York, April
Nesbitt, Lois, 'Ilya Kabakov', *Artforum*, No 8, New York,
April
Wallach, Amei, 'State of the Art', *New York Newsday*, 12
January
Wallach, Amei, 'Artful Assault on Sensibilities', *New
York Newsday*, 18 October

Burchard, Hank, 'Cell Blockbuster', *Washington Post*, 9
March
Lewis, Jo Ann, 'Cubicles of Cramped Souls', *Washington
Post*, 7 March
Heartney, Eleanor, 'Post-Utopian Blues', *Sculpture*, No
3, Washington DC, May/June

<div style="border:1px solid;padding:8px;">

Ilya Kabakov
7 Ausstellungen eines Bildes

Zur Eröffnung der Ausstellung
Sonntag, 13. Mai 1990, 11.30 Uhr
laden wir Sie herzlich ein.

Einführung: Boris Groys,
Universität Münster

Ilya Kabakov wird anwesend sein

Kasseler Kunstverein

Ständeplatz 16. 3500 Kassel
Öffnungszeiten:
Di–So 10–13 Uhr, Di–Fr 15–18 Uhr
Ende der Ausstellung: 24. Juni 1990
Himmelfahrt/Fronleichnam geschlossen

</div>

Archer, Michael, 'Invisible Yearnings: The TSWA Four
Cities Project', *Artscribe*, No 85, London, January/
February (1991)

Boym, Constantin, 'Reviving design in the USSR', *Print*,
New York, March/April

Selected exhibitions and projects
1990-91

1991
Receives grant from The Ministry of Culture, France, and lives in Paris

'Die Zielscheiben',
Peter Pakesch Gallery, Vienna (solo)
Artist's book, *The Targets*, edition the artist, New York

'Sowjetische Kunst um 1990',
Kunsthalle, Dusseldorf (Installation, *The Red Wagon*, with musical arrangement by Vladimir Tarasov); **The Israel Museum**, Jerusalem (Installation, *Why 'The Red Wagon' Didn't Come to Israel*); **Central House of Artists**, Moscow (Installation, *Why 'The Red Wagon' Didn't Come to Moscow*) (group)
Cat. *Sowjetische Kunst um 1990*, DuMont, Cologne, texts Jöurgen Harten, Boris Groys, et al.
Artist's book, *The Red Wagon*, edition the artist, New York

'Night Lines',
Outdoor exhibits sponsored by the **Centraal Museum**, Utrecht, The Netherlands (group)
Permanent installation, *Whose Wings Are These?*

'Trans/Mission',
Centre for Contemporary Art, Malmö (group)
Installation, *Mental Institution, or Institute for Creative Research*
Cat. *Trans/Mission*, Centre for Contemporary Art, Malmö, texts, Lars Nittve, Ilya Kabakov, et al.
Artist's Book, *Mental Institution, or Institute for Creative Research*, edition the artist, New York

'Devil on the Stairs: Looking Back on the Eighties',
Institute of Contemporary Art, Philadelphia; **Newport Harbor Art Museum**, Newport Beach, California (group)
Installation, *The Man Who Flew into His Painting*
Cat. *Devil on the Stairs: Looking Back on the Eighties*, Institute of Contemporary Art, Philadelphia, texts Robert Storr, Judith Tannenbaum
Artist's book, *The Man Who Flew into His Painting*, edition the artist, New York

'Dislocations',
The Museum of Modern Art, New York (group)
Installation, *The Bridge*
Cat. *Dislocations*, The Museum of Modern Art, New York, text Robert Storr
Artist's book, *The Bridge*, edition the artist, New York

'1991 Carnegie International',
Carnegie Museum of Art, Pittsburgh (group)
Installation, *We Are Leaving Here Forever!*

Selected articles and interviews
1990-91

Gambrell, Jamey, 'Report from Moscow: The Perils of Perestroika', *Art in America*, No 3, New York, March
Sokolov, Mikhail, 'Russian Art: The Crucial Century', *Apollo*, London, January
Zamkov, Vladimir, 'The Old Guard and ...', *Apollo*, London, January

1991

Bruderlin, Marcus, 'Ilya Kabakov: Gallery Pakesch', *Artforum*, No 10, New York, Summer

Jocks, Heinz-Norbert, 'Sowjetische Kunst um 1990', *Kunstforum*, No 103, Cologne, May/June

Wieczorek, Marek, '*Night Lines* Turns Utrecht into Vegas North', *Journal of Art*, No 7, Los Angeles, September

Meinhardt, Johannes, 'Malmö: Trans/Mission', *Artforum*, No 4, New York, December

Bonami, Francesco, 'Dislocations – The Place of Installation', *Flash Art*, No 162, Milan, January/February (1992)
Cotter, Holland, 'Dislocating the Modern', *Art in America*, No 1, New York, January (1992)
Danto, Arthur, 'Dislocationary Art', *The Nation*, No 1, New York, January (1992)
Heartney, Eleanor, 'Reviews: Dislocations, MOMA', *ARTnews*, No 1, New York, January (1992)
Cotter, Holland, 'Dislocating the Modern', *Art in America*, No 1, New York, January (1992)

Dannatt, Adrian, 'The Carnegie International', *Flash Art*, No 162, Milan, January/February (1992)

Ilya Kabakov
DIE ZIELSCHEIBEN

12. Februar 1991 – 16. März 1991

Selected exhibitions and projects
1991-92

Cat. *Carnegie International*, Carnegie Museum of Art, Pittsburgh, texts Lynne Cooke, Mark Francis
Artist's book, *We Are Leaving Here Forever!*, edition the artist, New York

'Wanderlieder',
Stedelijk Museum, Amsterdam (group)

'Normandy-Neman' memorial-sculpture, commissioned by the City of Orly, France

'Ilya Kabakov, Yuri Kuper: 52 Entretiens dans la Cuisine Communitaire',
Ateliers Municipaus d'Artistes, Marseille; **La Criée**, Halle d'Art Contemporain, Rennes (solo)
Cat. *Ilya Kabakov, Yuri Kuper: 52 Entretiens dans la Cuisine Communitaire*, Ateliers Municipaux d'Artistes, Marseilles, text Ilya Kabakov

Artist's books, *The Fly with Wings*, edition the artist, New York; *Die Kunst des Fliehens*, Hanser Verlag, Munich, with additional text by Boris Groys

1992
Moves to New York and marries Emilia Kanevsky

'Das Leben der Fliegen (The Life of Flies)',
Kunstverein, Cologne (solo)
Artist's book, *Das Leben der Fliegen/The Life of Flies*, Edition Cantz, Stuttgart, additional texts Nicola Von Velsen, Boris Groys

'Dans la Cuisine Communitaire (On the Communal Kitchen)',
Galerie Dina Vierny, Paris (solo)
Artist's book, *Dans la Cuisine Communitaire*, Galerie Dina Vierny, Paris

Life with an Idiot,
The Netherlands Opera,Hetmuziek Theater, Amsterdam
Costumes and sets, Ilya Kabakov; music, Alfred Schnittke,
Book, *Life with an Idiot*, The Netherlands Opera, Amsterdam, texts Alfred Schnittke, Viktor Jerofejev, Ilya Kabakov, Boris Groys

Documenta IX,
Kassel, Germany (group)
Installation, *The Toilet*
Cat. *Documenta IX*, Kassel, Germany, text Bart De Baere
Artist's book, *The Toilet*, edition the artist, New York

'Incident at the Museum, or Water Music', (musical arrangement by Vladimir Tarasov)
RFFA, New York, **Museum of Contemporary Art**, Chicago; **Hessisches Landesmuseum**, Darmstadt,

Selected articles and interviews
1991-92

Groys, Boris, 'Kunst und Widerstand im Sowjetreich', *PAN*, No 2, Munich
Solomon, Andrew, 'Soviet Art Assumes Its Place in World Market', *The Journal of Art*, No 9, Los Angeles, November
Sommar, Ingrid, 'Postmodern Power Station', *ARTnews*, No 8, New York, October
Wallach, Amei, 'Censorship in the Soviet Block', *Art Journal*, No 3, New York, Autumn

1992

Smolik, Noemi, 'Ilya Kabakov', *Kunstforum*, No 119, Cologne

Tupitsyn, Victor, 'From the Communal Kitchen: A Conversation with Ilya Kabakov', *Arts Magazine*, New York, October

Adcock, Craig, 'Documenta IX', *Tema Celeste*, No 37/38, Milan, Autumn
Galloway, David, 'Postmortem – Documenta IX: The Bottom Line', *Art in America*, No 9, September (1993)
Kuijken, Ilse, 'Documenta IX', *Kunst & Museumjournaal*, No 6, Amsterdam

Bonami, Francesco, 'Ilya Kabakov: Ronald Feldman Fine Arts', *Flash Art*, No 168, Milan, January/February (1993)
Artner, Alan G., 'Beginning Again – A Soviet Artist

Selected exhibitions and projects
1992-93

Germany, **Fundació Antoni Tàpies**, Barcelona, **Fundação Calouste Gulbenkian**, Lisbon (solo)
Cat. *Incident at the Museum, or Water Music*, Museum of Contemporary Art, Chicago, text Ilya Kabakov, Richard Francis

'Illustration as a Way to Survive',
Koninklijke Academie voor Schone Kunsten, Kortrijk, Belgium; **Ikon Gallery**, Birmingham; **Centre for Contemporary Arts**, Glasgow (solo)
Cat. *Illustration as a Way to Survive*, Kanaal Art Foundation, Belgium, text Ilya Kabakov

Recieves Arthur Kopcke Award, Kopcke Foundation, Copenhagen

Permanent Installation, *Unhung Painting*
Ludwig Museum, Cologne (solo)
Artist's book, *Unhung Painting*, edition the artist, New York

1993

'The Empty Museum' (with students of Staatliche Hochschule für Bildende Kunste – Stadelschule),
Staatliche Hochschule für Bildende Kunste – Stadelschule, Frankfurt (solo)

'Rendez (-) Vous'
Museum van Hedendaagse Kunst, Ghent (group)
Cat. *Rendez (-) Vous*, Museum van Hedendaagse Kunst, Ghent, Belgium, text Bart De Baere

'Het Grote Archief (The Big Archive)',
Stedelijk Museum, Amsterdam (solo)
Cat. *Het Grote Archief (The Big Archive)*, Stedelijk Museum, Amsterdam, text Ilya Kabakov

'Ilya Kabakov: Das Boot meines Lebens (The Boat of My Life)',
Kunstverein, Salzburg, Austria (solo)
Artist's book, *Das Boot meines Lebens/The Boat of My Life*, edition the artist, New York

Artist's project, Ilya and Emilia Kabakov, 'True Stories', *Flash Art*, No 172, Milan, October

Selected articles and interviews
1992-93

Finds Painting is no Longer Enough', *Chicago Tribune*, 25 July (1993)
Deitcher, David, 'Art on the Instalment Plan', *Artforum*, No 5, New York, January (1993)
Koplos, Janet, 'Of Walls and Wandering', *Art in America*, No 7, July
Princenthal, Nancy, 'Artist's Book Beat', *Print Collector's Newsletter*, No 6, New York, January/February
Huther, Christian, 'Ilya Kabakov', *Kunstforum*, No 127, Cologne, July/September (1994)

Groys, Boris, '"With Russia on Your Back": A Conversation between Ilya Kabakov and Boris Groys', *Parkett*, No 34, Zurich
Jolles, Claudia, 'Kabakov's Twinkle', *Parkett*, No 34, Zurich
Storr, Robert, 'The Architect of Emptiness', *Parkett*, No 34, Zurich
Levi Strauss, David, 'Cumulus from America', *Parkett*, No 33, Zurich
Thorn-Prikker, Jan, 'On Lies and Other Truths', *Parkett*, No 34, Zürich
Veire, Frank Vande, 'Ilya Kabakov: The Exhibition as Installation', *Kunst & Museumjournaal*, No 2, Amsterdam

1993

Hofleitner, Johanna, 'Ilya Kabakov: The Boat of My Life', *Flash Art*, No 172, Milan, October

Ilya Kabakov
Das Boot meines Lebens
11.8. - 3.10.1993

Selected exhibitions and projects
1993-94

Permanent installation, *School No 6*
Chinati Foundation, Marfa, Texas

'Von Malewitsch bis Kabakov',
Kunsthalle, Cologne (group)
Installation, *Before Supper*
Cat. *Von Malewitsch bis Kabakov*, Prestel, New York,
Munich, texts Stephan Diedrich, Evelyn Weiss

Joseph Beuys Prize, Beuys Foundation, Basel,
Switzerland

Max Beckmann Prize, Frankfurt, Germany

Permanent installation, *Concert for a Fly* (Musical
arrangement by Vladimir Tarasov),
Chateau d'Oiron, France (solo)

XLV Venice Biennale (group)
Installation, *The Red Pavilion* (with Emilia Kabakov,
musical arrangement by Vladimir Tarasov),
Artist's book, *The Red Pavilion*, edition the artist, New
York
Receives Honorary Diploma, XLV Venice Biennale

'NOMA oder: Der Kreis der Moskauer Konzeptualisten
(NOMA, or the Moscow Conceptual Circle)',
Kunsthalle, Hamburg (solo)
Artist's book, *NOMA oder: Der Kreis der Moskauer
Konzptualisten*, Kunsthalle, Hamburg, Cantz Verlag,
Stuttgart,

Invitation card, **The Red Pavilion**, XLV Venice Biennale

1994
'Tyrannei des Schönen : Architektur der Stalin-Zeit',
MAK, Austrian Museum of Applied Arts, Vienna
(group)
Installation, *The Red Wagon*
Cat. *Tyrannei des Schönen : Architektur der Stalin-Zeit*,
Prestel, New York, Munich, text Peter Noever

'The Golden Underground River, The Boat of My Life,
The Album of My Mother'
Centre National d'Art Contemporain, Grenoble (solo)

'Korytarz dwòch banalosci (The Corridor of Two
Banalities)' (with Joseph Kosuth)
Center for Contemporary Art, Warsaw (solo)

'Europa-Europa',
**Kunst-und Ausstellungshalle der Bundesrepublik
Deutschland**, Bonn (group)

Selected articles and interviews
1993-94

Virshup, Amy, 'Russian Lessons', *ARTnews*, No 5, New
York, January

'Kabakov Receives the Beuys Prize', *Flash Art*, No 171,
Milan, Summer

McEvilley, Thomas, 'Venice the Menace', *Artforum*, No
2, New York, October
Renton, Andrew, 'Venice Biennale – Antidote or
Double-bluff?', *Flash Art*, No 172, October
Devriendt, Miriam and An Van der Linden, '45th
Biennale of Venice 1993', *Forum International*, No 19,
Antwerp, October/November
Wallach, Amei, 'Art & Hype in Venice', *New York
Newsday*, 23 June
Bonami, Francesco, 'Ilya Kabakov: Tales from the Dark
Side', *Flash Art*, No 177, Milan, Summer (1994)
Madoff, Steven Henry, 'Venice: We Are the World?',
ARTnews, No 7, September

Muller, Silke, 'Eastern European Art in Hamburg', *Flash
Art*, No 175, Milan, March/April (1994)
Muller, Silke, 'Ilya Kabakov: NOMA', *Kunstforum*, No
126, Cologne, March/June (1994)

Bonami, Francesco, 'Robert Irwin, Justen Ladda,
Gober, Robert, 'Ilya Kabakov', *Flash Art*, No 168, Milan,
January/February
Decter, Joshua, 'Allegories of Cultural Criticism', *Flash
Art*, No 170, Milan, May/June
Groys, Boris, 'Ilya Kabakov: The Art of
Communication', *Arti, Art Today*, March/April
Periz, Ingrid, 'Ilya Kabakov', *art /text*, No 44, Sydney

1994

Fayet, Catherine, 'Ilya Kabakov', *Artefactum*, Antwerp,
Autumn

Selected exhibitions and projects
1994-95

Installation, *The Man Who Never Threw Anything Away*

'Operation Room, Mother and Son',
Museum of Contemporary Art, Helsinki; **National
Museum of Contemporary Art**, Oslo (solo)
Artist's book, *5 Albumia/5 Albumer/ 5 Albums*, Museum
of Contemporary Art, Helsinki, National Museum of
Contemporary Art, Olso, additional texts, Boris Groys,
Tuula Arkio, Karin Hellandsjø

1995
'Africus',
1st Johannesburg Biennale (group)
Installation, *Unfinished Installation*
Cat. *1st Johannesburg Biennale*, Greater Johannesburg
Metropolitan Council, texts Laura Fergusson, et al.

'C'est ici que nous vivons (We Are Living Here)',
Centre Georges Pompidou, Paris (solo)
Cat. *Ilya Kabakov: Installations 1983-1995*, Éditions du
Centre Georges Pompidou, Paris, texts Nadine
Poullion, Boris Groys

'The Rope of Life and Other Installations',
Museum für Moderne Kunst, Frankfurt, (solo)
Permanent installation, *Change of Scene VIII*
Cat. *The Rope of Life and Other Installations*, Museum
für Moderne Kunst, Frankfurt, texts Ilya Kabakov,
Hubert Beck, Mario Kramer

Permanent installation, *The School Library*,
Stedelijk Museum, Amsterdam

Permanent installation, *The Man Who Never Threw
Anything Away*,
Museum of Contemporary Art, Oslo
Book, *Søppelmannen/The Garbage Man*, National
Museum of Contemporary Art, Oslo, texts Ilya Kabakov,
Karin Hellandsjø, Boris Groys

Permanent installation, *No Water*,
MAK, Austrian Museum of Applied Arts, Vienna

'Next Wave Festival',
Brooklyn Academy of Music, New York
The Flies, musical phantasmagoria
Performances, Ilya Kabakov, Emilia Kabakov, Vladimir
Tarasov; composer, Vladimir Tarasov; costumes and set
design, Ilya Kabakov

'New Orientation. The Vision of Art in a Paradoxical
World',
4th Istanbul International Biennale
Installation, *The First Image of the Car, Unusual
Incident*
Cat. *4th Istanbul International Biennale*, Istanbul
Foundation for Culture and Arts, texts A. Murtozaoglu,
et al.

Awarded Chevalier des Arts et des Lettres, Paris

Selected articles and interviews
1994-95

Blom, Ina, 'Life in the Closet', *frieze*, No 21, London,
March/April

Groys, Boris, 'Ilya Kabakov: Answers of an
Experimental Group', *Artforum*, New York, September
Schumatzky, Boris, 'Ilya Kabakov', *Du*, No 1, Zurich

1995

Rian, Jeff, 'Ilya Kabakov', *Flash Art*, No 184, Milan
October
Jodidio, Philip, 'C'est ici que nous vivons',
Connaissance des Arts, No 519, Paris, July/August
Hyman, Susan, 'Ilya Kabakov: Centre Georges
Pompidou', *Sculpture*, Washington DC, May/June
(1996)
Chalumeau, Jean-Luc, 'Ilya Kabakov', *Ninety: Art in the
90s*, No 18, Paris

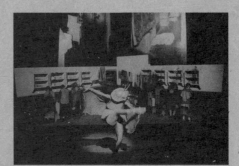

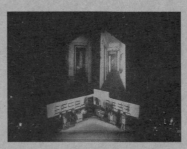

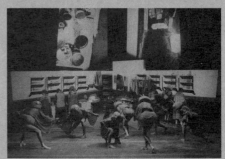

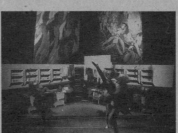

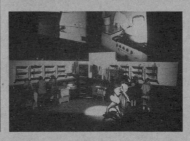

The Flies, 'Next Wave Festival', Brooklyn Academy of Music, New York

Selected exhibitions and projects
1995-97

Artist's book, *Über die »Totale« Installation/On the "Total" Installation*, Cantz Verlag, Stuttgart, text Ilya Kabakov

1996
Permanent installation, *Music on the Water* (Musical arrangement by Vladimir Tarasov), **Landeskulturzentrum**, Salzau, Kiel
Artist's book, *Musik auf dem Wasser/Music on the Water*, Verlag der Buchhandlung Walther König, Cologne, additional texts Vladimir Tarasov, Marianne Tidick, Thomas Deecke, Rainer Haarmann

'Retrospective: Der Lesesaal (The Reading Room)', **Deichtorhallen**, Hamburg (solo)
Cat. *Der Lesesaal (The Reading Room)*, Deichtorhallen, Hamburg, text Ilya Kabakov

'Sur le toit/Op het dak (On the Roof)', **Palais des Beaux-Arts**, Brussels (solo)
Artist's book, *Auf Dem Dach*, Richter Verlag, Dusseldorf, additional text Emilia Kabakov (1997)

Installation, *Monument to the Lost Glove*, **Espace Lyonnais pour l'Art Contemporain**, Lyon, to coincide with the G7 Summit

23rd Bienal de São Paulo,
Ciccillo Matarazzo Pavilion (group)
Installation, *Two Cabinets*
Cat. *23rd Bienal de São Paulo*, text, Katerina Koskinaetal, et al.

Permanent installation, *Healing with Paintings*, **Kunsthalle**, Hamburg

Permanent installation, *The Ship*,
Espace Lyonnais pour l'Art Contemporain, Lyon
Artist's book, *«1964–1984» La Navire/"1964-1984" The Ship*, Musée d'Art Contemporain, Lyon, additional text Thierry Raspail

'Stimmen hinter der Tür (Voices Behind the Door)', **Galerie für Zeitgenössische Kunst**, Leipzig (solo)

Book, *Ilya Kabakov, The Man Who Never Threw Anything Away*, Abrams, New York, texts, Amei Wallach, Robert Storr, Ilya Kabakov

1997
'The Life of Flies',
Barbara Gladstone Gallery, New York (solo)

Selected reviews and articles
1995-97

Neumaier, Otto; Alexander, Puhringer, 'Die Totale Installation', *noema art journal*, No 39, Salzburg

Barringer, Felicity, 'Ghosts of a Vanished World', *ARTnews*, New York, September
Tupitsyn, Victor, 'A Psychodrome of Misreading', *Third Text*, No 33, London, Winter
Storr, Robert, 'An Interview with Ilya Kabakov', *Art in America*, No 1, New York, January
Groys, Boris, 'Ilya Kabakov', *Artforum*, No 1, New York, September
Huin, Fernando, 'Kabakov: Sea of Voices', *Flash Art*, No 184, Milan, October

1996

Bauwell, Bert, 'With Kabakov on Russian Roof', *Gazet van Antwerpen*, Antwerp, 14 June
Brack, Jan, 'A Short Night on the Roof', *Knack*, Brussels, 7 July

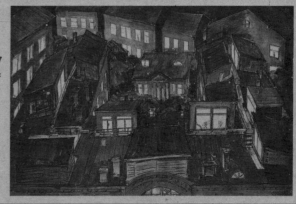

Storr, Robert, 'Ilya Kabakov: The Secret Anthropologist', *Tate*, No 10, London, Winter

1997
Schwabsky, Barry, 'Conceptualist Comments on the Soviet Union', *The New York Times*, 22 June
Boym, Svetlana, 'Ilya Kabakov', *Artforum*, No 10, New

Selected exhibitions and projects
1997-98

Installation, *Monument to the Lost Glove*,
organized by the Public Art Fund, New York
23rd Street and Broadway, New York

'Whitney Biennial',
Whitney Museum of American Art, New York (group)
Installation, *Treatment with Memories*
Cat. *Whitney Biennial*, Whitney Museum of American
Art, New York, Abrams, New York, texts Lisa Philips,
Louise Neri, David A. Ross

'Skulptur Projekte in Münster',
Munster, Germany (group)
Permanent installation, *Looking up. Reading the
words ...*
Cat. *Sculpture Projects in Münster 1997*, Verlag Gerd
Hatje, Munster, Germany, ed. Klaus Bussmann, Kasper
König, Florian Matzner

Permanent installation, *The Fallen Chandelier*,
Hochhaus zur Palme, Zurich

Receives Art Critics Association Award, New York

'Future Present Past',
XLVII Venice Biennale
Installation, *We Were in Kyoto* (with Emilia Kabakov)
Cat. *XLVII Venice Biennale*, texts Germano Celant,
Pontus Hulten, John Hanhardt, Lino Bubman, et al.

1998
Permanent installation, *The Metaphysical Man*,
Kunsthalle, Bremen

'The Palace of Projects' (with Emilia Kabakov),
organized by Artangel, London and Museo Nacional
Centro de Arte Reina Sofía, Madrid
The Roundhouse, London; **Upper Campfield Market**,
Manchester; **The Crystal Palace**, Museo Nacional
Centro de Arte Reina Sofía, Madrid (solo)
Artist's book, *The Palace of Projects*, Artangel, London,
Museo Nacional Centro de Arte Reina Sofía, Madrid

'16 Installaties (16 Installations)',
MUHKA, Museum van Hedendaagse Kunst, Antwerp
(solo)
Cat. *16 Installaties (16 Installations)*, MUHKA, Museum

Selected reviews and articles
1997-98

York, Summer
Falkenstein, 'Lord of the Flies', *New York Press*, 3
March
Akinsha, Konstantin, 'How Sweet it is to Hate Your
Motherland', *Arts and Letters*, New York, 21 March

Adams, Brooks, 'Turtle Derby: 1997 Whitney Biennial',
Art in America, No 6, New York, June
Rimanelli, David, '1997 Biennial Exhibition', *Artforum*,
No 7, New York, May
MacRitchie, Lynn, 'Time and Space at The Whitney
Rave', *The Financial Times*, London, 30 March
Schwabsky, Barry, '1997 Whitney Biennial', *art/text*,
No 58, Sydney, August/October
Kimmelman, Michael, 'Narratives Snagged on the
Cutting Edge', *The New York Times*, 21 March

Blazwick, Iwona, 'In Arcadia', *Art Monthly*, No 208,
London, July/August
Blase, Christoph, 'Die Beute des Kunstsommers aus
Venedig, Kassel und Münster', *Kunst-Bulletin*, Kriens,
Switzerland, July/August
Von Gerhard, Heinrich, 'Romantik geht auf Sendung',
Westfälische Hachrichten, Steinfurt, 16-27 July

1998

Kent, Sarah, 'Escape Root, Ilya Kabakov Presents "The
Palace of Projects",' *Time Out*, London, 1-8 April
Searle, Adrian, 'Ministry of Silly Ideas', *The Guardian*,
London, 24 March
Lubbock, Tom, 'At Home with the Ideal World
Exhibition', *The Independent*, London, 31 March
Feaver, William, 'Look 'n' Learn', *The Observer*, London,
29 March
Cork, Richard, 'The Palace of Fantasy Unchained', *The
Times*, London, 31 March
Hunt, Ian, 'The People's Palace', *Art Monthly*, No 216,
London, May
Morgan, Stuart, 'Ilya and Emilia Kabakov: The
Roundhouse, London', *frieze*, No 41, London,
June/July
Bartelik, Marek, 'Ilya and Emilia Kabakov: The
Roundhouse', *Artforum*, Vol 36, No 10, New York,
Summer

Demeester, Ann, 'Reizend door Kabakovs verhalen', *De
Morgan*, Brussels, 28 April
Dosogne, Ludo, 'Ik ben zo vrij als een vlieg', *Gazet van
Antwerpen*, Antwerp, 11 April

The Palace of Projects, in progress, studio, Long Island, New York

Selected exhibitions and projects
1998-99

van Hedendaagse Kunst, Antwerp, texts Ilya Kabakov,
Florent Bex

'Crossings/Traversées',
National Gallery of Canada, Ottawa (group)
Installation, *Two Windows*
Cat. *Crossings/Traversées*, National Gallery of Canada,
Ottawa, texts Diana Nemiroff, et al.

'Innenleben - Zur Geschicht des Interieurs ',
Städelsches Kunstinstitut, Frankfurt (group)
Installations, *The Toilet in the Corner*, *In the Closet*
Cat. *The History of Interior, from Vermeer to Kabakov*,
Städelsches Kunstinstitut, Frankfurt, text Dr Sabine
Schultze

'The Treatment with Memories',
Hamburger Banhof, Hamburg; **Museum für
Gegenwartskunst**, Berlin (solo)
Cat. *The Treatment with Memories*, Richter Verlag,
Dusseldorf, texts Ilya Kabakov, Emilia Kabakov

Artist's book, *Stimmen hinter der Tür 1964-1983 (Voices
Behind the Door)*, Galerie für Zeitgenössische Kunst,
Leipzig, additional texts Boris Groys, Klaus Werner

Receives Kaiserring Träger, 1998, Stadt Göslar,
Germany

Permanent installation, *My Grandfather's Shed*,
Mönchehaus Museum für Moderne Kunst, Göslar,
Germany

'The Children's Hospital', (with Emilia Kabakov)
Irish Museum of Modern Art, Dublin (solo)

'Retrospective of Drawings and Albums',
Stadtgalerie, Heerlen, The Netherlands; **Sprengel
Museum**, Hannover (solo)

Permanent installation, *The Last Step*,
commissioned by The City of Bremerhaven, Germany

1999
Retrospective
Kunstmuseum, Bern (solo)

'The Life and Creativity of Charles Blumental',
Mito Tower, Mito, Japan (solo)

Selected reviews and articles
1998-99

Rollin, Pierre, 'Ilya Kabakov, entre intimité et
universalité', *Le Matin*, Brussels, 7 May

Herbstreuth, Peter, 'Zu Besuch bei Hern und Frau
Kabakov', *Der Tagesspiegel*, Berlin, 15 May

Akinsha, Konstantin, 'How Sweet it is to Hate Your Motherland', Arts and Letters, New York, 21 March, 1997

Archer, Michael, 'Invisible Yearnings: The TSWA Four Cities Project', Artscribe, No 85, London, January/ February, 1991

Artner, Alan G., 'Beginning Again – A Soviet Artist Finds Painting is no Longer Enough', Chicago Tribune, 25 July, 1993

Asiaticus, 'Painters of Dissent', L'Espresso, No 11, Rome, 16 March, 1969

Barringer, Felicity, 'Ghosts of a Vanished World', ARTnews, New York, September, 1995

Bartelik, Marek, 'Ilya and Emilia Kabakov: The Roundhouse', Artforum, Vol 36, No 10, New York, Summer, 1998

Bauwell, Bert, 'With Kabakov on Russian Roof', Gazet van Antwerpen, Antwerp, 14 June, 1996

Beck, Hubert, The Rope of Life and Other Installations, Museum für Moderne Kunst, Frankfurt, 1993

Bertrund, Anne, 'L'Installation dans L'Installation dans …', Connaissance des Arts, No 13, Paris, June, 1989

Blazwick, Iwona, 'In Arcadia', Art Monthly, No 208, London, July/August, 1997

Blom, Ina, 'Life in the Closet', frieze, No 21, London, March/April, 1994

Bonami, Francesco, 'Dislocations – The Place of Installation', Flash Art, No 162, Milan, January/February, 1992

Bonami, Francesco, 'Ilya Kabakov: Ronald Feldman Fine Arts', Flash Art, No 168, Milan, January/February, 1993

Bonami, Francesco, 'Ilya Kabakov: Tales from the Dark Side', Flash Art, No 177, Milan, Summer, 1994

Bonito Oliva, Achille, 'Neo-Europe (East)', Flash Art, No 140, Milan, May/June, 1988

Bourriaud, Nicolas, 'Magiciens de la Terre', Flash Art, No 148, Milan, October, 1989

Boym, Svetlana, 'Ilya Kabakov', Artforum, No 10, New York, Summer, 1997

Brack, Jan, 'A Short Night on the Roof', Knack, Brussels, 7 July, 1996

Bruderlin, Marcus, 'Ilya Kabakov: Gallery Pakesch', Artforum, No 10, New York, Summer, 1991

Burchard, Hank, 'Cell Blockbuster', Washington Post, 9 March, 1990

Cembalest, Robin, 'The Man Who Flew into Space', ARTnews, No 5, New York, May, 1990

Chalumeau, Jean-Luc, 'Ilya Kabakov', Ninety: Art in the 90s, No 18, Paris, 1995

Chalupecky, J., 'Moscow Diary', Studio International, No 11, London, 1973

Cooke, Lynne, 'Aperto ma non troppo', Art International, Paris, Autumn, 1988

Cork, Richard, 'The Palace of Fantasy Unchained', The Times, London, 31 March, 1998

Cotter, Holland, 'Dislocating the Modern', Art in America, No 1, New York, January, 1992

Crispolti, E., 'First Documents on Contemporary Avant-garde Painting and Plastic Arts in the Soviet Union', Uomini e Idee, No 1, Naples, January/February, 1966

Danto, Arthur, 'Dislocationary Art', The Nation, No 1, New York, January, 1992

Decter, Joshua, 'Allegories of Cultural Criticism', Flash Art, No 170, Milan, May/June, 1993

Deitcher, David, 'Art on the Instalment Plan', Artforum, No 5, New York, January, 1993

Demeester, Ann, 'Reizend door Kabakovs verhalen', De Morgan, Brussels, 28 April, 1998

Dosogne, Ludo, 'Ik ben zo vrij als een vlieg', Gazet van Antwerpen, Antwerp, 11 April, 1998

Fayet, Catherine, 'Ilya Kabakov', Artefactum, Antwerp, Autumn, 1994

Feaver, William, 'Look 'n' Learn', The Observer, London, 29 March, 1998

Forgey, Benjamin, 'A Look at Unofficial Soviet Art …', Washington Star, 13 October, 1977

Francis, Richard, Incident at the Museum, or Water Music, Museum of Contemporary Art, Chicago, 1992

Furlong, William, 'The Unofficial Line: Ilya Kabakov', Art Monthly, London, April, 1989

Gambrell, Jamey, 'Perestroika Shock', Art in America, No 2, New York, February

Gambrell, Jamey, 'Report from Moscow: The Perils of Perestroika', Art in America, No 3, New York, March, 1990

Glueck, Grace, 'Art People', The New York Times, 7 October, 1977

Gookin, Kirby, 'Ilya Kabakov', Artforum, No 1, New York, September, 1988

Graham-Dixon, Andrew, 'Comrades in Art', The Independent, London, 28 February, 1989

Grout, Catherine, 'Ilya Kabakov: Along the Margins', Flash Art, No 132, Milan, February/March, 1987

Groys, Boris, '"With Russia on Your Back": A Conversation between Ilya Kabakov and Boris Groys', Parkett, No 34, Zurich, 1992

Groys, Boris, 'I. Kabakov's Albums', A-Ya, No 2, Paris, 1982

Groys, Boris, 'Ilya Kabakov', A-Ya, No 2, Paris, 1980

Groys, Boris, 'Ilya Kabakov', Artforum, No 1, New York, September, 1995

Groys, Boris, 'Ilya Kabakov: Answers of an Experimental Group', Artforum, New York, September, 1994

Groys, Boris, 'Ilya Kabakov: The Art of Communication', Arti, Art Today, March/April, 1993

Groys, Boris, 'Kunst und Widerstand im Sowjetreich', PAN, No 2, Munich, 1991

Groys, Boris, et al., 'L'Art au Pays des Soviets', Les Cahiers du Musée national d'art moderne, No 26, Centre Georges Pompidou, Paris, Winter, 1988

Groys, Boris, Das Leben der Fliegen/The Life of Flies, Edition Cantz, Stuttgart, 1992

Hall, James, 'Rooms with a View', Arena, London, Spring, 1989

Heartney, Eleanor, 'Nowhere to Fly', Art in America, No 3, New York, March, 1990

Heartney, Eleanor, 'Ilya Kabakov at Ronald Feldman Fine Arts', Art in America, No 9, New York, September, 1988

Heartney, Eleanor, 'Post-Utopian Blues', Sculpture, No 3, Washington, DC, May/June, 1990

Heartney, Eleanor, 'Reviews: Dislocations, MOMA', ARTnews, No 1, New York, January, 1992

Herbstreuth, Peter, 'Zu Besuch bei Hern und Frau Kabakov', Der Tagesspiegel, Berlin, 15 May, 1998

Hilton, Tim, 'Portraits of Mother Russia', The Guardian, London, 1 March, 1989

Hofleitner, Johanna, 'Ilya Kabakov: The Boat of My Life', Flash Art, No 172, Milan, October, 1993

Huin, Fernando, 'Kabakov: Sea of Voices', Flash Art, No 184, Milan, October, 1995

Hunt, Ian, 'The People's Palace', Art Monthly, No 216, London, May, 1998

Huther, Christian, 'Ilya Kabakov', Das Kunstwerk, Vol 41, Stuttgart, February, 1989

Huther, Christian, 'Ilya Kabakov', Kunstforum, No 127, Cologne, July/September, 1994

Hyman, Susan, 'Ilya Kabakov: Centre Georges Pompidou', Sculpture, Washington, DC, May/June, 1996

Jocks, Heinz-Norbert, 'Sowjetische Kunst um 1990', Kunstforum, No 103, Cologne, May/June, 1991

Jodidio, Philip, 'C'est ici que nous vivons', Connaissance des Arts, No 519, Paris, July/August, 1995

Jolles, Claudia, 'Eric Bulatov and Ilya Kabakov', Flash Art, No 137, Milan, November/December, 1987

Jolles, Claudia, 'Kabakov's Twinkle', Parkett, No 34, Zurich, 1992

Jones, Claudia, Das Schiff, Kunsthalle, Zurich, 1989

Kabakov, Ilya, Artist's books: see Chronology

Kabakov, Ilya, 'Discussion of the Three Layers', A-Ya, No 6, Paris, 1984

Kabakov, Ilya, 'Kitchen Series', A-Ya, No 6, Paris, 1984

Kachur, Lewis, 'Ilya Kabakov: He Lost His Mind, Undressed, Ran Away Naked', Art International, No 11, Paris, Summer, 1990

Kalinovska, Milena, 'London', Contemporanea, New York, November/December, 1988

Kent, Sarah, 'Escape Root, Ilya Kabakov Presents "The Palace of Projects"', Time Out, London, 1-8 April, 1998

Kimmelman, Michael, 'Narratives Snagged on the Cutting Edge', The New York Times, 21 March, 1997

Konecny, D., 'Ilya Kabakov', Vytvarné umeni, No 1, Prague, 1969

Konecny, D., 'The Problem of Technique in the Young Moscow Experimental School', Prague-Moscow, No 2, Moscow, 1966

Koplos, Janet, 'Of Walls and Wandering', Art in America, No 7, July , 1993

Kramer, Mario, The Rope of Life and Other Installations, Museum für Moderne Kunst, Frankfurt, 1993

Kuijken, Ilse, 'Documenta IX', Kunst & Museumjournaal, No 6, Amsterdam, 1992

Levi Strauss, David, 'Cumulus from America', Parkett, No 33, Zurich, 1992

Lewis, Jo Ann, 'Cubicles of Cramped Souls', Washington Post, 7 March, 1990

Lloyd, Jill, 'The "Untalented Artist" – A Schizophrenic Way of Life', Art International, No 8, Paris, Autumn, 1989

Lubbock, Tom, 'At Home with the Ideal World Exhibition', The Independent, London, 31 March, 1998

MacFarlane, Kate, Ten Albums 1972-1975, Riverside Studios, London, 1989

Martin, Jean-Hubert, 'The Whole Earth Show', Art in America, No 5, New York, May, 1989

McCoy, Pat, 'Ilya Kabakov', Arts Magazine, No 8, New York, April, 1990

McCoy, Pat, 'Ilya Kabakov', Tema Celeste, No 17/18, Milan, October/December, 1988

Meier-Rust, K., 'Schickt uns Ethnogen!', Du, No 1, Zurich, 1985

Meinhardt, Johannes, 'Malmö: Trans/Mission', Artforum, No 4, New York, December, 1991

Misiano, Viktor, 'Eric Bulatov and Ilya Kabakov', Flash Art, No 137, Milan, November/December, 1987

Moncada, G., 'Three Other Paintings of Dissent: New Experience and Research in Russia', Il Giorno, Bologna, 8 July, 1975

Morgan, Stuart, 'Kabakov's Albums', Artscribe, London, May, 1989

Morgan, Stuart, 'Ilya and Emilia Kabakov: The Roundhouse', London', frieze, No 41, London, June/July, 1998

Muller, Silke, 'Eastern European Art in Hamburg', Flash Art, No 175, Milan, March/April, 1994

Nesbitt, Lois, 'Ilya Kabakov', Artforum, No 8, New York, April, 1990

Neumaier, Otto, 'Die Totale Installation', noema art journal, No 39, Salzburg, 1995

Pacukov, V., 'I. Kabakov', A-Ya, No 2, Paris, 1982

Pakesch, Peter, Before Supper, The Graz Opera House, Austria, 1988

Pely-Audan, Annick, 'Ilya Kabakov at Centre National des Arts Plastiques', Cimaise, Vol 34, Paris, January/February, 1987

Periz, Ingrid, 'Ilya Kabakov', art/text, No 44, Sydney, 1993

Puhringer, Alexander, 'Die Totale Installation', noema art journal, No 39, Salzburg, 1995

Renton, Andrew, 'Ilya Kabakov: Riverside Studios, London', Flash Art, No 147, Milan, Summer, 1989

Rian, Jeff, 'Ilya Kabakov', *Flash Art*, No 184, Milan October, 1995

Rifkin, Ned, *Ten Characters*, Hirshhorn Museum and Sculpture Garden, Washington DC, 1990

Rollin, Pierre, 'Ilya Kabakov, entre intimité et universalité', *Le Matin*, Brussels, 7 May, 1998

Russell, John, 'Ilya Kabakov Portrays Communal Soviet Life', *The New York Times*, 20 May, 1988

Sabo, A., 'Ilya Kabakov: Glebovics Leo Trefari', *Új Müvészetért*, No 2, Budapest, 1978

Schumatzky, Boris, 'Ilya Kabakov', *Du*, No 1, Zurich, 1994

Schwabsky, Barry, 'Conceptualist Comments on The Soviet Union', *The New York Times*, 22 June, 1997

Searle, Adrian, 'Ministry of Silly Ideas', *The Guardian*, London, 24 March, 1998

Shearman, Zoë, *Ten Albums 1972-1975*, Riverside Studios, London, 1989

Shepherd, Michael, 'Ilya Kabakov: ICA', *Arts Review*, Vol 41, London, 7 April, 1989

Smolik, Noemi, 'Ilya Kabakov', *Kunstforum*, No 119, Cologne, 1992

Sokolov, Mikhail, 'Russian Art: The Crucial Century', *Apollo*, London, January, 1990

Solomon, Andrew, 'Soviet Art Assumes Its Place in World Market', *The Journal of Art*, No 9, Los Angeles, November, 1991

Sommar, Ingrid, 'Postmodern Power Station', *ARTnews*, No 8, New York, October, 1991

Storr, Robert, 'Ilya Kabakov: The Secret Anthropologist', *Tate*, No 10, London, Winter, 1996

Storr, Robert, 'The Architect of Emptiness', *Parkett*, No 34, Zurich, 1992

Storr, Robert, 'An Interview with Ilya Kabakov', *Art in America*, No 1, New York, January, 1995

Storr, Robert, *Ilya Kabakov, The Man Who Never Threw Anything Away*, Abrams, New York, 1996

Thorn-Prikker, Jan, 'On Lies and Other Truths', *Parkett*, No 34, Zürich, 1992

Tupitsyn, Margarita, 'From Sots Art to Sovart', *Flash Art*, No 137, Milan, November/December, 1987

Tupitsyn, Margarita, 'Ilya Kabakov', *Flash Art*, No 126, Milan, February/March, 1986

Tupitsyn, Margarita, 'Ilya Kabakov', *Flash Art*, No 142, Milan, October, 1988

Tupitsyn, Victor, 'From the Communal Kitchen: A Conversation with Ilya Kabakov', *Arts Magazine*, New York, October, 1992

Tupitsyn, Victor, 'A Psychodrome of Misreading', *Third Text*, No 33, London, Winter, 1995

Tupitsyn, Victor, 'Ilya Kabakov', *Flash Art*, No 151, Milan, March/April, 1990

Veire, Frank Vande, 'Ilya Kabakov: The Exhibition as Installation', *Kunst & Museumjournaal*, No 2, Amsterdam, 1992

Vettese, Angela, 'Eric Bulatov, Ilya Kabakov', *Flash Art*, No 138, Milan, January/February, 1988

Virshup, Amy, 'Russian Lessons', *ARTnews*, No 5, New York, January, 1993

Von Velsen, Nicola, *Das Leben der Fliegen/The Life of Flies*, Edition Cantz, Stuttgart, 1992

Wallach, Amei, 'Censorship in the Soviet Block', *Art Journal*, No 3, New York, Autumn, 1991

Wallach, Amei, *Ilya Kabakov, The Man Who Never Threw Anything Away*, Abrams, New York, 1996

Watkins, Jonathan, 'Ilya Kabakov', *Art International*, No 8, Paris, Autumn, 1989

Wierzchowska, W. 'In the Studios of Moscow Graphic Artists', *Projekt*, No 4, Warsaw, 1977

Woodward, Richard B., 'Other Places, Other Rooms', *ARTnews*, New York, September, 1988

Wroblewska, P., 'In the Studios of Moscow Graphic Artists', *Projekt*, No 4, Warsaw, 1977

Wulffen, Thomas, 'Malerei ist Illustration', *Kunstforum*, Vol 110, Cologne, November/December, 1991

Zamkov, Vladimir, 'The Old Guard and ... ', *Apollo*, London, January, 1990

Public Collections

Museum Ludwig, Aachen, Germany
Stedelijk Museum, Amsterdam
MUHKA, Museum van Hedendaagse Kunst, Antwerp
Fondation La Caixa, Barcelona
Museum für Gegenwartskunst, Basel
Bochum Museum, Bochum, Germany
Kunsthalle, Bremen
Fonds Regional pour l'Art Contemporain, Bretagne
City of Bremerhaven, Germany
Museum Ludwig, Cologne
Museum für Moderne Kunst, Frankfurt
National Deutsche Bibliothek, Frankfurt
Museum van Hedendaagse Kunst, Ghent
Mönchehaus Museum für Moderne Kunst, Göslar
Kunsthalle, Hamburg
Museum of Contemporary Art, Helsinki
Landeskulturzentrum, Kiel, Germany
City of Kuanju, South Korea
Musée d'art contemporain, Lyon
City of Munster, Germany
The Museum of Modern Art, New York
City of Orly, France
Museum of Contemporary Art, Oslo
Musée national d'art moderne, Centre Georges Pompidou, Paris
Musée Maillol, Paris
City of Seville, Spain
Museum of Contemporary Art, Seoul, South Korea
City of Utrecht, The Netherlands
Museum Moderner Kunst, Vienna
MAK, Austrian Museum of Applied Art, Vienna
Hochhaus zur Palme, Zurich

Comparative Images

page 39, **Erik Bulatov**
Red Horizon

page 122, **Paul Cézanne**
Viaduct
Pushkin Museum, Moscow

page 11, **Collective Action Group**
Action: Painting

page 82, **Donald Judd**
Untitled
Permanent installation, Münster
Westfälisches Landesmuseum für Kunst und Kulturgeschichte, Münster, Germany

page 124, **Donald Judd**
Permanent installation of works, Chinati Foundation, Marfa, Texas

page 106, **El Lissitzky**
Von zwei Quadraten (Story of Two Squares)
Victoria and Albert Museum, London

page 32, **Studio of Francisco Infante, Moscow**

page 13, **Wassily Kandinsky**
The Last Judgement

page 128, **Allan Kaprow**
Yard

page 39, **Komar and Melamid**
Portrait of Melamid's Father

page 129, **Jannis Kounellis**
Untitled

page 34, **A. Kruchenykh**
Learn Art

page 42, **Kazimir Malevich**
Black Square
State Russian Museum, St Petersburg

page 14, **Konstantin Melnikov**
Rusakov Workers' Club

page 129, **Mario Merz**
Appoggiati; Numeri Cancellati

page 128, **Claes Oldenburg**
The Store

page 129, **Carolee Schneeman**
Eye Body/Four Fur Cutting Boards

page 68, **Vladimir Tatlin**
Model for a Projected Monument for the III International

List of Illustrated Works

page 38, **Agonizing Surikov**, 1972–75
page 40, **Anna Petrovna Has a Dream**, 1972–75
pages 78-79, **The Artist's Library**, 1997
page 69, **The Big Archive**, 1993
pages 140-143, **The Boat of My Life**, 1993
page 33, **Boy**, 1965
page 36, **Calf?**, 1971
page 46, **Carrying out the Slop Pail**, 1980
pages 60-61, 120-121, **The Communal Kitchen**, 1991
page 77, **Destroyed Altar**, 1996
page 41, **The Flying Komarov**, 1972–75
page 52, **Gastronom**, 1981
page 15, **The Glue**, 1980
page 107, **Heads**, 1968
pages 130-131, **Healing with Paintings**, 1996
page 12, **Hello, Morning of Our Homeland!**, 1981
page 53, **Holidays, No. 2**, 1987
page 53, **Holidays, No. 6**, 1987
page 36, **How Much?**, 1970
pages 74-75, **Incident at the Museum**, or **Water Music**, 1991
page 32, **In the Room**, 1965–68
pages 112-119, **The Life of Flies**, 1992
pages 50-51, **The Man Who Flew into Space from His Apartment**, 1986
pages 48-49, 98-99, 101-105, **The Man Who Never Threw Anything Away**, 1985–88
pages 108-111, **Mental Institution**, or **Institute of Creative Research**, 1991
pages 62-63, **The Metaphysical Man**, 1989/98
pages 132-135, **Monument to the Lost Glove**, 1996
pages 26-27, **NOMA**, or the **Moscow Conceptual Circle**, 1993
pages 92-94, **On the Roof**, 1996
pages 136-139, **The Palace of Projects**, 1998
page 123, **The Path**, 1982
page 33, **Pipe, Stick, Ball and a Fly**, 1966
page 14, **The Poetry Train**, 1974
page 37, **Queen Fly**, 1965
pages 22-25, **The Red Pavilion**, 1993
pages 18-19, 20-21, 68, **The Red Wagon**, 1991
page 16, **The Release**, 1983
pages 9, 10, 124-127, **School No. 6**, 1993
pages 66-67, **The Ship**, 1986/92
page 16, **Shower**, 1978
page 43, **Sitting-in-the Closet**
Primakov, 1972–75
page 35, **Stool, Cat ...**, 1964
pages 54-59, **Ten Characters**, 1985–88
pages 64-65, **The Toilet**, 1992
pages 28, 29, **Treatment with Memories**, 1997
pages 70-73, **We Are Living Here**, 1995
page 76, **We Were in Kyoto**, 1997